THE
BARBIZON
SCHOOL
& THE ORIGINS OF
IMPRESSIONISM

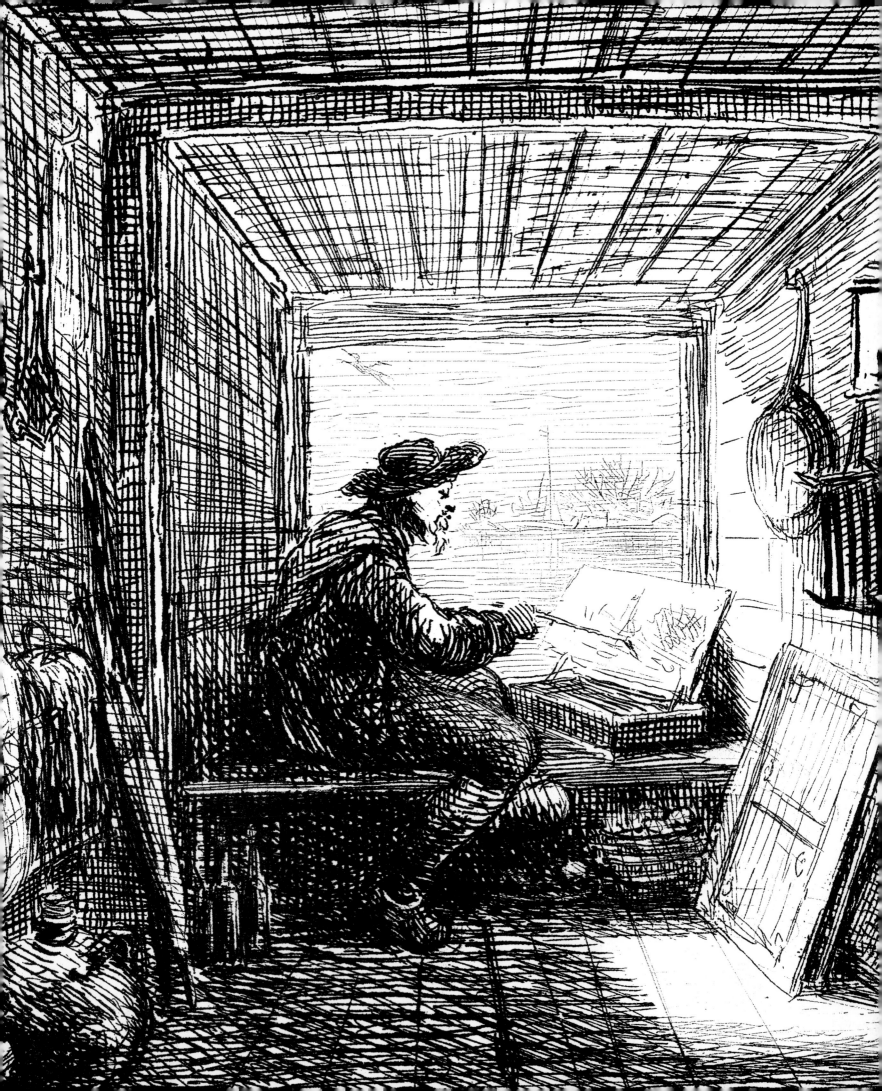

THE
BARBIZON
SCHOOL
& THE ORIGINS OF
IMPRESSIONISM

STEVEN ADAMS

Phaidon Press Limited
140 Kensington Church Street
London W8 4BN

© 1994 Phaidon Press Limited
First published in 1994

A CIP catalogue record of this
book is available from the
British Library

ISBN 0 7148 2919 6

Printed in Hong Kong

Frontispiece
Charles-François Daubigny
The floating studio from *Voyage
en Bateau*, 1862

Contents

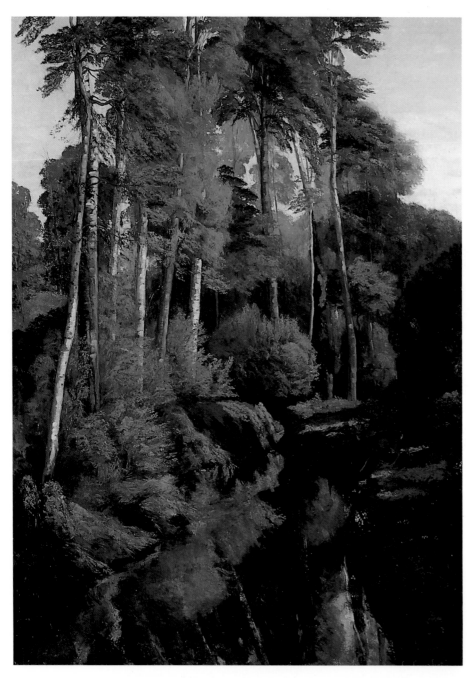

1
Gustave Courbet
Stream in the forest, 1862
Oil on canvas, 157 x 114 cms

Fontainebleau offers all the beauties of nature joined together close to Paris: imposing views and a grandiose bleakness, majestic forests and century old beeches, clearings where heather grows among the sand and sandstone; pools and mossy ponds. The forest of Fontainebleau is a veritable school of contemporary landscape painting. There is not a single artist among the most famous who has not passed through it.

Frédéric Henriet, *Le Paysagiste au Champs,* 1876 [1]

At Easter in 1863 Claude Monet and Frédéric Bazille left Paris for Chailly-en-Bière, a small village a mile and a half from Barbizon, on the edge of the forest of Fontainebleau. They came to the district to make studies for landscape paintings in the open air in a pleasant, picturesque environment conveniently close to the capital. In the villages of Moret, Marlotte, Chailly and Barbizon, painters could commune with nature and find respite from the rough and tumble of the fiercely competitive art world of Second Empire Paris. At the end of a day's painting in the forest of Fontainebleau or the plains of Chailly they could return to village inns such as the Auberge Ganne, at Barbizon, Mère Anthony's *auberge* at Marlotte or Le Cheval Blanc at Chailly. There, under the paternal eye of an innkeeper, happy to extend credit to impecunious painters, they could play the bohemian, drink cheap wine, find a square meal,

rub shoulders with colleagues and plain-speaking country folk, and all for three francs, seventy-five centimes.

Many contemporary accounts of the forest of Fontainebleau, its settlements and occupants, endorse this image of a rural idyll far from the pressures of city life. Unlike much of the French countryside the forest of Fontainebleau was said to be largely unspoilt. Wandering through its sandy wastes, virgin forests and rocky outcrops the artist could, according to contemporary guide books, catch a glimpse of a primordial past, commune with nature and gain both spiritual and physical refreshment. Achille Faure's essay 'L'Eté du Paysagiste', published in 1867, presents the countryside as something of a moral sanctuary. Writing on the spiritual benefits of painting in the country he says:

As for myself during these periods of work and contemplation that raise the spirits and heighten the senses, I take no interest in the controversies that divide men, nor the currents of opinion that distract them. No newspaper comes to disturb the harmony that intoxicates me. I withdraw into myself and forget. For me the world is reduced to that little corner of the earth that I see before me. It is to increase my strength and to concentrate my efforts that I willingly limit my horizons in this way. [2]

These sentiments were echoed by the poet and essayist Benjamin Gastineau. He knew of no better cure for 'the social spleen' than communion with nature in the solitude of the forest, and gave the following advice to the world-weary middle classes:

Do not worry about staining your new trousers, Monsieur, or about turning your beautiful silk dress green, Madame, stretch out on the thick green grass of this secluded clearing. Does it not seem as if the tainted vapours that clouded your imagination have already disappeared, that your internal vision brightens, that your conscience is cleansed? Worldly preoccupations vanish and the sacred dialogue between man and nature begins.[3]

The material and spiritual pollution of the city as opposed to the 'sacred dialogue' between man and nature. That was the principle at least. In reality, the forest of Fontainebleau was not as unspoilt as many commentators would have us believe. The clearings in the forest were likely to have been planted with pine trees for the timber industry; the rocky outcrops were quarried and the sandy wastes plundered for mortar for use in the capital. From the 1840s Barbizon and its surroundings had become one of the main sites where Parisians could come to experience nature.[4] In 1849 the extension of the railway to the departmental capital of nearby Mélun brought hoards of visitors to the forest. A contemporary guide book complains that the once virgin forest was now criss-crossed with countless paths laid out for bourgeois visitors; as one mid-century writer put it: 'everyone today knows Fontainebleau. For the Parisians, above all, the railway has turned it into a suburb.'[5]

Evidence of a bourgeois invasion of the countryside can be found in several of the paintings that Monet worked on during his visits to the forest in the mid-1860s. Preparatory studies for his painting *Le déjeuner sur l'herbe* (plate 2) show a middle class picnic taking place in the dappled shade of a clearing in the forest near the Bas-Bréau road about a mile and a half from Chailly. The picture is suffused with signs of the city. Men and women are dressed in city clothes; the women in the composition wear gowns similar to those found in contemporary fashion plates, a source used in several of Monet's paintings of the period. A white cloth, spread on the ground, is covered with crockery, glass, food and bottles of wine. To the right of the painting a servant struggles with a wicker picnic hamper; in the foreground stands a whippet, a fashionable breed among the Parisian upper middle classes and apparent in many popular images of Second Empire *haute-bourgeois*

society. Moreover, Monet's visitors do not appear to be the first to have stopped at this spot; on the right of the painting, carved on the bark of the silver birch, is the letter 'P' and the shape of a heart.

Monet and his subjects were, in fact, following a well-beaten path first taken by artists some 40 years earlier. Landscape painters had visited Barbizon, Chailly, and its surrounding plains and forests since the mid-1820s. Jean-Baptiste-Camille Corot made studies in the forests as early as 1822 and the painters Paul Huet and François-Louis Français were listed among the first residents of the Auberge Ganne at Barbizon in the mid-1820s. Théodore Caruelle d'Aligny, another resident at the auberge, came every year to paint in the forest between 1828 and 1840. Théodore Rousseau, considered by many mid-nineteenth-century art critics to be the leader of the new naturalistic school of French landscape painting, lived in Barbizon from 1836 but had visited the area on a number of occasions since 1827. During the 1830s Rousseau was joined on painting expeditions by his disciples Jules Dupré and Narcisse Diaz de la Peña, and in the 1840s other painters associated with the area around Fontainebleau – Charles Jacque, Louis-Nicholas Cabat, Gustave Courbet, Charles-François Daubigny, Jacques-Raymond Brascassat, Alexandre-Gabriel Decamps, Camille Flers, Constant Troyon and Jean-François Millet – made frequent visits to the area, with many later taking up permanent residence.

Some of the artists associated with the district were known for the meticulous finish of their work while others had a reputation for daring, impulsive handling of paint. Some artists painted wild, uninhabited landscapes, while others painted scenes from peasant life. Painting from this area is conspicuous for its diversity and art critics often struggled to find meaningful labels to describe the new styles of naturalistic painting that emerged in France in the early 1830s. Those artists responsible for first setting out the path followed by Monet and his contemporaries had, however, one thing in common, their interest in native rural imagery, and this is one of the defining features of the informal federation of landscape painters that in the late nineteenth century came to be called 'The Barbizon School'.[6]

The Barbizon painters' contribution to the development of landscape painting in France was important. In the early nineteenth century the French countryside was practically ignored as a picturesque site for artists. The forest of Fontainebleau was known mainly for its reserves of game, and references to the area in guide books and historical surveys focused, first and foremost, on descriptions of the nearby château and its gardens rather than

2
Claude Monet
Le déjeuner sur l'herbe, 1865–6
Oil on canvas, 130 x 181 cms

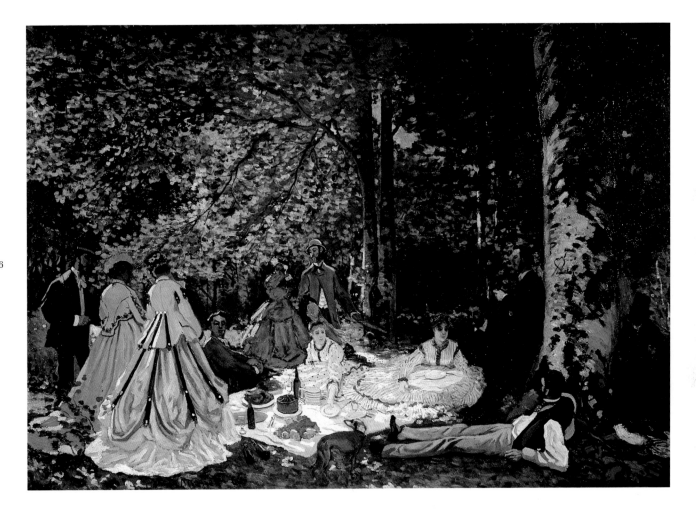

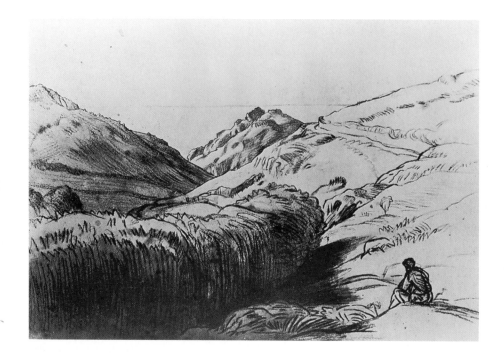

the picturesque charms of the forest. The first instinct of many French landscape painters during this period was to head south to the Roman Campagna in search of subject matter. Many academic landscape painters believed that nature was best experienced not through close contact with the flora, fauna and inhabitants of the everyday countryside but rather through idealized accounts of nature found in the poetry of Homer, Virgil and Theocritus, and in the paintings of Claude Lorrain and Nicolas Poussin. By the late 1820s, however, landscape painting began to change and many of the artists associated with the Barbizon School increasingly looked for subject matter closer to home, to the royal parks of Saint-Cloud, Compiègne, Versailles and Fontainebleau, and to the countryside around Paris. Huet, Dupré, Rousseau, Diaz, Flers, Cabat and Corot were partly responsible for creating a climate in which landscape paintings of the everyday world could begin to compete for serious critical attention alongside landscape paintings based upon classical themes. By the mid-1830s, a number of left-wing and liberal artists and critics saw historical landscape painting as an increasingly outmoded style. In fact, by the 1850s the forest of Fontainebleau had almost become an analogy for nature itself. It served as one of the principal sites earmarked for an experience of the natural world and began to take on something of the function that ancient Rome had had in the past. In the same way that an international community of painters and grand tourists had flocked to Italy to see and paint classical antiquity in the eighteenth century, so the painters and bourgeois tourists of nineteenth-century France – the very characters featured in Monet's *Le déjeuner sur l'herbe* – flocked to see and paint the forests and villages around Fontainebleau.

This general shift away from a style of landscape painting based upon themes from classical literature towards a more naturalistic style based upon the visible fabric of the French countryside was by no means straightforward. Naturalistic landscape paintings were not uncommon throughout the late eighteenth and early nineteenth centuries. They formed part of many private collections and were even on display in the national collection at the Louvre. Moreover, images of the French countryside appeared in popular culture: in prints, on porcelain, in theatrical performances, in landscape gardens and parks. The history of more mimetic, naturalistic landscape painting in France is marked not so much by its appearance on the cultural scene during the first half of the nineteenth century but rather by its changing status. At the start of the century naturalistic landscape paintings were often seen as distinctly inferior to those based upon themes from classical

3
Théodore Rousseau
Le col de la faucille, undated
Black crayon on paper,
dimensions unknown

4
Attributed to Théodore Rousseau
Paris seen from the heights of Belleville, c. 1830
Oil on canvas, 21 x 34 cms

5
Jean-Baptiste-Camille Corot
The road, 1860–5
Oil on canvas, 40 x 56.5 cms

Fig. 1
Diaz and Corot sitting on
boulders in the forest of
Fontainebleau, 1854
Photograph by Charles Marville

6
Jean-Baptiste-Camille Corot
*Painters in the forest of
Fontainebleau*, c.1830–5
Pen, ink and pencil on paper,
32.2 x 51.4 cms

history and mythology. Around the middle of the century the status of landscape painting is wildly unstable. Naturalistic landscape paintings, such as Corot's *The road* (plate 5) of 1860–5, generally low-key accounts of the countryside, were the subject of hot debate among artists and critics; they were admired for their 'poetry' by some observers and thought rather bland by others. Some conservative critics, the last advocates of an academic approach to landscape painting, still pined for the classical landscapes inspired by the example of Poussin. By the end of the century, however, images of the countryside were widely accepted and relatively few artists, critics or collectors would have judged a picture upon the intrinsic dignity of subject matter alone. The aim of this book is to chart the often complex development of landscape painting in the first half of the nineteenth century and to explain the role of Barbizon painting in the evolution of rural imagery in the 50 years that led up to the first Impressionist exhibition.

The book begins by looking at landscape painting in France in the years following the restoration of the Bourbon monarchy in 1817. Chapter one examines the status of landscape painting in the early nineteenth century and its place within an academic pecking order which made rigorous divisions between history and landscape painting. The chapter goes on to observe in greater detail the differences between various categories of landscape painting in early nineteenth-century France, in particular the distinctions between idealized classical landscapes and the more humble, naturalistic images of the everyday world. It seems that the nuances between the different categories carried some weight within the professional milieu of the Académie, but meant much less to a bourgeois lay audience. The middle class men and women that played an increasingly active part in the political and economic life of France during the nineteenth century were not, on the whole, schooled in the classics, and arcane images taken from Greek or Roman history meant little to them. They had made their way in the world through their entrepreneurial skills as bankers, railway magnates, industrialists and financiers, and several academics and conservative art critics worried about the effects that this ill-educated and venal class was likely to have on the fine arts in France.

Chapter one also explores the way in which academic attitudes towards landscape painting were progressively compromised not only by the influence of the middle-brow tastes of the Parisian middle classes but also by the renewed interest in seventeenth-century Dutch art and the spectacular success of British landscape painting shown at the Salon of 1824. The subtle academic distinctions

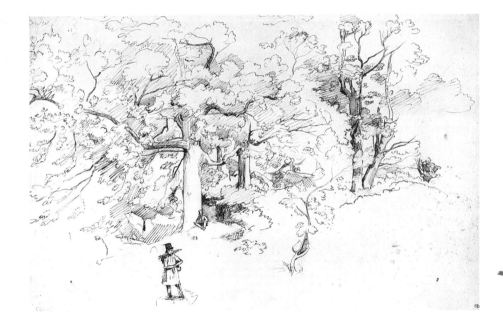

between one form of landscape painting and another meant relatively little to Dutch and British painters. Unlike the French, they were not part of a cultural tradition that had subjected the arts to 150 years of academic casuistry. The Dutch and the British, not unlike the Parisian middle classes, had a taste for landscape paintings taken from experience rather than booklearning.

Some landscape painters connected with Barbizon had conventional careers in Parisian ateliers and art schools. Others, however, were initially trained as porcelain painters or earned part of their living by decorating stage scenery or making lithographs or engravings, and aspects of images found in popular art recur frequently in landscape painting. The compositional formats of popular printed *vignettes*, for example, bare a marked similarity to those used in landscape paintings of the 1830s and 1840s, and the sweeping vistas seen in many of the landscapes shown at the Salons similarly have their counterparts in dramatic theatrical performances held at the panorama in Paris. It is apparent from the outset that it is difficult to make clear-cut distinctions between high and low culture in early nineteenth-century landscape painting. Chapter two, therefore focuses on visual representations of rural France not only in painting but also in popular prints, porcelain decoration, theatrical performances, guide books and travelogues, especially those devoted to Fontainebleau, and examines the influence of popular culture on landscape painting of the period.

The July Revolution of 1830 saw the end of the old aristocratic order and a key stage in the rise of the middle classes in French political and economic life. Chapter three examines the links between the political ideals of the July Monarchy and the changing fortunes of the landscape painters associated with Barbizon. The supporters of the new regime were often keen collectors of small, naturalistic landscape paintings and provided a valuable source of patronage to many Barbizon painters. The chapter also looks at stylistic changes that overcame landscape painting in the mid-1830s and the shift of interest away from picturesque images animated by dramatic scenic effects towards a more restrained and naturalistic style of painting. Not least, chapter three looks at some of the technical innovations put into practice by Rousseau, Diaz, Corot and others, and the developing importance of *plein air* painting, especially *plein-air* painting in the forests at Fontainebleau, the subject of Corot's drawing of 1830–5 (plate 6). Rousseau's Paris seen from the heights of Belleville (plate 4) of 1830, for instance, uses dramatic shifts in scale between the fore and background, and encourages the spectator to fear the horizon of the city in a manner similar to that used by spectators of the panorama. The putative spectator is absent in Rousseau's painting; his presence is only marked by the foothold given to the observer by the scale of the foreground. In his small drawing of *Le col de la faucille* (plate 3), the awe-inspired observer is given a material presence and looks across the bleak romantic landscape.

The revolutions of 1789 and 1830 were essentially bourgeois in that they ultimately served the ends of the middle classes, creating a liberal climate fit for *laissez-faire* private enterprise. The uprising of February 1848, however, was motivated by more democratic ideals. The revolution of February that saw the end of the July Monarchy and the June Days that followed was acted out by workers from the city and countryside. The period saw, in addition, a dramatic influx of peasants from the countryside to the city, the introduction of universal suffrage and the consequent political fight for the hearts and minds of French peasants. From the late 1840s the peasant was seen by some as a traditional symbol of everything that was unspoilt in a nation gripped by industrialization. Others saw the peasantry as an unstable social class likely to rise against its masters as it had done in 1793; peasants were ill-educated, violent, socially unstable, superstitious and poorly equipped to deal with the demands of a newly industrialized economy. It is easy to appreciate why painted images of the landscape and those who worked the land took on an added political resonance. Chapter four looks at the Republican Government's patronage of the arts, and the careers of Barbizon painters in the late 1840s and early 1850s. It goes on to examine departures in the visual representation of rural life and compares rural imagery with depictions of the French peasant in literary and historical accounts of the mid-nineteenth century.

The final chapter focuses on landscape painting during the Second Empire, in particular the critical fortunes of Barbizon painters in the decade leading up to the first Impressionist exhibition of 1874. Barbizon painters fared poorly in the reactionary political climate of the 1850s. A new regime eager to establish its political credentials had recourse to more conventional forms of art: religious pictures, history paintings and politically tendentious images of the Emperor Napoléon III and his family. However, in the 1860s many of the old stylistic divisions between the various genres became increasingly blurred. For many middle class art lovers, highly finished paintings with anecdotal subjects taken from modern history or everyday life became the most respected and popular of the genres; art inspired by classical myth and history became, in turn, largely unrelevant for the self-made middle classes.

7
Jean-François Millet
The gleaners, 1857 (detail)
Oil on canvas, 83.5 x 111 cms

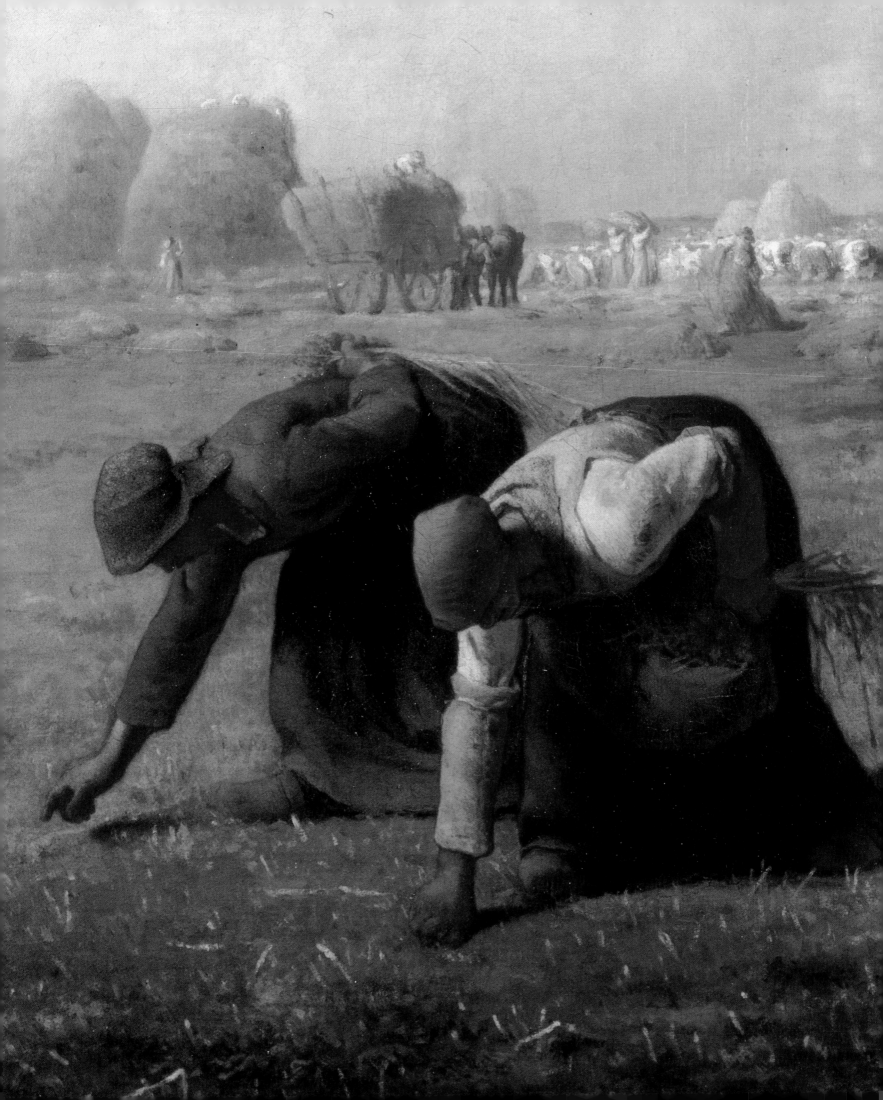

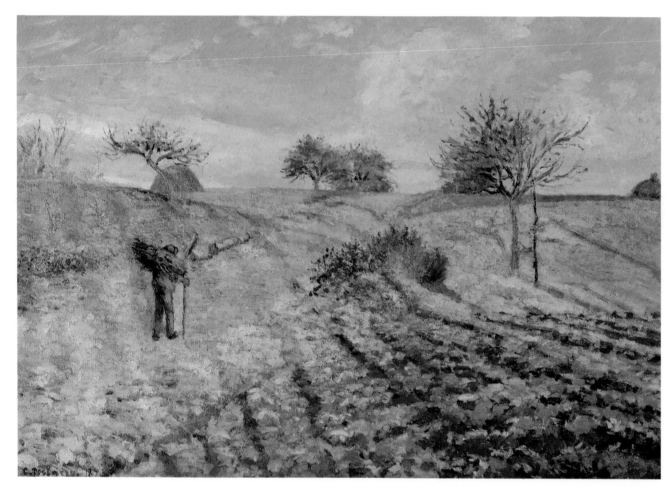

8
Camille Pissarro
The hoar frost, 1873
Oil on canvas, 65 x 93 cms

Barbizon painting, with its emphasis upon everyday images of the countryside, began to share in this popularity and many of its exponents were rewarded with official honours by the State. By the late 1870s Barbizon painting was widely admired and individual pictures frequently exchanged hands for tens of thousands of francs both in France and abroad. In 1889 America and France scuffled for possession of what was once one of the most vilified of Barbizon paintings, Millet's *The gleaners* (plate 7), which was eventually returned to France at a cost of 800,000 francs. An image of revolution in 1857, the painting had shifted in meaning by the end of the 1880s to serve as a cipher for everything that was wholesome about France.[7] During the Third Republic rural imagery had shed most of its radical connotations and once radical pictures now served to remind France that its roots were to be found in the soil. In 1914 the image of Millet's gleaners was worth dying for; the French government used the image of the gleaners as a recruitment poster in World War One. By the 1880s historical landscape painting was virtually forgotten and Barbizon painters had earned a place in the history of French art as the precursors of the new, naturalistic style of painting we now call 'Impressionism'.

But the story does not end here. Even a cursory glance at Barbizon painting and Impressionism reveals profound differences: the former concentrated on the countryside whereas the latter increasingly turned to urban themes. Both schools, moreover, used a wide variety of techniques, from impulsive gestures to meticulously drawn details, and the very idea of an Impressionist or Barbizon style is hard to sustain save as a convenient label. And the notion that the one style leads neatly and directly on to the other (as some commentators, both ancient and modern, would have us believe) is compromised at every turn by the responses of artists and critics alike. In practice, the interface between Barbizon and Impressionism is delightfully messy. Chapter five aims to take Barbizon painting out of its traditional niche in the modernist canon of French art and work it back into the fabric of avant-garde painting of the 1870s and 1880s.

Fig. 2
Gustave Le Gray
A road in the forest of Fontainebleau, calotype, early 1850s

Fig. 3
Gustave Le Gray
Forest of Fontainebleau, calotype, early 1850s

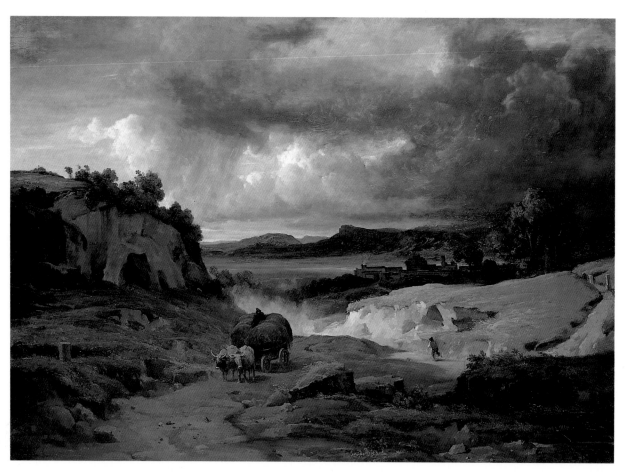

9
Jean-Baptiste-Camille Corot
La Cervara, Roman Campagna,
1827
Oil on canvas, 69.3 x 95 cms

Images of the countryside had achieved a special place within the cultural fabric of fin de siècle France. By the 1880s Barbizon painting was widely admired; it exchanged hands for large sums, sometimes tens or even hundreds of thousands of francs, and was sought after by collectors both in France and abroad. Impressionist painting, once thought to be the work of political intransigents and madmen, had similarly been welcomed into the cultural fold. Octave Mirbeau, writing a catalogue for Monet's 1889 exhibition of 147 landscape paintings, organized to coincide with the Exposition Universelle, described his work as an innovative and progressive response to current literary, philosophical and scientific trends.[1] Even critics of the right had now come to terms with Impressionism. Camille Mauclair, art critic of the *Mercure de France*, saw the movement as bringing nineteenth-century French art to a glorious conclusion.[2] Impressionist painting provided, he insisted, a clear demonstration of the health and vigour of French culture. By the end of the nineteenth century landscape painting embodied notions of scientific progress, patrimony and cultural authority; it was part of a cherished tradition in French art and formed a valuable cultural asset for a nation dogged by economic decline and persistent memories of defeat at the hands of the Prussians in 1870.[3] The Prussians may have been renowned for their military prowess, but France, it was felt, held the high ground in matters of culture.

Landscape painting may have been a fitting vehicle for national aspirations in the 1880s, but for much of the first half of the nineteenth century its cultural profile was very different. It was subject to a form of apartheid which placed it apart from, and well below, history painting, the most respectable of the genres. In order to understand the workings of this system of separate development, in which paintings were judged not just on their aesthetic merits but on the intrinsic dignity of their subject matter, it is necessary to lay out some of the cultural, institutional and technical conventions that defined the genre in the 1820s.

Grande peinture and *paysage historique*

In the latter part of the nineteenth century artists were admired for their individualism. The romantic notion that a painting was a vehicle for the unique, creative insight of its author was widely accepted by collectors, artists, critics and the state. In the early part of the century, however, painting and sculpture were shaped by a prescriptive aesthetic code written and overseen by a branch of the state-sponsored Institut de France, the Académie des Beaux-Arts. Newly reformed in 1816 after its abolition during the French Revolution, the Académie was responsible not only for the education of painters and sculptors through its satellite, the Ecole des Beaux-Arts, but also supervized

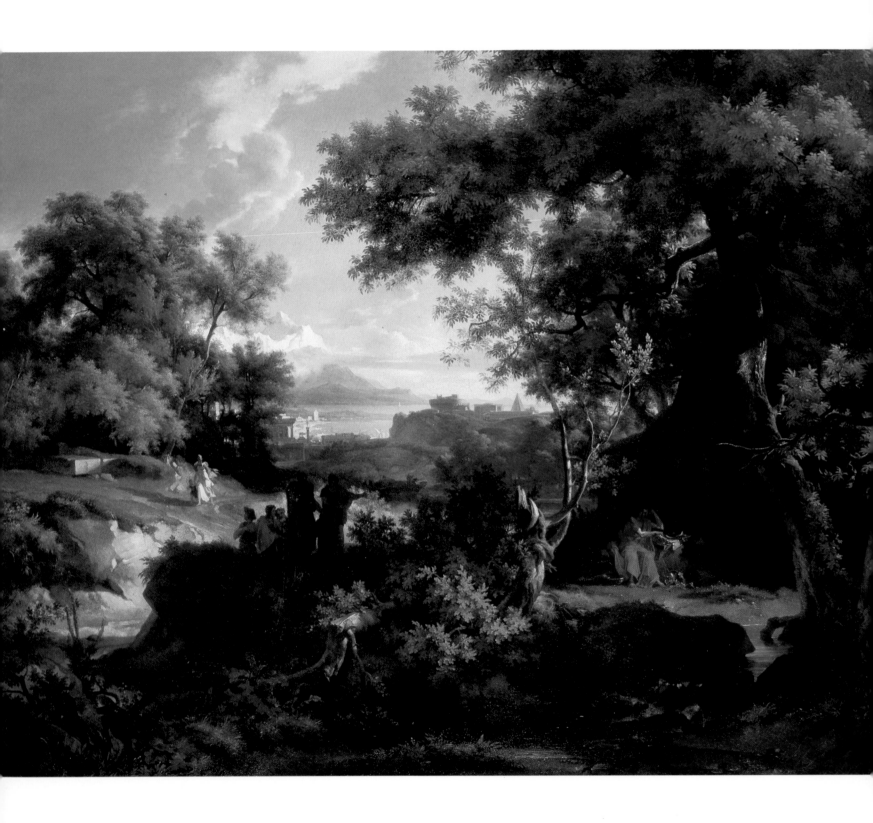

10
Achille-Etna Michallon
Democritus and the Abderitains,
c.1817
Oil on canvas, 115 x 146 cms

11
Jean-Victor Bertin
Classical landscape, 1800
Oil on canvas, 63.5 x 87 cms

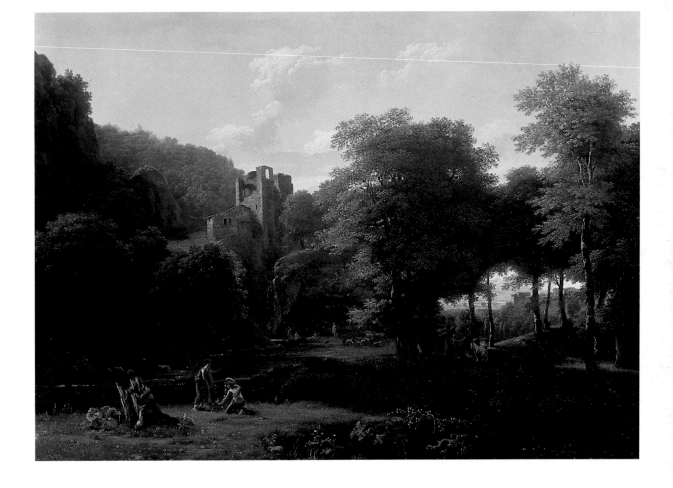

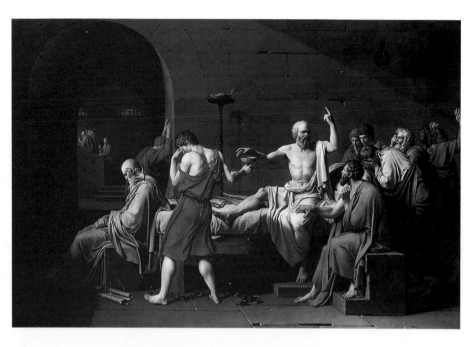

12
Jacques-Louis David
The death of Socrates, 1780-7
Oil on canvas, 129.5 x 196.2 cms

13
Jean-Baptiste-Joseph Wicar
*Virgil reading the Aeneid before
Augustus and Livia*, undated
Oil on canvas, 46 x 69 cms

14
Pierre-Henri de Valenciennes
Landscape of Ancient Greece,
1786
Oil on canvas, 100 x 152 cms

15
Pierre-Henri de Valenciennes
Arcadian landscape, undated
Oil on canvas, 88 x 126 cms

the selection of paintings for the Salon, a public exhibition of painting and sculpture held every other year in Paris. The Salon was a particularly important platform because it constituted the only public forum in which artists were able to display their work. Since its inception in 1648, the Académie had embraced a dogmatic teaching programme which maintained that painting and sculpture should follow the example set by artists in classical antiquity and taken up again by painters and sculptors during the Renaissance.[4] In essence, this academic dogma was based upon long established literary conventions and maintained that the depiction of heroic actions by men and women from the biblical or classical past was the most intellectually respectable form of painting, and that the function of the artist was to render human experience through generic, literary themes showing nature not as it appears, but in an idealized form. The seventeenth-century painter Nicolas Poussin, widely admired in academic circles in the early nineteenth century and a formative influence on academic landscape painting of the period, summed up this approach to painting in a letter to his friend and biographer, the academician André Felibien. Poussin states:

A painter is not a great painter if he does no more than imitate what he sees, any more than the poet. Some are born with an instinct like that of animals which leads them to copy easily what they see. They only differ from the animals in that they know what they are doing and give some variety to it.[5]

History painting not only reshaped the world in an idealized form, it was also good for you; it portrayed the actions of great men and women and inspired noble thoughts in the minds of the spectators. The history painter Jacques-Louis David and his pupils shaped the genre in the last years of the eighteenth and first years of the nineteenth centuries. Their works depicted high-minded themes from the bible, ancient history or mythology in an idealized, neo-classical style. Stories were set out in austere, frieze-like compositions with figures striking declamatory, theatrical poses. The style is visible in David's *Death of Socrates* (plate 12), in Jean-Baptiste Wicar's *Virgil reading the Aeneid before Augustus and Livia* (plate 13) and is repeated on countless occasions in academic history painting throughout the nineteenth century.

Other forms of painting, in contrast, were seen by some artists and critics as distinctly inferior. Wicar, writing in 1793, maintained that landscape painters performed no useful function on the grounds that the genre had little moral weight; its subject matter, unlike history painting,

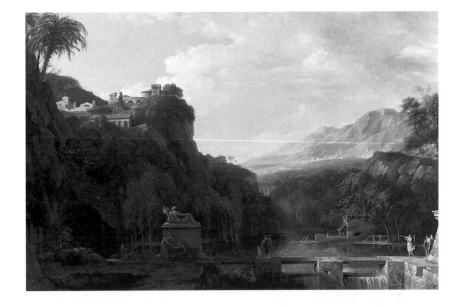

did not have the capacity to inspire noble thought or action.[6]

In the early nineteenth century, however, the status of landscape painting began to change. Quatremère de Quincy, Secretary of the newly reformed Académie, petitioned for an academic prize to be bestowed on landscape painters. The *Prix de Rome* had been awarded each year to students of history painting since 1797 and the foundation of a similar prize for landscape painting in 1816 (to be given every four years) did much to raise the professional standing of the genre. However, the prejudices that separated history from landscape painting also served to divide sub-categories within landscape painting itself. Landscape painting gained respectability in academic circles less by asserting its independence from history painting and more by claiming kinship with it. A new hybrid began to emerge, that was half history painting and half landscape: *paysage historique*. Published in 1800, the *Elémens de perspective par principes* by the painter and theorist Pierre-Henri de Valenciennes, re-invented the genre of landscape painting to acknowledge rather than to challenge the traditional hierarchical divisions between the genres. Historical landscape painting, for Valenciennes, was respectable because, like history painting, it aspired to a *bel idéal* by improving upon nature; it also depicted the actions of great men, albeit on a smaller scale with greater emphasis on the landscape at the expense of the figures. The conventions of historical landscape painting can be seen in Valenciennes' *Landscape of Ancient Greece* of 1786 (plate 14) and in Achille-Etna Michallon's *Democritus and the Abderitains* of 1817, the winning entry for the first *Prix de Rome* for landscape painting (plate 10) and Bertin's *Classical Landscape* (plate 11). In each instance nature was afforded dignity by its stage-managed idealization, the careful arrangement of trees and the insertion of Greek, Roman or biblical heroes, or fragments of classical architecture, into the composition. Historical landscape painting's dependence upon seventeenth-century convention can be seen by comparing the work of Valenciennes, Michallon, Bertin and Jean-Charles-Joseph Rémond with Poussin's *Landscape with the funeral of Phocion* painted in 1648 (plate 16) and *Landscape with Saint Jerome* (plate 17). Here, landscape dominates the composition but the picture is given intellectual sustenance by its subject, in this instance the burial of the Athenian statesmen, wrongly convicted and executed for treason. 'Some so-called amateurs', Valenciennes noted, have doubted the talents of 'great men' such as Poussin and have suggested that seventeenth-century Dutch painters – Jan Winants, Karel Dujardin, Nicolaes Berghem and Jacob Van Ruisdael – capture the natural

16
Nicolas Poussin
Landscape with the funeral of
Phocion, 1648
Oil on canvas, 114 x 175 cms

17
Nicolas Poussin
Landscape with Saint Jerome,
c. 1636–7
Oil on canvas, 155 x 234 cms

18
Jean-Charles-Joseph Rémond
Rape of Proserpine,
c.1821
Oil on canvas, 114 x 146 cms

world with greater veracity. This is perhaps the case, he concedes, but Poussin's mission is far greater than that undertaken by seventeenth-century Dutch artists. When Poussin paints a tree it is something majestic without blemishes. It aspires to nature as it should be rather than nature as it appears – 'the trees that come from Poussin's brush', Valenciennes writes, 'have the majesty of *la belle nature*'. Most Dutch artists, in contrast, only mimic the visible world, they paint simply what is before their eyes without any attempt to improve upon nature. Valenciennes explained the difference between the conception of nature found in the paintings of Poussin and those of his northern contemporaries:

What a difference between a picture representing a cow and some sheep grazing in a field and one of the funeral of Phocion; of a landscape by the banks of the Meuse and the Arcadian Shepherds; of a rainy scene by Ruisdael and a flood by Poussin. The former are painted with the sensation of colour and the latter with the colour of sensation.[7]

Valenciennes' point is an important one. The argument that a picture of a Greek hero was more worthy than a picture of a sheep, because of the intrinsic dignity of the subject and the sentiment it provoked in the mind of the spectator, was stated on numerous occasions by conservatives in the nineteenth century and used to criticize not only mimetic Dutch art of the seventeenth century but also other forms of essentially mimetic art such as British, Barbizon, Realist, Naturalist and Impressionist painting.

The high-brow profile of *paysage historique* had important implications for the professional standing of those who produced it. Landscape painters could only depict literary themes if they were well educated. They were required to have an understanding of classical literature and history, and to be able to read it, not in translation but in the original Latin or Greek. Classical literature in translation, Valenciennes insisted, gave only a vague impression of the original text in the same way that an engraving gave only a vague idea of the original painting. Painters needed, in addition, an understanding of modern literature, modern history, natural history and geography, as well as a grasp of geometry to master linear and aerial perspective. They should, moreover, be well-travelled; the *Elémens* gives a recommended itinerary which includes – intriguingly for an arch-classicist like Valenciennes – the Near East, Switzerland and France as well as sites in Italy and Greece. Not least, he recommended that the landscape painter should have a grasp of chemistry so that he could understand the composition and mixture of pigments.

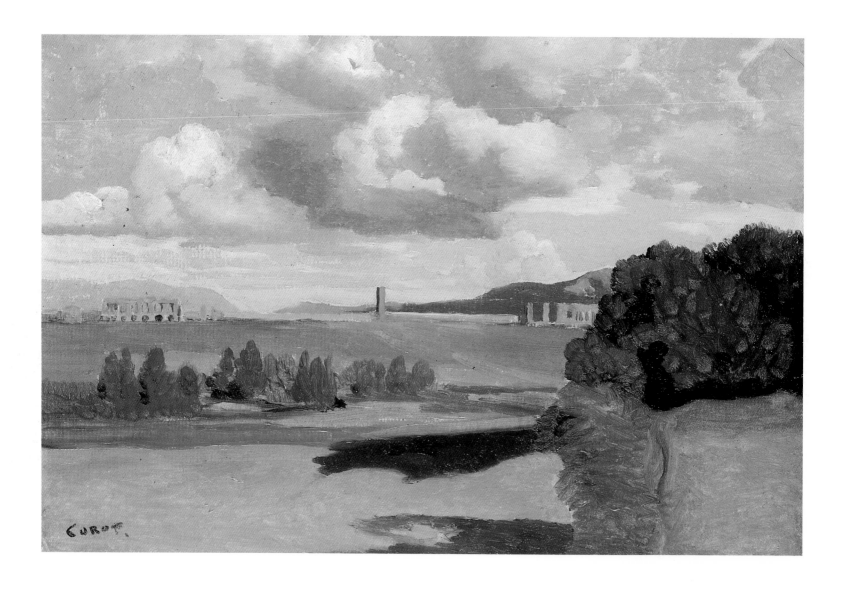

19
Jean-Baptiste-Camille Corot
The Roman Campagna with the
Claudian aqueduct, 1826–8
Oil on paper mounted on can-
vas,
21.6 x 33 cms

20
Théodore Caruelle d'Aligny
Italian landscape, 1822–7
Oil on paper mounted on
canvas, 41.2 x 68.8 cms

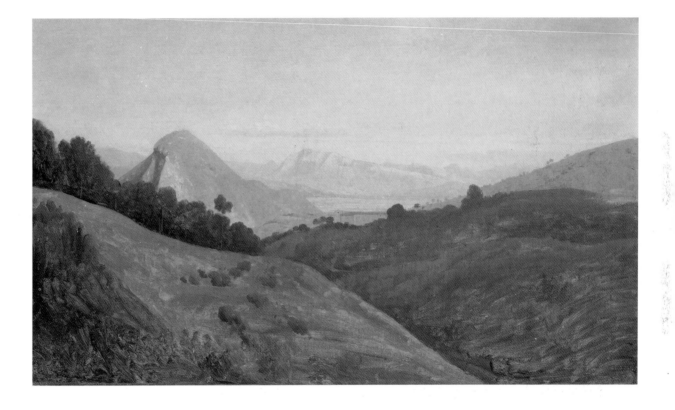

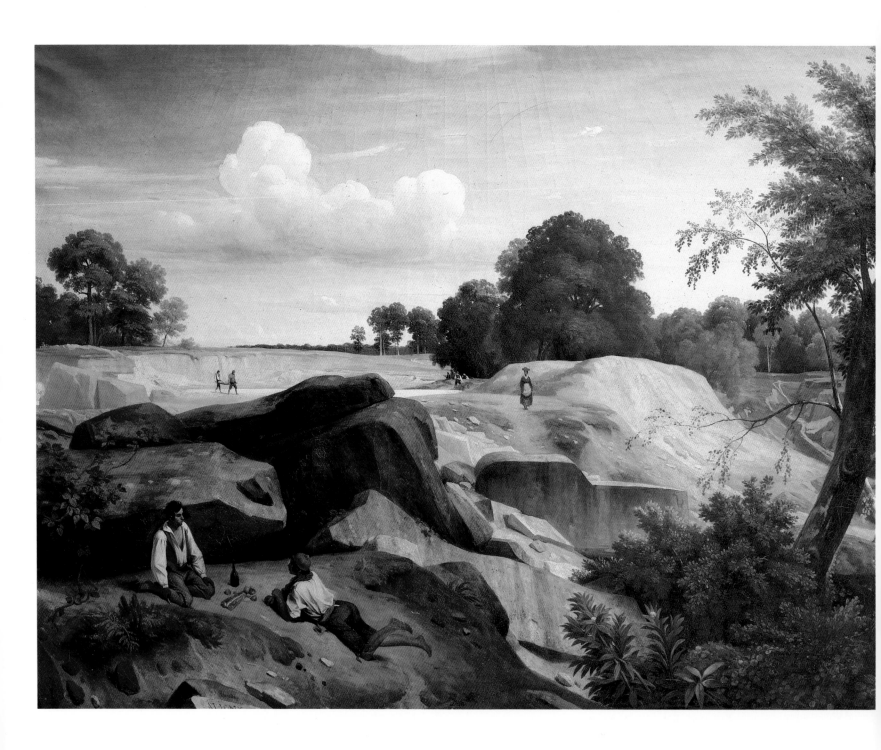

Many of these ideas – the notion that art and literature had much in common, that they were based on the liberal arts and that they were the preserve of intellectuals and 'philosophes' – were in circulation on the eve of the foundation of the French Académie Royale 150 years earlier in 1648. It seems that an art student at the Académie during the mid-seventeenth century would have felt quite at home in the same institution 150 years later.

A survey of the subjects set for the final stages of academic competitions for the *Prix de Rome* in the early nineteenth century shows, again, the extent to which the two genres – history painting and historical landscape painting – were linked. In 1821 students entering the final stage of the competition for the *Prix de Rome* for historical painting were asked to paint a work on the theme of Samson and Delilah; landscape painters entering for the prize for historical landscape that same year were required to paint versions of the Rape of Proserpine. Rémond's painting of the the theme (plate 18) was one of several interpretations of the subject submitted by competitors in the final round of the competition. In 1825 students of history painting were set the subject of Antigone burying Polynices; students of historical landscape, the Hunt of Meleager. In the years 1829, 1833 and 1837 students were set the themes of the Death of Adonis, Ulysses and Nausica and Apollo guarding the flocks of Admetus. Despite landscape painting's new found status, its academic exponents were, where possible, keen to link history painting with landscape, and to stress that the genre marked a continuation rather than a break with tradition. Even new departures in landscape painting, such as the vogue for sketching in the open, were presented in terms of tradition rather than innovation. Tales of Poussin, Claude, Gaspard and others painting in the Italian countryside were recycled to substantiate the working practices of early nineteenth-century academic landscape painters.[8]

What were the essential ingredients of historical landscape painting and how were they assembled? *Paysages historiques* were the result of a protracted process in which nature was subject to a continuous round of refinements. Painters of historical landscapes, like history painters, began their studies by copying engravings of landscape paintings from instruction manuals and continued their training by drawing and painting from landscapes in the Louvre.[9] They were trained to make detailed preparatory line drawings and a sequence of coloured oil sketches to plot the compositional layout, perspectival recessions, and the tones and value of colours in the final work. In fact, virtually every aspect of the painting – the interpretation of the subject, the composition and colour scheme – would be

21
Théodore Caruelle d'Aligny
View of the sandstone quarries of Mont Saint-Père, forest of Fontainebleau, c.1833
Oil on canvas, 163 x 215 cms

22
Théodore Caruelle d'Aligny
Rocks at Fontainebleau, c.1842
Oil on paper, mounted on canvas, 33.4 x 49.2 cms

fixed before the painter began the final version. In many instances, the finished tableau would be assembled from a sequence of separate landscape and figure studies. The desert of Beersheba, for example, in Corot's historical land-scape *Hagar in the wilderness* (plate 24), shown at the Salon of 1835, was made up of separate studies made in Civita Castellana and the forest of Fontainebleau and then grafted together to form an idealized backdrop for the scene from Genesis 16. Hagar, Abraham's maid servant, her son and the archangel Michael were added to lend the painting the final touch of intellectual respectability. Caru-elle d'Aligny's landscape *View of the sandstone quarries of the Mont Saint-Père, forest of Fontainebleau* (plate 21) depends upon conventions similar to those used by Corot. The painting, shown at the Salon of 1833, is carefully com-posed with a well placed tree flanking the righthand side of the picture and, like Corot's painting, was made from a series of *plein air* studies made in the forest of Fontainebleau. The identity of the two small figures and the title of the painting place it, however, in a quite differ-ent league to Corot's *Hagar in the wilderness*.

It is curious to discover that this painstaking and high-ly selective method of landscape painting also depended upon close observation of the natural world. Valenciennes, writing in the *Elémens*, encouraged artists to paint before the motif and advised a maximum working time of about two hours. More sustained studies before the motif were impossible, he insisted, because of the shifting position of the sun and the resulting change in the position of shadows and value of colours.[10] In some respects, this method of working looks similar to that used by Claude Monet in paintings of the 1890s in which one canvas was exchanged for another as the lighting conditions changed. Monet's series paintings were, however, complete works, ready for public scrutiny and were turned out in some quantity for collectors in France and abroad. In the early part of the nineteenth century, by contrast, *plein air* studies were made mainly by students as *aides memoires*; they were largely of interest to other professionals and in academic circles would not have been seen as complete paintings in themselves. Some indication of the status of prepara-tory studies and *plein air* sketches is given when one con-siders that they were often sold after the death of an artist to be bought by masters for use as teaching aids in the ate-lier. Peter Galassi has suggested that they fulfilled a func-tion similar to plaster casts in the studio of a history painter.[11] Seemingly naturalistic oil paintings such as Valenciennes' *Ruins in the grounds of the Villa Farnese* of 1782 and Corot's studies such as the small sketch of the *Roman Campagna with the Claudian aqueduct* (plate 19)

23
Léon Cogniet
*The artist in his room at the
Villa Medici*, 1817
Oil on canvas, 44.2 x 36.5 cms

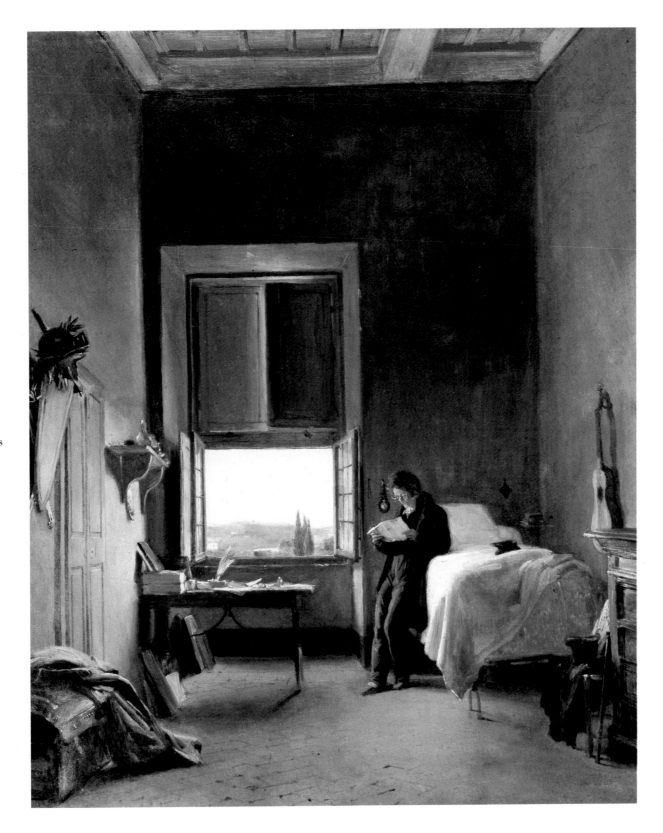

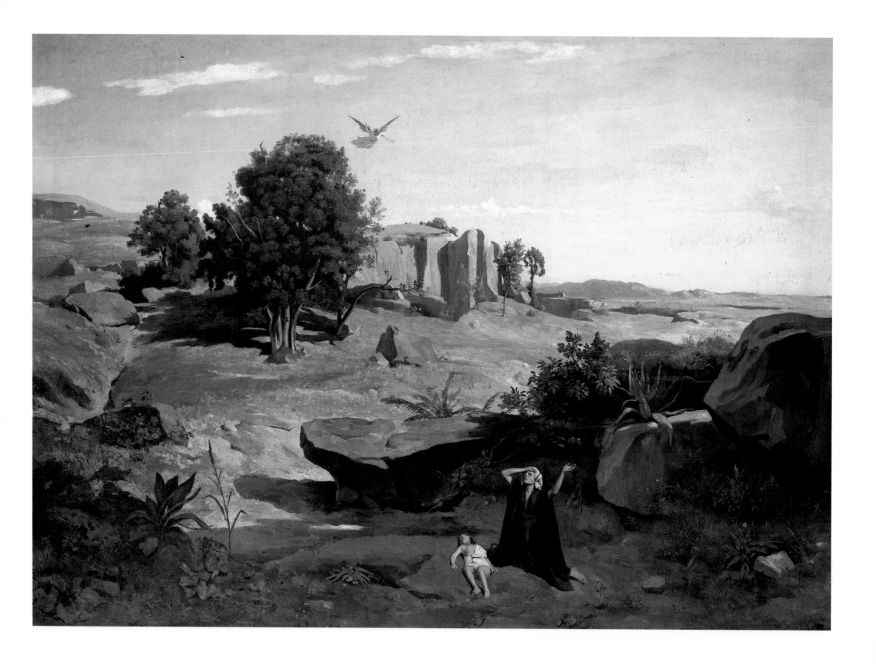

made on his first visit to Italy in 1825, in practice only provided a means whereby the artist could gather and assimilate information about the visible world in order to impart a degree of spontaneity and verisimilitude into more elaborate landscapes made in the studio. In academic circles, at least, the natural world was constantly held at arm's length. And it is important to remember that for many landscape painters nature was Italian. The French Academy in Rome based at the Villa Medici was the ultimate destination of recipients of the *Prix de Rome* for landscape painting. In Rome, working before the motif was a common practice in academic circles but the results of painting *en plein air* had to be refined and processed by the literary imagination and follow visual conventions laid down by Claude and Poussin. In a eulogy on the work of the founders of historical landscape painting, Valenciennes describes how Poussin, Annibale Carracci, Titian and Domenichino, imbued with a reading of Homer, Virgil and Theocritus, closed their eyes to see ideal nature, a nature 'adorned with the riches of the imagination, which only genius can conceive and represent.'[12] The notion that nature is best seen with closed eyes says much about the workings of academic landscape painting in early nineteenth-century France.

Paysage Pastorale and *Paysage Portrait*

Immediately below *paysage historique* in the pecking-order of early nineteenth-century academic landscape painting came *paysage pastoral*, or *paysage champêtre*. Millin de Grandmaison's *Dictionnaire des Beaux-Arts* written in 1806, recognized two broad categories of landscape painting, the heroic or ideal and '*le style champêtre ou pastoral*'. Heroic landscape painting loosely corresponded to Valenciennes' conception of historical landscape: here, nature is at its most picturesque and is animated with classical temples, pyramids and obelisks. The second category, however, represents nature in a more informal manner. 'In the *style champêtre*, the natural world', Millin writes, '...appears without ornament and without pretence'. The landscape painter may, however, borrow the odd 'ornament' or picturesque motif to lend the scene a touch of dignity. Millin is winningly relaxed in his attitudes towards landscape painting and heaps indiscriminate praise upon a broad cross-section of artists from the Dutch and Italian schools. Under the category of *style champêtre*, for instance, he includes painters such as Paulus Potter, Adriaen van de Velde, Jacob van Ruisdael and Nicolaes Berghem. Their works, he notes, show a degree of fidelity towards nature but they do not paint *portraits exacts*, mimetic accounts based just upon

24
Jean-Baptiste-Camille Corot
Hagar in the wilderness, 1835
Oil on canvas, 180.3 x 270.5 cms

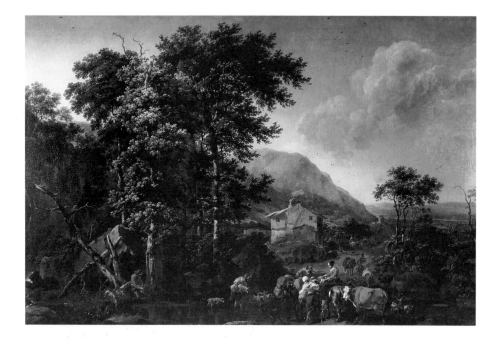

appearance.[13] Berghem's *Landscape* in the Louvre is a good working example of the genre (plate 25). The countryside is not animated with characters from classical antiquity but at the same time it is clear from the arrangement of the composition, the delicate handling of the foliage and the use of diffused light and soft hues, that the painting is more than a simple transcription of visual experience.

Claude-Joseph-François Lecarpentier, a painter and teacher at the Ecole de Dessin at Rouen, was clearer in his description and compared *paysage champêtre* not with high-minded classical tragedy but with the more contemplative note struck by pastoral poetry. Valenciennes, however, provided a more fulsome description of the lower echelons of landscape painting. He notes that a *paysage pastoral* is similar in conception to a historical landscape and adds, intriguingly, that it requires as much if not more imagination to practise it. The painter of *paysages champêtres* has to strike a delicate balance in his work and has, at once, to be faithful to nature and yet present it at its best; he must paint with charm but without affectation. In effect, the genre must mobilize some of the same noble sentiments as *paysage historique* but do so through a process of refining nature alone without the line-up of characters and buildings that are found in historical landscape. The examples of pastoral poets – Virgil, Longinus, Theocritus, Tasso, Montesquieu and La Fontaine – are given as literary models, and Poussin, Jacques Stella, the Carracci and Domenichino are listed as the most accomplished exponents of the genre.[14]

For the very lowest form of landscape painting, *paysage portrait*, Valenciennes maintained that only a modest form of talent was necessary. Invention, the power to select a subject and to refine it, the very process outlined by Poussin and which the critics had so admired in Corot's *Hagar in the wilderness*, was absent in *paysages portraits*. They required only the eye and the hand (but not, it seems, the intellect) to record the principal characteristics of the painter's chosen motif. Even so, Valenciennes recommended that landscape painters might include some object of curiosity to cheer up this generally undemanding form of painting. For Valenciennes, most Dutch landscape painters of the seventeenth century, such as Paulus Potter and Jan van Goyen, merely recorded the commonplace world around them uncritically and without any hint of informed selection.[15] It is interesting to note, however, that in the eighteenth century the same painters – Berghem, Dujardin and Ruisdael – were held in greater esteem and were thought to occupy a higher, quite different category, that of *paysage champêtre*, and did so again

25
Nicolaes Berghem
Landscape, 1653
Oil on canvas, 130.5 x 195.5 cms

26
Nicolaes Berghem
Peasants with cattle by a ruined aqueduct, late 1650s
Oil on oak, 47.1 x 38.7 cms

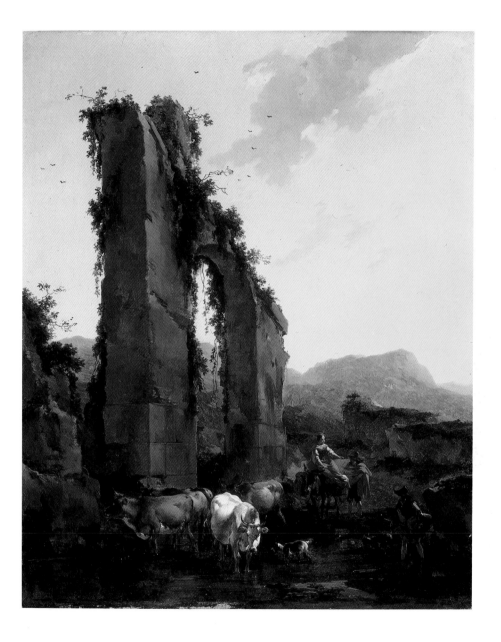

in the mid-1820s when theorists began to re-examine and question the merits of some of the hierarchical subdivisions in landscape painting.

Dutch painting and early nineteenth century France
Despite the protestations of academic painters, naturalistic Dutch landscape painting of the seventeenth century was widely admired in some circles. After the death of Louis XIV in 1715 there was a widespread reaction to the intellectualism of seventeenth-century academic painting. Dutch art with its dependence upon everyday images of the city and countryside tied in neatly with this new-found hostility towards more erudite forms of painting. The late seventeenth-century theorist, Roger de Piles was an articulate opponent of classical, academic dogma and an ardent admirer of seventeenth-century Dutch painting. Berghem and Philips Wouwermans, and in the latter half of the century, Ruisdael, were also widely admired, not least by Simon Lantara and Jean-Louis Demarne, naturalistic French landscape painters who are often cited as precursors of Barbizon painting.[16]

French art dealers of the eighteenth century such as Gersaint, Basan and Le Brun were similarly enthusiastic about Dutch landscape and imported many examples of paintings from the Low Countries into France. Dutch painting also became an increasingly important component of the royal collection: the Count of Angivilliers, the King's director of works, began to put together an encyclopaedic collection of paintings, among them works by Adriaen van de Velde, Ruisdael, Berghem, Dujardin and Van Goyen. Consistent with the aims of the Enlightenment, the collection was both a museum of public instruction and a summary of knowledge about art rather than a partisan display of personal taste.[17] An interest in Dutch art can also be seen in the proposals for the foundation of a Dutch Academy of painting and sculpture during the French occupation of the Netherlands in 1809. Under the direction of Louis-Napoléon Bonaparte, King of Holland, a commission was established to oversee the education of Dutch artists. Although some sections of the Dutch Academy took on a distinctly neo-classical character – Wicar and Bertel Thorvaldsen, for instance, were proposed respectively as professors of history painting and sculpture – the institution was prepared to accept national differences between French and Dutch art and encouraged more naturalistic forms of landscape painting in keeping with the northern tradition.

Dutch seventeenth-century landscape painting continued to influence French painters in the 1820s even after the enforced repatriation of works plundered during the

27
Lazare Bruandet
Small Landscape, undated
Oil on panel, 230 x 190 cms

Revolution and Empire. Dutch art's status as a force in early nineteenth-century landscape painting depended largely, it seems, upon the milieu in which it was seen. At some levels, it carried a professional health warning and was thought to have had much in common with preparatory sketches in that it was perceived as a useful teaching-aid but hardly formed a model of good practice for finished tableaux. Conservative critics such as Paul de Saint-Victor, even as late as the 1850s, recoiled at the lack of refinement in the work of Ruisdael.[18] At other levels, however, it appears that Dutch landscape paintings could be appreciated in their own right. Paintings by Van Goyen, Aelbert Cuyp, Ruisdael, Dujardin, Berghem and Wijnants remained on show in the Louvre, they formed an important part of many private collections and were admired by artists and the public at large. In the early nineteenth century two main trends in landscape painting were identified. One group known as the Méridionaux took its lead from classical artists and was largely influenced by a fundamentally conservative tradition of landscape painting centred around Rome. Faced with the natural world, the first instinct of the Méridionaux was to idealize it. The other group, the Septentrionaux, followed the example of seventeenth-century Dutch artists and painted essentially naturalistic landscape paintings.

Here, another symptom of cultural apartheid emerges: outside the Académie and Ecole, early nineteenth-century painters and middle class amateurs could indulge their tastes for more mimetic forms of landscape painting without risking the censure aimed at academic painters. Inside the Académie and Ecole, however, seventeenth-century Dutch art continued to be viewed with suspicion. This division between the worlds of the bourgeois amateur and the academic landscape painter, and the respective frames of reference of the Septentrionaux and Méridionaux, are important because the history of early nineteenth-century French landscape painting can be characterized in terms of the cultural standards of the former gradually encroaching upon those of the latter. Early nineteenth-century critics, both liberal and conservative, often saw the rise of landscape painting devoid of classical or biblical allusion as a general sign of the rising social fortunes of the middle classes. Some critics lamented the decline of neo-classical *paysages historiques*. Others, like Deperthes, saw *paysages champêtres* and *paysages portraits* as a more accessible and democratic style in art, the meanings of which were not dependent upon an aristocratic classical education. Such painting was seen as a sign of an impending, more democratic, social order, an order that was to take a clearer shape during the July Monarchy.[19]

28
Jean-Louis Demarne
The road, 1803
Oil on canvas, 44 x 55 cms

29
Jean-Louis Demarne
The gust of wind, undated
Oil on canvas, dimensions
unknown

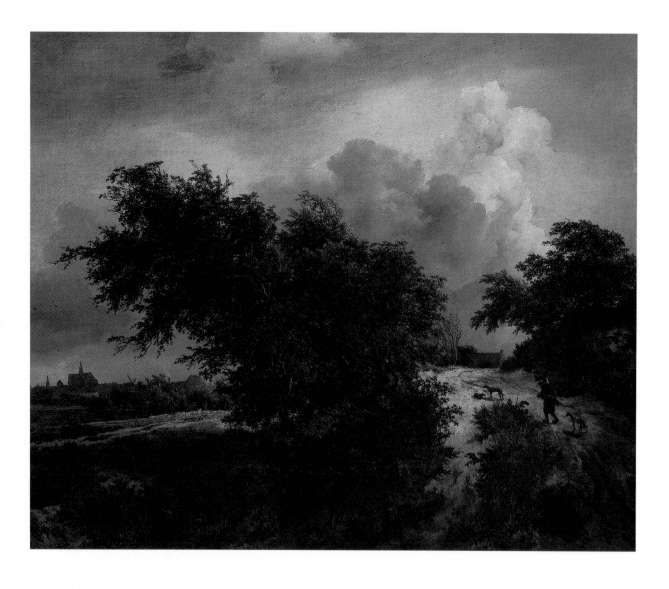

30
Jacob Isaacksz van Ruisdael
The bush, undated
Oil on canvas, 68 x 82 cms

31
Jan van Goyen
Landscape with two oaks, 1641
Oil on canvas, 88.5 x 110.5 cms

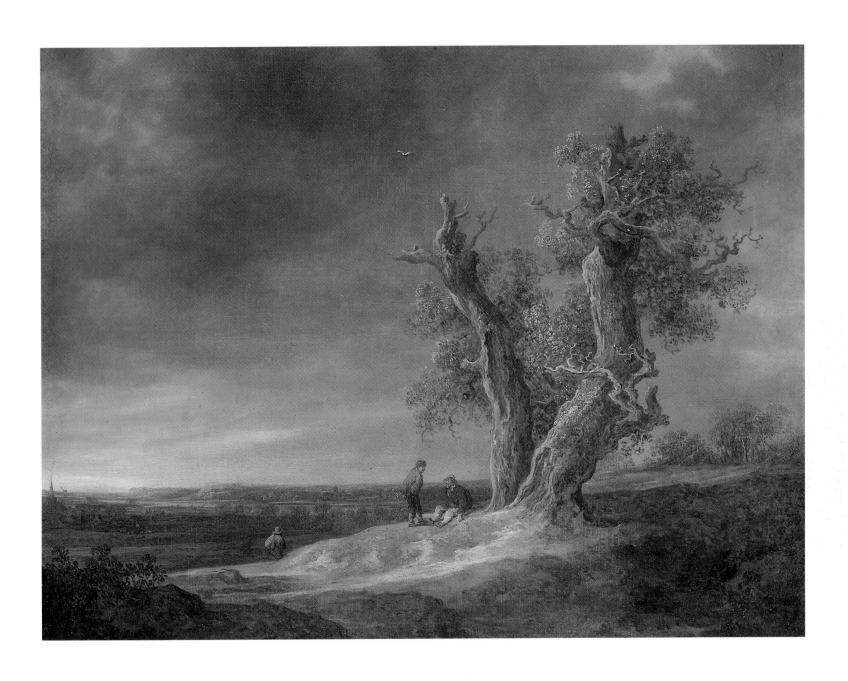

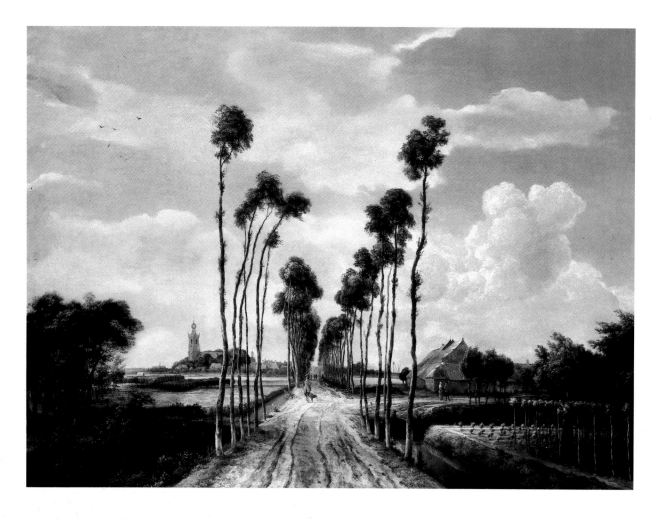

32
Meyndert Hobbema
The avenue, Middelharnis, 1689
Oil on canvas, 103.5 x 141 cms

33
Jan van Goyen
Two large sailing boats, and cattle by the river, 1647
Oil on panel, 39.5 x 60.5 cms

34
Georges Michel
The lime kiln, undated
Oil on canvas, 55.9 x 71.1 cms

Georges Michel

Dutch seventeenth-century landscape painting had a particularly strong influence on the work of the early nineteenth-century painter Georges Michel. In fact, the artist himself saw his work in terms of pictorial precedent set by seventeenth-century painting; his wife recalled how after painting the rubbish dumps of Pantin or the cleaning of a reservoir in the north of Paris he would stand back and compare the result with memories of the picturesque motifs of hillocks and waterfalls found in the works of Aelbert Cuyp.[20] One of the strongest links between the work of Michel and that of the following generation of landscape painters can be found in terms of the brisk application of paint and the dramatic use of light and shade. Close examination of the surface of many of Michel's paintings shows a daring range of techniques, more daring in many instances than the generation of painters that succeeded him.

In Michel's *Stormy landscape with ruins on a plain* (plate 35) storm clouds and transient shafts of sunlight are shown raking across a melancholy landscape. These features are common motifs in Michel's work and are articulated not with needle sharp clarity but with a meteorological shorthand made up of bravura gestures of pigment. Distances are marked by delicate passages of thin paint in which the coloured warm ground is often visible; the effects of rain are marked, in turn, by delicate turpentine washes, and the direction of the wind is suggested by the lines left by the application of a coarse brush across the surface of the pigment. Similar features are found in the paintings of Narcisse Diaz de la Peña, in some of Rousseau's small studies, and in works by Dupré and Decamps. It has been suggested that Michel's influence is visible in Corot's *La Cervara, the Roman Campagna* (plate 9), painted in 1827, in which the shaft of rain, small figure and sharply contrasting, bright rocky outcrop appear in the centre of the composition.[21]

Perhaps the most significant similarity between the work of Michel and the Barbizon painters is found in their choice of subject matter. Many of Michel's paintings are based upon the depiction of an immanent world which formed part of the artist's experience. Michel's wife recorded his antipathy towards the idea that an artist should travel abroad to find appropriate subjects to paint and recalled how at about three in the afternoon, after a day's work in his studio, he would set off to Belleville, the plains of Saint Denis, the Buttes Chaumont, the Bois de Vincennes or Pantin to make studies on paper after nature.[22] More importantly, Michel's paintings are often complete works rather than preparatory sketches, links in a generative chain that

35
Attributed to Georges Michel
*Stormy landscape with ruins on
a plain*, undated
Oil on paper mounted on can-
vas, 55.6 x 80.6 cms

terminate in the depiction of some pastoral anecdote. There are some instances where Michel uses seventeenth-century costume and other devices strongly reminiscent of Dutch painting. For the most part, however, his subject matter, like that of all the landscape painters associated with Barbizon, is based upon contemporary rural motifs.

It is important to consider that much of what we know about Michel comes from a critical study by Alfred Sensier written in 1873. Sensier was a collector, critic and art administrator and his biography was, in effect, a reading of the life and work of Michel by a tendentious critic working in collusion with an art dealer. Sensier's associate, Paul Durand-Ruel had recently bought a number of paintings from Michel's widow and the monograph was, as Christopher Parson's and Neil McWilliam have indicated, part of a sophisticated marketing campaign designed to promote the work of the artist.[23] In the monograph Sensier conjured up a compelling detective story in which the artist was rescued from oblivion. Michel's work was, apparently, admired by a few connoisseurs who had snapped up paintings in galleries and bric-a-brac shops, but little was known about the man himself. A few of the older residents of Montmartre, Sensier recalled, had faint recollections of a man wandering off to the plains of Montmartre with his easel and box of colours but could not remember who he was or what became of him. Quite by chance, Michel's widow was discovered in 1849 living with her daughter in the Rue Breda, and chapter two of Sensier's book is devoted to Madame Michel's recollections of her husband's life and career.

There were other painters working at the turn of the century that were not subjected to Sensier and Durand-Ruel's publicity machine, and examination of their work indicates that Michel's Dutch-inspired naturalism was not an isolated phenomenon. In the late eighteenth and early nineteenth century Claude Chauvin and Nicolas-Antoine Taunay painted battle and historical scenes which often required the addition of a topographically accurate backdrop. Taunay, in fact, sketched as a youth in the forest of Fontainebleau. Louis-Gabriel Moreau, Jean-Baptiste-Gabriel Langlacé and J L Robert painted panoramic vistas of the landscape around Paris, many of which were shown in early nineteenth-century Salons. Jean-Louis Demarne, a friend of Michel, specialized in genre scenes based upon Dutch models of the seventeenth century such as *The gust of wind* (plate 29) stripped of allegory or anecdote. The net influence of these artists on the work of later generations of landscape painters is limited but it is worth registering their presence to demonstrate again that French naturalism does not begin at Barbizon.

British art and Restoration France

Early nineteenth-century French landscape painting, especially in its more romantic and naturalistic forms, was also influenced by British art. British painting found its way into Restoration France through a variety of routes. A number of aristocratic families took refuge in Britain during the Revolution and although some looked on the liberal political institutions in Britain with suspicion, others returned to France as ardent anglophiles and admirers of British art or French painting made in 'la manière anglaise'. Louis-Philippe d'Orléans, an exile during the Revolution and a self-confessed anglophile, counted in his collection works by Newton Fielding, William Callow and Thomas Shotter Boys. The Duke of Broglie, the Duke of Aumale and the Prince of Joinville bought small water-colours, landscape paintings, lithographs and engravings; Durand-Ruel recorded the young Duke of Aumale and the Prince as frequent visitors to his father's gallery in the 1830s.[24] Two patrons, however, deserve particular attention: the Duke and particularly the Duchess of Berry.[25] The Duke began collecting paintings during his exile in England – Elisabeth Vigée Le Brun noted his penchant for works by Wouwermans which he acquired in London for next to nothing. On his return to France after the final defeat of Napoléon he and the Duchess founded the Société des Arts, an institution dedicated to the promotion of the work of progressive young artists, among them a number of British painters, engravers and lithographers. Unlike her husband, the Duchess preferred modern paintings to old masters and amassed an impressive collection of modern art which was displayed at Rosny, her country home, and later in the Pavillon de Marsan at the Tuileries in Paris. Recorded in the 1822 inventory of her collection were works by Richard Parkes Bonington, William Turner, Samuel Prout and Thomas Lawrence. The collection of modern paintings continued to expand with the acquisition of 22 works bought at the Salon in 1824 and became the subject of a two-volume collection of lithographic reproductions published between 1822 and 1826.

It was not only the aristocracy who admired British painting and engraving. Many Parisian dealers took a keen interest in British art, particularly in naturalistic landscapes in oil and, what the French considered to be the quintessentially English medium, watercolour. The Anglo-French dealer Thomas Arrowsmith played a key role in promoting the work of British painters in early nineteenth-century France. The memoirs of Paul Durand-Ruel record that Arrowsmith ran a brasserie on the Rue Saint-Martin frequented by a number of young painters and amateurs, one room of which was dedicated to showing work by John

36
Richard Parkes Bonington
In the forest of Fontainebleau,
c.1825
Oil on board, 32.5 x 24 cms

Constable and was named after him. Another British dealer active in the capital was one M Brown, who specialized in the sale of watercolours, works by Bonington in particular. British watercolour painters, according to Durand-Ruel came in great numbers to Paris during the Restoration '...and came to be much appreciated by our painters and some connoisseurs.'[26] It was Brown who first encouraged Durand-Ruel père to buy the work of British artists. He was, according to his son 'one of the first to buy watercolours by English painters and those of a number of French painters who began, following the example of their English colleagues, to execute remarkable works in this medium'. Although Durand-Ruel's account of his father's life and work is an attempt to cast the family business as a prophet of nineteenth-century French art, it is worth noting the perceived importance of British art during this period as a catalyst in the development of naturalistic landscape painting. It seems, in fact, to have been spoken about in the same breath as seventeenth-century Dutch and native French naturalistic landscape painting, and amateurs and dealers that collected or traded in one school usually collected and traded in the others.

Two of the most influential British landscape painters of the period were Richard Parkes Bonington and John Constable. Unlike Constable, who never set foot in France, Bonington took up permanent residence there. He moved to Calais with his family in 1816 and later registered as a student in the atelier of the history painter Baron Gros. Having studied watercolour painting in England with the exiled French painter Louis Francia, he attended Gros' atelier only sporadically and did not appear to have been particularly well disposed towards the rigorous formal training of a history painter. He had much greater success painting topographical watercolours, two of which were shown at the Salon of 1822, and were bought by the Duchess of Berry for the substantial sum of 430 francs. Bonington also showed works in the galleries of Madame Hulin and Schroth, dealers specializing in the sale of work by younger progressive artists, including Huet, Dupré and several other Barbizon painters. His interest in topographical watercolours also attracted the attention of both French and British publishers; he contributed to publications by J-F Ostervald, published a series of his own lithographs in an edition entitled *Restes et fragments d'architecture* in 1824 and contributed to Baron Taylor's monumental publication *Voyages pittoresques et romantiques dans l'ancienne France*.

Some indication of Bonington's influence can be given by the use of the term 'le Boningtonisme' to describe the naturalistic watercolours of a circle of young French

painters including Alexandre Colin, J-A Carrier and Huet, the latter a frequent visitor to the forest of Fontainebleau in the 1840s.[27] In fact, Bonington himself painted in the forests in the mid-1820s. In a small oil sketch of 1825 (plate 36) the artist recycles a number of Anglo-Dutch conventions in landscape painting – the up-turned portrait format of the canvas, the small cluster of trees perched on the edge of a rocky outcrop – and uses them to depict a part of the forest of Fontainebleau some ten years before the site became widely known as a resort for landscape painting. The paintings of this circle have much in common with the more mimetic forms of Dutch painting of the seventeenth century. They often specialize in understated subjects such as coastal scenes and panoramic vistas, again taken from commonplace experience rather than literary sources. Bonington's oil painting *A fish market, Boulogne* (plate 37), was shown at the Salon of 1824 where, together with Constable's *The haywain* (plate 38), it was awarded a gold medal. The painting shows a group of fishermen and traders in the centre of a composition set beneath a pale, translucent sky. The machinery of academic landscape painting is missing. Instead, Bonington uses understated pale blue and yellow tints to create subtle shifts in space between the figures in the foreground, the buildings in the middle distance and the moored boat near the horizon. Some critics sniped at the painting. The correspondent for the *Journal des Débats*, Etienne Delécluze, often generous to younger, more progressive painters, admired Bonington's technical facility but had doubts about the subject matter and remarked that he 'would rather have a bad picture of the bay of Naples than a pile of pike executed by the most able master', another instance of the redemptive power of noble subject matter. In general, however, British painting of this sort was popular outside academic circles and the ritual abuse directed at more unconventional artists on show at the Salon is an inaccurate gauge of public opinion.

John Constable exerted a more visible influence on French landscape painting. His works were generally well known in Paris where they were exhibited by dealers and widely reproduced in the form of mezzotints and engravings. Constable's fame in France, however, rested principally on the exhibition of *The haywain*, the *View of the Stour near Dedham* and another unknown painting of Hampstead Heath shown at the Salon of 1824. In January 1824 Constable wrote in a letter to John Fisher of the 'Frenchman's' attempts to acquire the 'Hay Cart' and the 'Bridge'. In May of the same year he wrote:

37
Richard Parkes Bonington
A fish market, Boulogne, 1824
Oil on canvas, 81.3 x 122 cms

My Frenchman (Arrowsmith) has sent his agent with the money for the pictures; they are now ready and look uncommonly well, and I think that they cannot fail to melt the stony hearts of the French painters. Think of the lovely valleys and peaceful farm houses of Suffolk forming part of an exhibition to amuse the gay Parisians.[28]

Constable's hunch was right. The pictures were on the whole well received: *The haywain* was awarded a gold medal by Louis XVIII and became so popular that it was later re-hung in a prime site in the principal room of the Salon. A handful of critics expressed their reservations – they too were worried about the commonplace subject matter – but responses to Constable's work were generally favourable. Stendhal, for example, noted the somewhat cursive technique and the absence of an ideal motif, but praised Constable's work for its naturalism.

Constable influenced a number of landscape painters associated with Barbizon. Paul Huet was an ardent admirer. He compared Constable's paintings to those of Cuyp, Ruisdael and Rembrandt and admired the way in which his work drew from experience rather than pictorial tradition. Constable, himself, had emphasized precisely this mimetic aspect of his work in a lecture to the Royal Society in London in 1836. Corot also admired British art (he claimed that it was the sight of a painting by Bonington in the window of Schroth's gallery that had first prompted him to become a painter) and several historians have detected signs of Constable's influence in his painting. Corot's *Ville d'Avray, entrance to a wood* (plate 39) of 1823–5, the period when Constable's influence would have been most keenly felt in Paris, bears a marked resemblance to several of Constable's landscapes of the period. The picture is vertical and a large tree flanked by a small figure takes central place in the composition, a device used frequently by Constable. Théodore Rousseau would also have been familiar with the work of Constable. He maintained close contact with John Arrowsmith and knew Paul Huet; an examination of his work shows an interest in vernacular nature and a picture surface animated with broken flecks of paint, features found constantly in Constable's work.

Critics and theorists

In the mid-1820s the demarcation lines that separated different categories of French painting began to be examined and questioned. The reception of Dutch and English art in France did much to erode these demarcation lines although it is interesting to see that these attitudes were also increasingly tested by critics and theorists. Etienne Delécluze counselled landscape painters to search for French rather than foreign motifs as early as 1822 and petitioned for reforms in his articles for the *Journal des Débats*. On the eve of the announcement of the winner for the 1825 *Prix de Rome* in historical landscape, Delécluze expressed reservations about the Académie's method of judging landscape painters. A notice posted at the Ecole announced the theme for the final round of the competition. It read: 'the subject proposed by the Académie is the hunt of the boar of Calydon. The moment you must depict is when Atalanta delivers the first blow to the animal and when Meleager comes to help her. You are required to show the city of Calydon.' The Académie laid down guidelines about everything except, Delécluze said, 'the most important part, the landscape.' The set subject, he maintained, was too prescriptive about circumstantial details and had little to say about the landscape of Etolia, its flora and the geography in which the event took place. Delécluze suggested that a subject specifying the time of day, sunset or sunrise, weather conditions and topographical features might be a better test of a landscape painter's mettle. In 1829 the same critic questioned the wisdom of setting students a historical subject set in Phoenicia when the majority had never set foot outside the department of the Seine.[29]

Landscape painting was being rethought not just by critics at the periphery of the profession but also by more serious-minded theorists at its centre. In 1817 Lecarpentier published his 'Essai sur le paysage'. The essay recycles many of the formulae set out by Valenciennes but with a marked difference in emphasis. Northern landscape painters have a much higher profile. The Carracci, Domenichino, Claude and Poussin are, as usual, singled out for praise but so too are Adam Elsheimer, Dujardin, Cuyp, Hobbema, Potter, David Teniers, Rembrandt, Ruisdael and even Van Goyen, a pariah for many academic theorists. Lecarpentier also indicates that, far from being linked to history painting, landscape painting has a unique charm. Many artists who began their careers as history painters, he recalls, were struck by the charms of nature, thereafter to defect and become landscape painters. Moreover, those best disposed to practise it were not intellectuals, as Valenciennes would suggest, but rather melancholics, prone to the contemplative life.[30] Not surprisingly, changes in the hierarchical organization of landscape painting ushered in a new body of theory to substantiate it. Landscape painters were no longer required to carry the intellectual baggage of the classical scholar but were required to be men of feeling, sensitive to nature's resonances. This switch from an intellectual response to

38
John Constable
The haywain, 1821
Oil on canvas, 130.2 x 185.4 cms

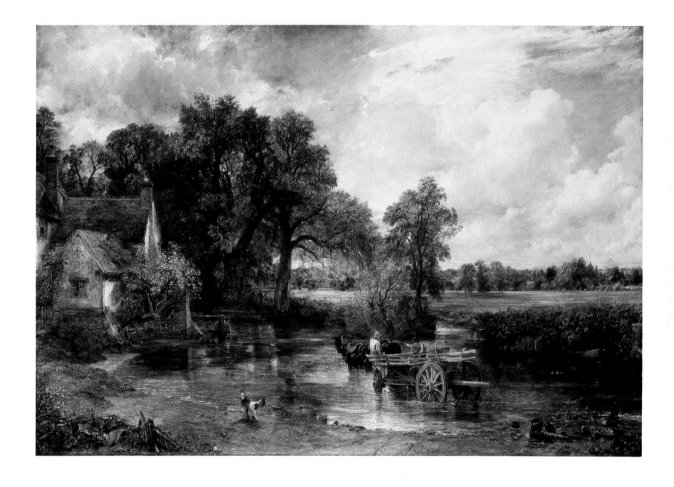

works of art to one based upon intuition and feeling, in essence a switch between a neo-classical, academic response to one informed by romanticism, is important in the development of nineteenth-century landscape painting. Throughout the 1820s and 1830s apologists for more naturalistic forms of painting justified it in terms of the unique emotional insights offered by the artists. In general, landscape painting became an altogether more egalitarian experience, a point picked up by the painter and theorist Jean-Baptiste Deperthes.

Deperthes re-examined many of the traditional assumptions underpinning academic categories of landscape painting. He questioned, for instance, the belief that the education of a history painter adequately equipped an artist to undertake other genres. Landscape painting was part of the education of history painters for the simple reason that landscapes often appeared in the backgrounds of history paintings. But the specialist landscape painter, Deperthes argued, needed to acquire a more substantial insight into the genre and address issues that would be deemed irrelevant for history painters. Landscape painters were advised to study nature in detail; they were required to study trees in the same way that students of history painting studied the proportions and parts of the human figure. He also argued that landscape painting had a greater social value because its content was less exclusive. Faced with a history painting, the well-informed connoisseur, Deperthes states, would be plunged into deep thought but the 'common crowd' would soon tire of the subject and just examine it superficially.[31] The middle class, common crowd, an increasingly potent force in the cultural life of early nineteenth-century France, needed only to have experienced the countryside to appreciate a picture of it. A classical theme, in contrast, required a body of knowledge acquired through a specialist (and class-based) education. The relationship between genres and the cultural backgrounds of those who bought paintings in early nineteenth-century Paris was also picked up by contemporary critics such as Jal and Chauvin both of whom had attributed the rise of landscape to the rise of the middle-brow, *parvenu* bourgeoisie. But Deperthes insists that the test of painting – all painting, irrespective of its place in the academic pecking-order – is to be found in its ability to move the soul of the spectator, and this could be done just as easily with a landscape as with a history painting.

At this stage it is possible to start piecing together some of the options open to landscape painters in the 15 years between Napoléon's fall and the revolution of July 1830. Artists active at this time would have been generally aware of the hierarchical divisions that separated the history painter from the landscape painter. The reader of Valenciennes *Elémens*, however, may have taken heart; landscape painting was enjoying something of a revival and was gaining respectability by aligning itself with *peinture historique*. Those painters that had not read Valenciennes or remained outside the sphere of influence of the Académie may not have worried greatly about the arcane subtleties that separated different types of landscape painting. They would have been the heirs of a period of cultural *laissez faire*, a tradition from the last century in which theoretical distinctions between one form of painting and another counted for little. Moreover, they may have been encouraged by the considerable interest generated by British and Dutch art in the 1820s. Although such paintings were often criticized by the press, they were increasingly admired by bourgeois and aristocratic collectors and the expanding network of art dealers active in the capital. Those that were aware of Valenciennes may also have been aware of other theorists – Deperthes, Lecarpentier, Delécluze – who were petitioning for some type of reform in landscape painting. They often paid lip-service to Valenciennes' ideas but inserted more and more caveats and exclusion clauses that undermined his basic tenets. Most of the painters active during the Bourbon administration of Louis XVIII and Charles X must have been aware that many of the structures used to explain and categorize landscape painting were looking very rickety. The genre was in the process of redefinition, a process that was to continue throughout the first three-quarters of the nineteenth century.

The cultural apartheid that divided history and landscape painting also separates aspects of modern art history, and art historians working today frequently make divisions between high and low culture. This form of apartheid might have worried some early nineteenth-century landscape painters. French images of the natural world occurred in painting but also on porcelain and in books of popular prints, travel guides, and painters that worked in one discipline often worked in others. Mid-century dealers, moreover, often blurred the boundaries between high and low culture by selling small landscape paintings alongside jewel boxes, dolls, small decorative bronzes and other *objets de luxe*. Even painters such as Michallon and Rousseau, competitors in the *Prix de Rome*, drew heavily on popular imagery and it is this facet of nineteenth-century culture that is examined in the next chapter.

39
Jean-Baptiste-Camille Corot
Ville-d'Avray, entrance to a wood, 1823–5
Oil on canvas, 46 x 34.9 cms

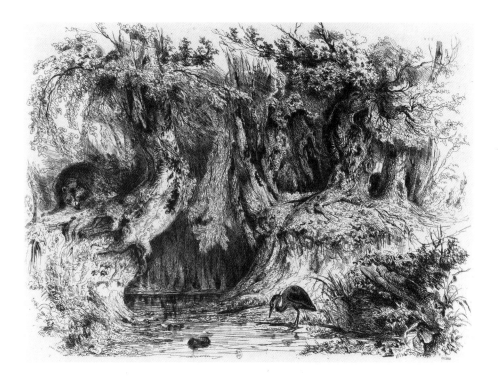

40
Paul Huet
The heron, 1833
Etching

41
Paul Huet
*Tour de Mont-Perrou, scene
from the banks of the Allier,*
from *Voyages pittoresques dans
l'ancienne France*, 1831
Lithograph

Panoramas, parks and porcelain:
nature and popular culture

Landscape painting took on various forms in early nine-teenth-century France and some had greater professional standing than others. It is important to remember, how-ever, that Parisian society, as Nicholas Green has lucidly demonstrated, experienced the natural world not just through landscape painting shown at the Salon but also through more popular forms of culture.[1] From the late 1820s the Parisian middle classes acquired a voracious appetite for images of the French countryside. Mechanized industry and the rise of middle class culture generated new forms of landscape imagery; the same technology that pulled steam trains of nature lovers out of the city to parks, forests and coasts also steam-powered printing presses to mass-produce images of the natural world experienced on those very same excursions. Charles Daubigny's engraving of a locomotive used to illustrate Jules Janin's *Voyage de Paris à la mer* of c. 1844 serves as a neat cipher for the intimate relationship that existed between new technology and the bourgeois grasp of the natural world during the 1830s and 40s.[2] From the late 1820s nature was read about in travelogues of rural France and seen on excursions to the countryside with the aid of pocket guide books; it was experienced at the Jardin des Plantes, at the spectacular theatrical performances held at the Paris panorama and diorama, and appeared on painted porce-lain, engravings, lithographs and photographs.

An insight into forms of culture other than 'fine art' is important because the compositions, the subject matter and the methods of presentation found in popular repre-sentations of the natural world also recur in the very cat-egories of landscape painting that gradually upstaged more erudite forms of historical landscape. The dramatic alpine scenes and Gothic vistas found, for example, in the paint-ed theatrical backdrops at the Paris diorama appeared again in the form of easel paintings on display at the Salon. The newly imported lions, tigers and panthers in the zoo-logical gardens at the Jardins des Plantes, were seen, in turn, in the form of paintings and sculptures of wild ani-mals by artists such as Antoine Barye (plate 42). In fact, many of the illustrations in guides to the Jardins bore a marked resemblance to landscape paintings.[3] The pavil-ions and cages, for example,were designed to look like country cottages or Gothic follies, motifs common in land-scape paintings, and there were even similarities in the ways in which illustrator and painter presented their respective images to their audiences. Guides to the gar-dens were illustrated with printed *vignettes,* images with-out frames in which the subject would appear to fade into the surrounding white page. This method of visual pre-sentation was unknown in academic painting of the early nineteenth century but was very common in the more naturalistic forms of landscape painting of the 1830s. In

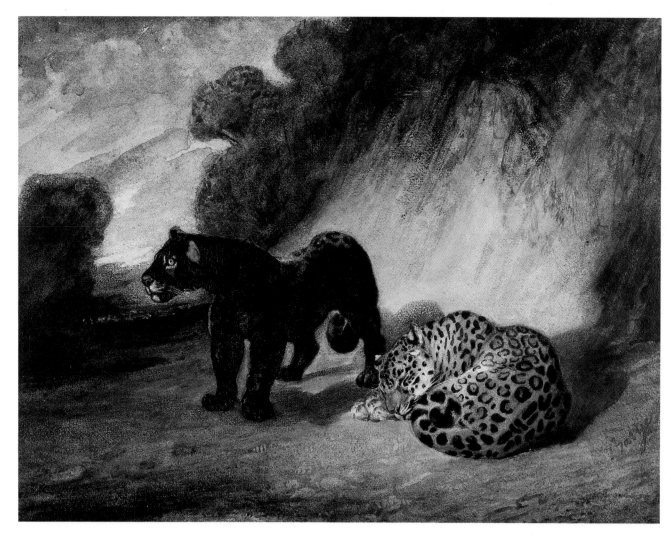

42
Antoine Barye
Two jaguars from Peru,
undated
Watercolour, gouache and ink
on paper, 24.2 x 31.7 cms

some instances, Charles-François Daubigny being a case
in point, the painter of naturalistic easel painting and the
illustrator of nature in popular guides were one and the
same. It is significant that the majority of the painters and
sculptors associated with Barbizon began their careers as
illustrators, print-makers or decorative painters rather
than 'fine' artists. Corot and Rousseau may have had a con-
ventional art education and lofty aspirations to compete
for academic prizes, but many Barbizon painters – Jules
Dupré, Narcisse Diaz de la Peña, Antoine Barye, Charles-
François Daubigny and Paul Huet – worked within a more
humble milieu, painting porcelain or theatrical backcloths,
making prints or engraving gems. They only graduated to
the realm of the fine arts at a later stage in their careers
and in many cases appear to have continued to use the
same repertoire of visual conventions in their work.[4] A
mid-century bourgeois visitor to the Salon gazing on a
painting of a mountainous landscape, a clearing in the for-
est of Fontainebleau, a picturesque view of the plains of
Saint-Denis, or the parkland around Saint-Cloud would
have read such images with minds primed not by classical
myth and history but rather with more popular images of
nature on show in various forms in the capital.

The panorama and diorama

Among the most conspicuous representations of nature
outside the field of the fine arts were the popular panora-
mas, cosmoramas and dioramas shown in Paris in the
1820s and 30s. While conventional landscape paintings
seen at the Salon maintained a clear distinction between
the world of the viewer and the world within the paint-
ing, the panorama, and especially the diorama, sought to
delight the spectator by plunging him into a theatrical
world in which the division between reality and artifice
became increasingly confused. Here, verisimilitude was
all important. Publicity leaflets made to promote the
panorama underscored the breathtaking naturalism of the
large 360 degree canvases by drawing the public's attention
to the fact that the scenes were painted from detailed
sketches and drawings made on site. Millin de Grand-
maison's *Dictionnaire des Beaux-Arts* warned painters
against the addition of too many potentially mobile sub-
jects – figures, ships and so on – in panoramic paintings on
the grounds that such features could reasonably be expect-
ed to move and had the capacity to undermine the panora-
ma's ability to deceive the spectator.[5]

First imported into Paris in 1799 by Robert Fulton and
James Barlow, panoramas were large, continuous land-
scape paintings mounted inside a circular structure illu-
minated from above with the aid of an oculus. Henry

Aston Barker's large sequence of panoramic drawings of
Paris made in 1802 (plate 43) gives an indication of the
manner in which the landscape unfolded before the
sweeping gaze of the spectator. The eye not only casts lat-
erally across the drawings but darts from meticulous
details of chimney stacks and window frames picked out
in the foreground to the minute representation of church
spires on the horizon. In the 1830s panoramas became
more ambitious and sought increasingly to erode the divi-
sion between reality and the painting. In 1831 Jean-
Charles Langlois introduced a ground glass oculus to
distribute light more evenly and naturalistically in his
panorama on the Rue de Marais, and in 1839 he contract-
ed the architect Jacques-Ignace Hittorff to design a more
ambitious structure on the Champs-Elysées in which dis-
plays measuring some 15 metres in height and 38 metres
in diameter could be seen. Langlois sought to bridge the
gap between art and reality even further by introducing
'faux terrains', in which real objects relating to the subject
would be used to complement the theme. The display of
the battle of Navarino, for example, could be seen from a
platform converted into a poop deck around which parts
of one of the ships that had taken part in the battle could
be seen.

The realism of the panorama, as many contemporary
critics noted, paled into insignificance when compared
with the diorama. So realistic were the images seen at the
diorama that some visitors felt compelled to throw mis-
siles at the calico and linen screens to confirm that the
scenes were painted rather than real.[6] Invented by Louis
Daguerre, the diorama consisted of a series of large
opaque and translucent painted screens mounted at the
far end of a darkened stage in a specially constructed
building. Above and behind the painted scenes a mixture
of natural and artificial light sources could be manipulat-
ed using ground glass and coloured filters to give the
appearance that the paintings were actually moving. The
mechanisms used to achieve these effects were so heavy
and complex in construction that they remained fixed in
position. Scene changes – most performances consisted of
two or three, ten- to 15-minute shows – were made by
moving the audience rather than the scenery. The audi-
torium, carrying sometimes 200 people, was mounted on
rollers and swivelled from one stage set to the next.

The most popular form of subject matter in the 1820s
was medieval architecture and mountain scenery shown
against a backdrop of spectacular and changing weather
conditions, intrinsically dramatic themes that lent them-
selves to theatrical tricks with light and sound effects. The
first diorama presented in Paris in July 1822 showed

43
Henry Aston Barker
Panorama of Paris, 1802
Pencil on paper, approx. 44.5 x
53.2 cms each

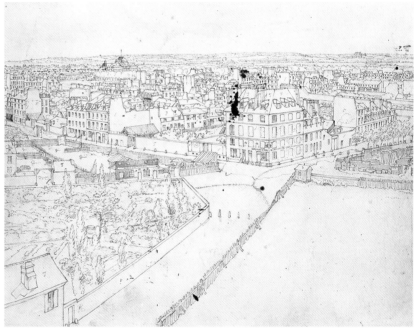

images of the valley of Sarnen in Switzerland and the construction of Trinity Chapel in Canterbury Cathedral, painted by Louis Daguerre and Charles-Marie Bouton respectively. Daguerre's *Valley of Sarnen* showed mountains, a lake, scattered hamlets and a little Swiss chalet. The performance, which lasted about 40 minutes, showed a sequence of realistic effects described as 'nature itself', including twinkling stars, the onset of an Alpine storm and, as darkness fell, the lighting of a lamp inside the mountain cottage. Daguerre's attempts at verisimilitude reached their apogee, however, in a performance which included the addition of a model Alpine chalet and a live goat, accompanied by music from an Alpine horn. Critics, who were usually well-disposed towards Daguerre's efforts, thought that he had gone too far in this instance. The experience of the diorama was contingent upon deception; the addition of a live goat, it was felt, compromised rather than enhanced the performance. Subsequent performances included the presentations of interiors of Chartres and Rouen cathedrals, the chapel at Holyrood House (plate 44), Edinburgh, the countryside around Paris, several Alpine vistas, the Basin of Commerce at Ghent and St Peter's in Rome.

Like the presentations at the panorama, the subjects on display in the Paris diorama were, for the most part, taken from the everyday experiences of the middle class spectators that paid so handsomely to see them. In the 1820s and 1830s there was a rising interest in Gothic and Romanesque architecture and in the scenery of some of the more remote parts of France. Italy was the primary point of focus for most tourists in the eighteenth century.[8] Travellers in the nineteenth century, by contrast, took an increasing interest in sights closer to home; they may not have trekked across the Pyrenees or visited far-flung Romanesque abbeys but they could buy books, look at paintings at the Salon, buy prints and see spectacular dioramas by those that had. Images of the medieval past struck an additional chord with readers of the novels of Walter Scott and other Gothic romances imported from Britain. Moreover, in the wake of Napoléon's fall there was a renewed interest in British culture. The British had played a key role in the protection of exiled Bourbons during the Revolution and Empire and had overseen their return in 1816. Furthermore, after the trauma of the Revolution – during which France had experienced the execution of the King, the decimation of its aristocracy and clergy during the Terror of 1793, the end of Catholicism as the state religion and the creation and subsequent destruction of an empire – some French men and women were keen to look back to the reassuring spiritual and

44
Louis Daguerre
Ruins of Holyrood chapel,
c.1824
Oil on canvas, 211 x 256.5 cms

45
Théodore Rousseau
Sunset in the Auvergne, c. 1830
Oil on panel, 20.3 x 23.8 cms

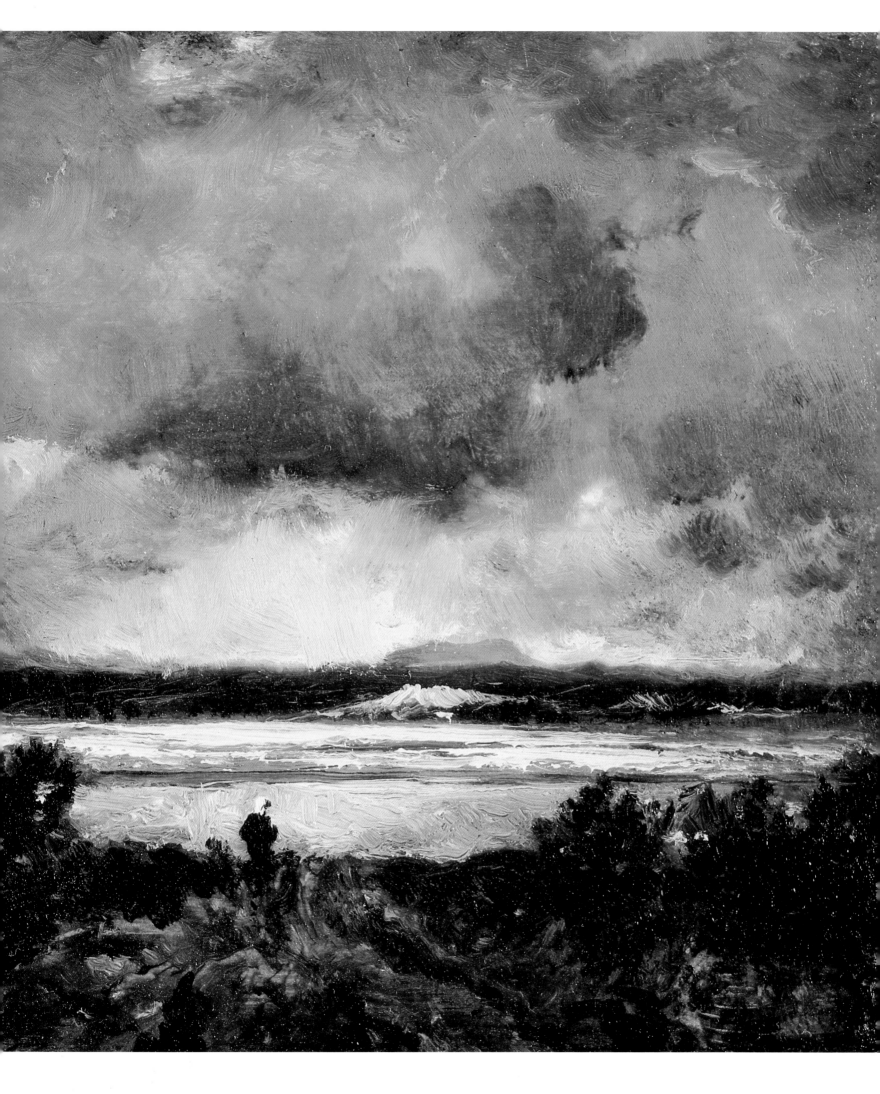

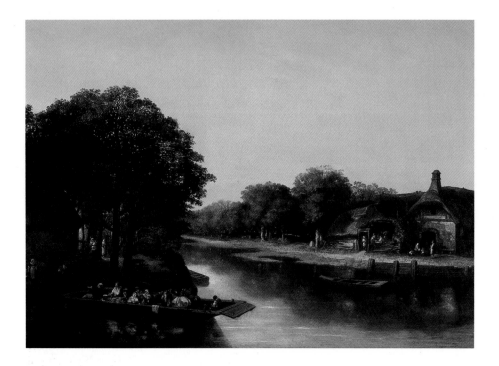

monarchical traditions of the past.[9] It is hardly surprising to discover, therefore, that the return of a medieval institution such as the Bourbon monarchy should go hand in hand with a renewed interest in medieval culture.

There were a number of similarities between the subjects on show in the panoramas and the dioramas and those featured in the more romantic and naturalistic examples of landscape painting found at the Salons of the 1820s. Presentations at the diorama provide a visual precedent for the subjects of a number of Barbizon paintings: Rousseau's *Sunset in the Auvergne* (plate 45), for example, shows nature in dramatic form revealing herself to a minute peasant woman in the middle distance of the painting. The size of the picture is small. Its scale, however, is monumental and Rousseau has mobilized many of the romantic visual conventions found in the diorama by setting the figure against the backdrop of a sweeping panoramic vista and the pyrotechnics of a spectacular sunset. Similar pictorial conventions were used by Diaz de la Peña in the *The ferry crossing at sunset* (plate 46), and also by Dupré and many other landscape painters associated with Barbizon. In some cases, however, the links between easel painting and the diorama were much more specific. The Duchess of Berry, patron of a number of naturalistic and romantic landscape painters, also established the *Diorama Montesquieu* in 1829 and contracted Paul Huet to work on two of the productions, a *View of Rouen* and a *View of the Château d'Arques*, the latter also the subject of an easel painting shown at the Salon of 1840 (plate 47).[10] Daguerre also showed paintings regularly at the Salon, some of which were based directly on scenes presented at the diorama, and it was hoped that the publicity generated by one medium would help promote the other. *The Effect of fog and snow seen through a ruined Gothic colonnade* (plate 48), shown at the Salon of 1826, was based on a diorama shown in Paris between August 1825 and May 1826. A painting based on a diorama presentation of the chapel at Holyrood seen in 1823 (plate 44) was shown at the Salon a year later together with another painting of Roslyn Chapel.[11] Daguerre and Bouton were both awarded the Légion d'honneur by Charles X following the Salon of 1825, although this was reputedly more for their work at the diorama than for their abilities as easel painters.

The three main conventions underpinning such images – personal experience, a sublime vision of the natural world and an interest in the transient effects of light and shade to help depict and dramatize it – have a long-term importance in nineteenth-century French art. They inform not only Barbizon painting but also many aspects of naturalistic landscape painting and, arguably, even some

46
Narcisse Diaz de la Peña
The ferry crossing at sunset,
1837
Oil on canvas, 76 x 117 cms

47
Paul Huet
View of the valley and the
Château d'Arques, near Dieppe,
c.1840
Oil on canvas, 114 x 165 cms

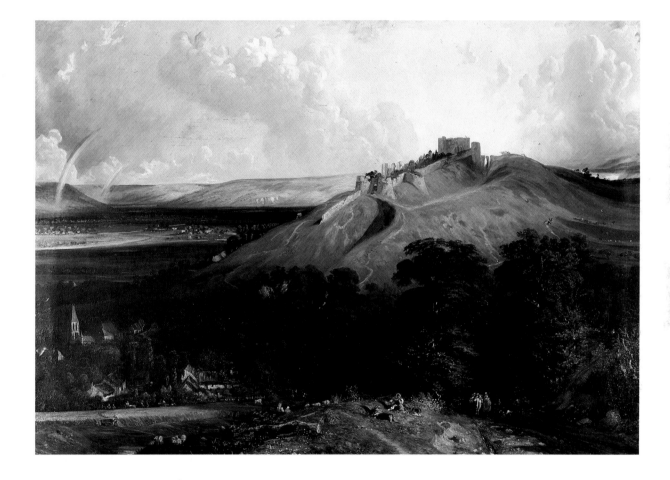

48
Louis Daguerre
*The effect of fog and snow seen
through a ruined Gothic
colonnade*, 1826
Oil on canvas, 102 x 154 cms

49
Claude Monet
Haystacks in the snow, 1891
Oil on canvas, 58.4 x 99.1 cms

strands of Impressionism. The struggle between man and the elements, the artist slugging it out in order to capture the fleeting effects of nature, often at its most hostile and dramatic, is captured in a number of Monet's series paintings made towards the end of the century. Monet made numerous references to the discomfort of cold and wind, and to the personal risks taken on such outdoor painting expeditions. His interest in the dramatic lighting generated by ice and snow, a popular theme until the mid 1890s, represents an interesting extension of romantic preoccupation with elemental forces.[12]

Travel guides: *Voyages Pittoresques*

Many of the same sweeping vistas, volcanic landscapes, desolate wastes, plunging chasms, haunted forests and Gothic ruins that appeared at the panorama, the diorama and the Salon were also visible in the form of richly illustrated guides to some of the more remote and mysterious areas of France. It is hardly surprising to discover that many of the artists that illustrated travel guides also painted landscapes and, in some instances, dioramas. Before the 1820s the French landscape was largely ignored as a site for landscape painters and tourism. Tourists were recorded in France in the eighteenth century; the palaces at Saint-Cloud, Versailles and Fontainebleau attracted some visitors, and tourists also made forays further south to towns around the Loire, to Lyons, and to the Roman sites at Aix, Nimes and Arles.[13] For the most part, however, the French countryside was seldom regarded with particular interest. In the 1820s this attitude began to change; the French began to record, visit, paint, and above all value, their native environment and travel guides played a key role in this change of attitude.

One of the first and most extensive guides to France was Baron Taylor's *Voyages pittoresques dans l'ancienne France*. Published in 17 volumes with contributions from Alphonse de Cailloux and Charles Nodier, it contained 2,700 lithographic prints.[14] The first volume, published in 1820, a survey of the department of the Auvergne, used an engraving of a Romanesque doorway (plate 50) as its frontispiece. Set beneath the tympanum is a *vignette* showing a traveller standing beside a medieval ruin looking at an exploding volcano on the horizon. The introduction to the volume speaks of the early history of the region when volcanoes 'threw up torrents of lava and hid the skies with black whirlwinds of ashes and smoke; the flames of the volcanoes glittering in the waters of the rivers that flow from the mountains'. The scene could quite easily have been lifted straight out of the Paris diorama. Indeed, Taylor was involved in theatrical productions in Paris

50
Baron Isidore Taylor
Frontispiece to the volume on the Auvergne from *Voyages pittoresques dans l'ancienne France*, 1820
Lithograph

51
Jean-Antoine-Théodore Gudin
Château de Baron, Auvergne from *Voyages pittoresques dans l'ancienne France*, 1831
Lithograph

throughout the 1820s and was closely connected with Robert Fulton who held the first licence for diorama productions alongside Daguerre and Bouton.[15] Other images in the same volume show brooding Romanesque and Gothic structures raked with light to cast menacing shadows; extensive vistas animated by rustics and flocks of sheep; mountain goats leaping across an apparently bottomless abyss to escape a hunter, rifle raised ready to shoot; snow-covered mountains in the midst of a storm or avalanche; smouldering volcanoes, and so on. Paul Huet's *Tour du Mont-Perrou* (plate 41) and Jean Antoine Theodore Gudin's *Château de Baron, Auvergne* (plate 51), with their dependence upon dramatic scenery lit with equally dramatic passages of light and shade and their use of minute figures, are broadly typical of many of the illustrations found in the *Voyages pittoresques*. Even descriptions of tamer countryside closer to Paris contain a heady mixture of ancient history, folklore and drama. After the Auvergne came volumes on the Languedoc, Burgundy, Picardy, Brittany, Dauphiné and Champagne with plates illustrated by an impressive line-up of artists, among them Bonington, Eugène Isabey, Ingres, Carle and Horace Vernet, Paul Huet, Bouton, Daguerre, Ciceri and Gericault all of whom had well-established reputations at the Salon.

Travel guides: Fontainebleau

Baron Taylor's publication was designed for wealthy armchair travellers and romantics. Individual volumes of the *Voyages pittoresques* were lavishly bound and sufficiently expensive to be published only on subscription. They were also extremely large and heavy and were clearly intended for use at home. In the comfortable confines of an affluent, bourgeois study, one could experience both the frisson of sublime natural forces and the heritage of one's native France; first-hand experience of the district was clearly by no means essential.

The 1830s, however, saw the publication of other, smaller, much cheaper travel guides designed to be used not in the study but in the open as a supplement to a first-hand experience of nature. In many instances the guides surveyed districts close to Paris, the most important market for such publications. One such guide was Etienne Janin's *Quatre promenades dans la forêt* of 1837, one of the first travel guides to the forest of Fontainebleau.[16] Earlier guides to the district exist, but they were generally concerned with the château and gardens rather than the surrounding countryside. However, Janin's guide, inspired by an epic poem written in praise of the district by Alexis Durand, a local workman turned poet, was concerned primarily with the historical and picturesque qualities of the

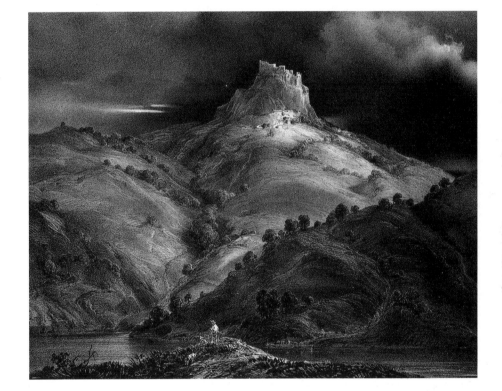

region. The guide leads the reader through one of France's few remaining virgin forests. Other forests have had many of their natural features removed, Janin explains, because untamed nature was not fashionable. Some forests, he complains, have become like cities, criss-crossed by highways; others have been cleared for farm land, planted with pines or quarried for stone. (Interestingly, the forests around Fontainebleau *were* criss-crossed with paths, planted with pines, cleared for agriculture and extensively quarried!) Despite the fact that it was once much larger and extended almost to Nemours, the forest of Fontainebleau has for the most part, the guide informs us, escaped many of these ravages. Here, the leaves rustle gently in the breeze, one can hear the sound of a waterfall, the songs of birds, the call of the crows, the cries of the owl and the happy song of a shepherd. Even the most accessible parts of the forest, Janin reassures us, provide the visitor with an array of contrasting and remarkable things to see. Wander deeper into the forest and mysterious clearings suddenly appear and individual oaks, some as many as 500 years old, can be seen.

The purpose of a trip to the forest is clear from the outset; it is to provide the traveller with spiritual refreshment attained by total absorption in the contemplation of nature. Nature is described at its purest, the virgin forest is presented as a remnant of some harmonious natural order left over from time immemorial, a sentiment found in the work of many painters associated with the district. Something of this sentiment is evident, for example, in the rural tranquillity of Corot's painting of the *Forest of Fontainebleau* (plate 53) of 1831. Here a peasant girl, barefoot and absorbed in a book, reclines by a stream winding around an outcrop of sandstone. The broken rocks scattered around Corot's pool, and many other sections of the forest, were frequently described as being the result of some natural cataclysm in the long-distant past. The sense of primordial nature is especially apparent, however, in paintings without figures and domestic animals such as Rousseau's *Plateau de Bellecroix*. Here, scattered rocks are visible in the lower left-hand section of the painting and a dismembered tree appears on the right as if it has been struck by some natural disaster.

The primordial and picturesque appeal of the forest is discussed at length in François Desnoyers' *Ebauche de Fontainebleau* published in an anthology of writings about the district dedicated to Claude-François Denecourt in 1856. The poem describes the dramatic scenery in terms of some faint memory of a long distant battle or natural disaster, so violent that it has caused the rocks to contort and writhe in pain. He writes:

52
Narcisse Diaz de la Peña
*The hills of Jean de Paris
(forest of Fontainebleau)*, 1867
Oil on canvas, 84 x 106 cms

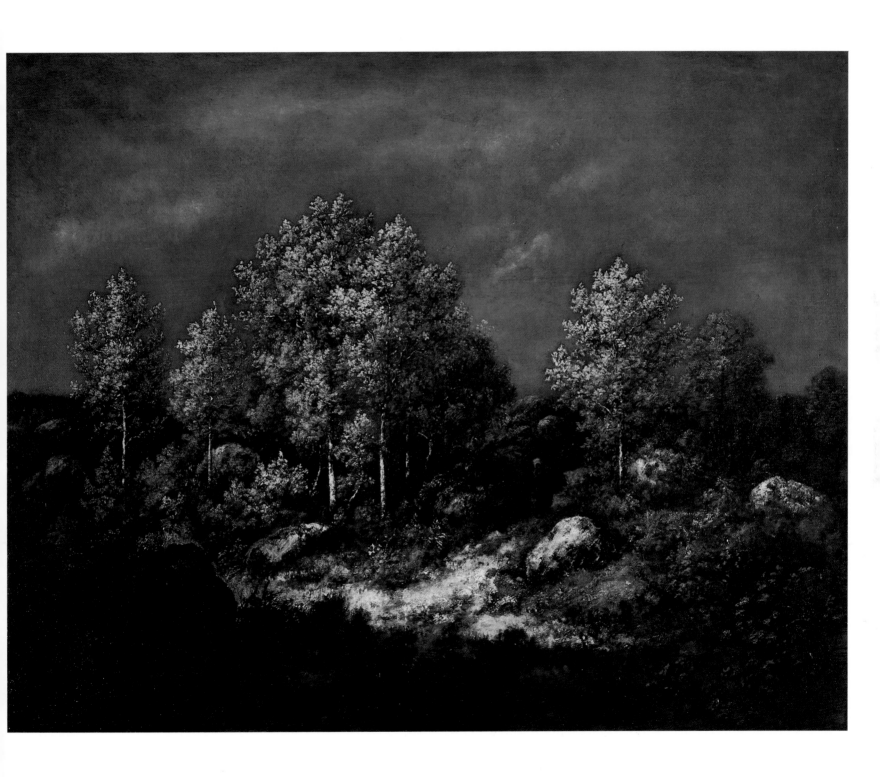

53
Jean-Baptiste-Camille Corot
The forest of Fontainebleau,
1831
Oil on canvas, 176 x 241 cms

Looking into the past as if across a prism we see a world collapsing. The echo of a cataclysm vibrates across time, we dream, we remember a combat of Titans, a diluvial chaos.[17]

Pictorial references are common throughout the poem. The very term, *ébauche*, is most frequently used to describe a rapidly painted sketch and the poem is riddled with graphic descriptions of natural phenomena. The landscape, for instance, is described by Desnoyers as being 'bathed in golden mists with a pure azure sky beyond'. Health is another important point of reference in this and many accounts of the forest. As several guide books noted, the high altitude of the forest, and its sandy soil, created an intrinsically dry and healthy environment, a point of some concern for Parisians following the cholera epidemics of 1831 and 1848. The forest is suffused, Desnoyers states, with the 'breath' of fragrant pines, with gusts of spring air, and line after line in the poem makes connections between happiness, health and clean, fresh air.

Janin's *Quatre promenades* also contains a wealth of scientific information on the flora and fauna of the district. Descriptions of trees are listed, each appended by some historical anecdote. The oak, we are reminded, provided the wood for the Trojan horse and in the Golden Age, according to ancient lore, honey flowed from its bark. The juniper is listed as the oldest tree in France and was used to flavour *eau de vie*, known by 'bonnes femmes du pays' as 'rabbit's piss'. Classical literature is a constant point of reference throughout the guide; mushrooms, of numerous varieties, both edible and poisonous, are recorded in detail with references to their appearance in Pliny's *Natural History*. The reader is also reminded that one should pass through the forest silently with a degree of respect lest one should meet the 'Black Man', a giant huntsman who, though friendly enough to the local peasantry, once terrified the hunting party of Henri IV.

Unlike many guides of the eighteenth century, which often contained specific references to classical scholarship, Janin's guide covers a much wider range of cultural references. It has something for everyone: a catalogue of flora and fauna for the amateur scientist; ancient and modern history for the would-be scholar; ghosts and miracles for the visitor in search of the sublime and, not least, a topographical guide to the forest itself. Though somewhat confusing to the modern reader, this broad spread of subject matter and references gives an insight into some of the meanings that would have attended a trip to the forest for a middle class visitor and also some of the connotations associated with landscape paintings of the district in

the 1830s and 1840s. Faced with a landscape painting strewn with rocks, a viewer may well have conjured up an image of the pre-historic past. Presented with an image of Diaz de la Peña's *The hills of Jean de Paris* (plate 52), a popular destination with many visitors and one known for its cool breezes, the spectator may well have pondered on the forest's reputation as a safe haven from disease. Confronted with a painting of a lonely forest clearing, the spectator may have speculated on the ancient myths that abound in the forest and even felt a mild frisson of fear lest the 'Black Man' should appear.

Janin's 1836 guide makes only passing reference to the district's appeal to artists. Claude-François Denecourt's *Guide du voyageur dans le palais et la forêt de Fontainebleau,* written only three years later, described the area as a charming *rendezvous* for travellers and a 'vast atelier of our young artists'. The guide carried the sub-title, 'choix de promenades les plus pittoresques...' and contains numerous references to the visual appeal of the forest.[18] Denecourt notes that within a modest area there is a broad cross-section of different prospects. It is important to remember that one of the main attractions of the district for landscape painters was its remarkably wide range of picturesque subjects – isolated trees, forests, rocky outcrops, distant views, lonely clearings and isolated pools. Rousseau's *Plain at Chailly* of 1833, Paul Huet's *Rocks at Apremont* and Jules Dupré's *Plateau de Bellecroix* of 1830 give some indication of the range of subjects on offer to painters and tourists alike. Moreover, these diverse motifs were all within easy reach of the capital.

Denecourt played an important role in helping to promote the forest as a resort for tourists. In addition to the *Guide du voyageur*, he published several other popular guides together with illustrated maps, souvenirs and lithographs of the district. He also obtained exclusive rights to open up new paths from M de Bois d'Hyver, the Crown's Agent for the management of the forest. New walks through the area were described in a series of *Indicateurs*, short guides to the forest published annually from the mid-1840s. Greater access to the countryside around Fontainebleau for both tourists and artists was also made possible by the extension of the railway from Paris to the provincial capital Mélun in 1849. The introduction to Bernard's guide *Fontainebleau et ses environs* of 1853 explains how railways had the ability to 'catapult' the traveller through the *banlieu* to the unspoilt countryside beyond. Bernard notes that on entering the town of Fontainebleau the château 'slips' into view. It is an interesting verb to describe what must have been a new category of visual experience.[19] The 39 miles from Paris to

Fontainebleau could now be covered in as little as an hour and images would have passed before the traveller's carriage window not only at an unprecedented speed of almost 40 miles per hour but without the harsh vibration and lurching motion of coach travel on cobbled or rutted roads. Thanks to steam, 'that divine and invincible force which has no rival', 'everyone' in Paris now had access to the château and surrounding parkland and countryside. And Bernard means 'everyone'; trains had third-class accommodation for Parisians of very modest means, described in the guide as 'the scarecrows of the delicate classes'.[20]

Janin's *Voyage de Paris à la mer*, a guide for travellers taking the railway north to the coast, another increasingly popular subject among landscape painters, was similarly optimistic about the advantages of new technology in travel. The guide, illustrated with *vignettes* of the towns and countryside along the route to Normandy by Daubigny and Antoine-Léon Morel-Fatio, describes steam technology as the poetry of the nineteenth century. Janin explains:

Nineteenth-century poetry, it has to be said, is steam. In the past it was only the true poet who ventured out on wings of the imagination into unknown lands. These days the whole world is a poet on flaming wings of steam.[21]

In fact, travel by locomotive was so quick that Janin wondered whether prose, a less labour-intensive method of reportage, would be more appropriate to describe the new experiences opened up to the traveller by steam technology, and noted that Napoléon's dictum that Paris, Rouen and Le Havre were but one city linked by the Seine, its main street, had all but come true.

By the early 1850s conditions in the forest and surrounding countryside began to change dramatically and Fontainebleau was seen by some commentators to be little different from other popular tourist resorts such as Versailles and Saint-Cloud. In some instances the signs of cultural pollution were modest and did not present a serious threat to the environment. Frédéric Henriet writing in 1863 refers to the strains of fashionable opera that could sometimes be heard in the forest. He writes:

Occasionally, tourists who stray to the bottom of the gorge, are surprised to hear the snatch of a song from a comic opera of Rossini or Meyerbeer. If they try to discover the whereabouts of so unexpected a sound they almost always meet a landscape painter who is trying to relieve the tedium of his study by bringing back some memory of Parisian life. These days painters are the true lords of the forest of Fontainebleau.[22]

In other cases, however, the pollution was more intrusive. Bernard refers to the need to escape from Paris as the suburbs gradually expand. Gone, for example, is the countryside that used to flourish just outside the city. Bernard complains that the capital's environs are now 'scattered with factories', they are poisoned with 'all sorts of unhealthy fumes'. On arrival at Fontainebleau, however, the forest and the 'deserts of Saint Louis, Francis I and Henri IV' were found to be planted with pines, many, ironically, cultivated to supply the paper industry for the rapidly expanding publishing market, part of which encouraged visitors to the forest in the first place. The once rocky wastes which gave the country such charm now, Bernard laments, have the cultivated air of an English landscape garden. The cause of the invasion was clear; Bernard writes:

The admiration of artists, poets and tourists still grows. It seems that it grows from the wounds and the false embellishments that the forest administration has for too long continually lavished on its lonely wastes, on its bare rocks, its long arid plains and narrow sombre valleys.[24]

The proliferation of guides to the forest brought about a growth in the number of tourists and also an increase in the number of paths to lead them to picturesque sites. In fact, the number of newly constructed routes through the forest increased to such an extent that by the early 1850s they were said to have totalled almost 1,500 miles, making it impossible for guides to provide accurate directions. Bernard warned against the dangers of fatigue for travellers lost in a maze of newly extended paths.

The most poignant illustration of the extent to which the forest was besieged by tourism must be the sad fate of a medieval hermitage, one of the oldest buildings in the forest, pre-dating even that of the hunting lodge of François I. The hermitage was founded in the fourteenth century around a community of monks who had moved to the district to care for Guillaume, an aged hermit. Later destroyed and taken over as a hide-out for bandits, the site became a place of pilgrimage for members of the court in the seventeenth century. Courtiers conducted torch-light processions to the hermitage then returned to the château to feast and dance. The hermitage was ideally qualified as a picturesque location: echoes of a medieval past, banditti, torch-light processions, courtly *fêtes-champêtres*, these images were the very life-blood of contemporary guide books. By the 1850s, however, the spot had been laid low by tourism and Bernard's guide laments that the hermitage was now used as a kiosk to sell cigarettes and beer.[25]

Prints and Porcelain

One of the main areas in which landscape painting and popular culture overlapped was in the field of the graphic arts. A number of the landscape painters that later became associated with the Barbizon School – Dupré, Daumier, Daubigny, Huet, Millet, Corot and others – made lithographs, engravings and etchings, and several were trained as artisan engravers making at least part of their living producing graphic illustrations and designs for the rapidly expanding print industry.

Prints fulfilled a variety of functions in the 1820s and 1830s. At one end of the spectrum there were large numbers of artisan print-makers who earned their living engraving calling-cards, making maps and illustrations for books and periodicals. Technological advances in printing – the steam press, machine-made paper and mechanical binding machines – made it possible to produce illustrated books, journals and magazines in vast quantities and at very low prices. New techniques of wood-engraving enabled images to be printed alongside text in one operation; in the eighteenth century the process had required two separate operations and was consequently more expensive. Publications – travel guides, serialized books, picture magazines such as the *Magazin Pittoresque*, *L'Illustration* and other popular journals – were assembled and distributed by *editeurs*, fiercely competitive businessmen who could co-ordinate complex production methods and had well-developed marketing skills and a keen insight into popular tastes in illustrated literature.[25]

Prints were also used to promote an artist's career. Magazines such as *L'Artiste* regularly carried lithographs and engraved reproductions of paintings alongside Salon reviews. Prints of this type, often drawn or engraved by the painters themselves, were seen not as original works in their own right but only as a means of reproducing and publicizing Salon paintings. Jules Dupré made only a few prints during his career and these appear to have been used in exactly this manner. In some instances, however, prints appeared in art magazines such as *L'Artiste* and were also distributed by art dealers.[26] The same graphic image, therefore, had two functions: the first as an illustration of an artist's work and the second as something approximating an original work of art in its own right. Alexandre Decamps' magazine *Le Musée* of 1834 reproduced collections of artists' prints and implied that the illustrations were something more than graphic reproductions of an artist's work. The venture was important because it marked one of the first instances in nineteenth-century French culture in which a printed image began to be considered as a worthy vehicle for artistic expression. How-

54
Charles-François Daubigny
The storm from *Chants et
Chansons Populaires de la
France*, 1842
Etching

55
Charles-François Daubigny
The cedar tree from *Le Jardin
des Plantes*, 1842
Etching

56
Charles- Daubigny
The poet's song from *Chants et
Chansons Populaires de la
France*, 1842
Etching

57
Charles-François Daubigny
The swallows from *Chants et
Chansons Populaires de la
France*, 1842
Etching

58
Charles-François Daubigny
*The eagle's nest in the forest of
Fontainebleau*, from *l'Artiste*
1844
Etching

59
Jean-Camille-Corot
The concert, c.1844
(Le concert champêtre)
Oil on canvas, 98 x 130 cms

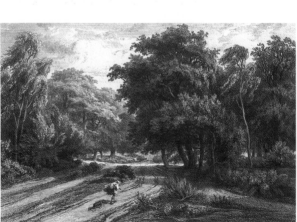

ever, by the early 1850s artists' prints, a genre still common
at the end of the twentieth century, began to appear in
some quantity. Here, etching was often used in preference
to wood-engraving. Unlike wood-engraving, which
required the image to be cut into the block with painstak-
ing care, etching was capable of depicting impulsive ges-
tures, direct evidence of fleeting movements of the artist's
hand. Baudelaire described the medium as 'the crispest
translation of the artist's personality'; as such it was often
thought to be a more appropriate medium for a work of
art.[27] Editions of prints became increasingly popular in the
1860s, and towards the end of the decade began to be
reproduced in quantities small enough to ensure that the
images retained a degree of exclusivity and hence value.
This aspect of print-making became especially important
among circles of amateurs because commonplace
mechanical methods of reproduction had all but stripped
engravings of any aesthetic and financial value. In some
instances, however, print-making was used purely for cre-
ative purposes. Corot, an artist who rarely concerned him-
self with publishing ventures, made use of a number of
printing techniques, in particular the *cliché-verre*, a tech-
nique closely allied to photography.[28]

Daubigny provides an interesting case study among
Barbizon painters, having worked as an artisan print-
maker, a painter and later as a maker of fine art prints.
Like many painters during the late 1830s and 1840s he
took full advantage of the expansion in the publishing
industry and made numerous wood and steel engravings
to illustrate travel guides, editions of poetry, popular songs
and novels. Working alongside Trimolet, his collaborator,
Daubigny produced illustrations for several cheap, popu-
lar publications such as Michel Raymond's *Le Mâcon,
Moeurs Populaires* printed by Delloye, and was also
involved in providing five of the illustrations for a presti-
gious guide to the Jardin des Plantes published by Curmer
in 1842. In the same year he produced drawings and steel-
plate etchings for Delloye's illustrated periodical *Chants
et Chansons Populaires de la France*.[29] In 1844 Daubigny,
working alongside Morel-Fatio, contributed *vignettes* to
Janin's guide *Voyage de Paris à la mer* mentioned earlier.
Some measure of the importance of the illustrations can be
found in the way the introduction to the book calls atten-
tion to the quality of the prints, the care with which they
have been made and to their valuable role in supple-
menting the text. This high profile is partly explained by
the fact that Daubigny and Morel-Fatio began to consoli-
date their careers as landscape painters in the 1840s and
wily *editeurs* like Curmer were able to trade on these rep-
utations in marketing their publications.

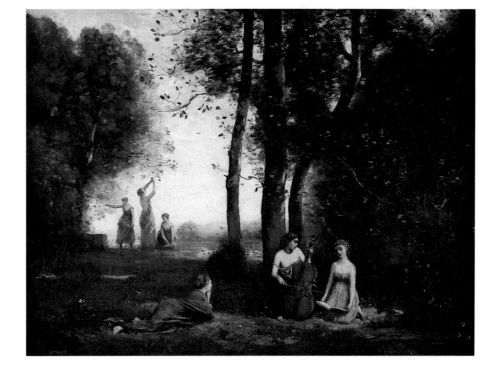

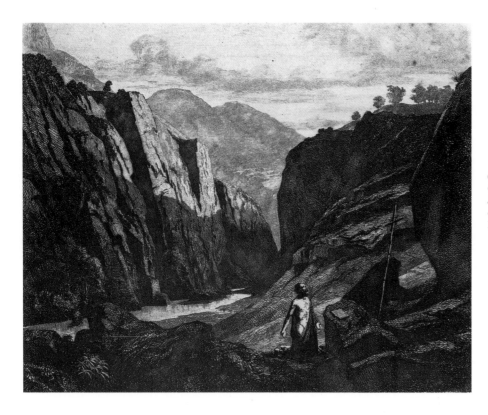

60
Charles-François Daubigny
Saint Jerome from *l'Artiste*,
c.1840
Etching

Daubigny also used print-making as a means of promoting his own career as a landscape painter. In 1838 he made his first attempt to reproduce a painting, *View of Nôtre Dame de Paris and the Ile Saint-Louis*, which was also seen at the Salon. Although this particular etching was not published, graphic reproductions of subsequent Salon paintings appeared regularly and played a key role in publicizing his work. In 1840 he showed a painting of Saint Jerome at the Salon which was followed up by a favourable review in *L'Artiste* together with a reproduction of the painting in the form of an etching (plate 60), which, in turn, was exhibited at the Salon the following year.[30] Other art magazines also reproduced Daubigny's work. *Les Beaux-Arts*, a short-lived publication of 1843–4, reproduced an etching of the countryside surrounding Choisy-le-Roi made after a painting by Daubigny shown at the Salon. *L'Artiste*, in turn, reproduced Daubigny's etching (plate 58) after *The eagle's nest in the forest of Fontainebleau* also seen at that year's Salon. Trading on his now well-established career as a Salon painter, Daubigny took his work as a printer one step further and began to make suites of prints which stood as works in their own right. Independent etchings were first seen in the mid-1840s but began to appear more frequently in the early 1850s. In 1851 Daubigny produced and distributed two suites of etchings which were made in large numbers and sold at the low price of one franc apiece with a discount of one franc for the portfolio of six.

Daubigny's etchings and engravings provide another demonstration of the way in which images of nature, some from the world of the fine arts, some from the world of popular culture, overlap. His work appeared in periodicals, in guides to the coast, the countryside and to the Jardin des Plantes. He made landscape engravings for reproduction in art magazines to promote his landscape paintings on show at the Salon and also created landscape etchings as works of art in their own right. Moreover, the visual conventions of landscape representation do not appear to change that much as we cross the boundary from illustration to fine art. A few prints use established conventions in academic landscape painting. This is apparent in Daubigny's early etching of *Saint Jerome* in which the small figure of the Saint and separate studies of landscape combine to make something resembling a conventional *paysage historique*. For the most part, however, conventions in print-making actually begin to determine the appearance of landscape painting. In the 1830s books and magazines were often illustrated with small *vignettes* in which a centrally located motif would be surrounded by trees or foliage. This method of composition, adapted

from medieval techniques of book illustration in which margins would sometimes be decorated with leaf motifs, is apparent in many of Daubigny's illustrations for Curmer's guide to the Jardin des Plantes, in a number of the plates for the *Chants et Chansons Populaires* and most conspicuously in *Le Petit Chaperon Rouge* used to illustrate an edition of stories by Perault. Similar devices also appear both in independent etchings and in those made after landscape paintings. *Pool with stags* (plate 62), an independent etching made in 1845, shows two animals set within a frame marked by the edge of a stretch of water and the lower branches of the trees in the background. Closer examination shows another *vignette* of a leaping stag in the far distance, a compositional device also used in the background of *The arbour* of 1841. The method is repeated constantly in the 1840s and after. It is worth noting the broad similarity between the printed *vignette* and devices used in contemporary landscape paintings in which bright, centrally placed motifs gradually bleed off into dark, surrounding frames. This type of composition is apparent in the paintings of Daubigny, Diaz, Rousseau, Millet and Troyon during the 1830s and 1840s. The convention is an important one. It marks a clear interface between print-making, popular imagery and landscape paintings, and constitutes one of the main differences between romantic landscapes of the 1820s and 1830s and the more traditional compositions used by academic landscape painters.[31]

Etching and engraving accounted for the vast majority of the early works of Charles Jacque. Initially trained in the atelier of a map-engraver around 1830, his work later began to appear in a wide variety of publications. In London he made illustrations for an edition of Shakespeare's plays and for a *History of Greece*. On his return to Paris he continued to work as a jobbing illustrator contributing to the *Magazin Pittoresque*, various editions of illustrated short stories and novels, and to Curmer's *Les français peint par eux-mêmes*. By the late 1830s Jacque had established a reputation as an engraver and it was at about this time that he started to paint. He worked at the Académie Suisse, an independent atelier providing art students with facilities to draw from the life-model and, with Jeanron, developed an interest in the paintings of Georges Michel, an enthusiasm clearly reflected in his work of the period. Despite his increasing interest in painting, he continued to produce prints in quantity throughout his career, making contributions to the satirical magazine *Charivari* and also producing suites of etchings for amateurs, similar to those executed by Daubigny.

It is also interesting to discover that the Barbizon's only *sculpteur-paysagiste*, Antoine Barye, worked under

comparable conditions but producing editions of bronzes rather than prints. Barye studied at the Ecole des Beaux-Arts, competed unsuccessfully for the *Prix de Rome* in the early 1820s and, like a number of Barbizon painters, initially earned part of his living outside the field of the fine arts. He worked for one M Fauconnier, engraving gems and decorating jewellery, examples of which were sold to the Duchess of Berry and paraded at court. Disheartened by his failure at official competitions and apparently unable to afford a model, Barye made drawings and wax models of the animals in the Jardins des Plantes. The much acclaimed bronze sculptures of animals were reproduced in limited editions in a variety of sizes and were collected among others by the Duke d'Orléans, the Duke of Nemours and the Duke of Luynes. They also formed an important part of the displays in several fashionable galleries in Paris where they were shown alongside other *objets de luxe*. Durand-Ruel refers to a collection of 'beaux bronzes' by Barye displayed on the table in his gallery on the Rue de la Paix in the mid-1840s.[33]

Other Barbizon painters made prints under very different circumstances. Those landscape painters that had initially been trained as artists rather than artisans appear to have been less enthusiastic about print-making or else employed the medium for its creative potential alone. Théodore Rousseau made only ten prints throughout his career and only one of these was ever published. Corot made a number of prints but appears to have been primarily interested in the visual qualities offered by print-making and seems never to have considered the medium as an alternative source of income or as a means of publicizing his work. Corot was particularly interested in *cliché-verres*, a method of print-making in which the image was scratched or brushed on to prepared glass and then printed with the aid of light-sensitive photographic paper. Marks scratched on an opaque painted surface would produce a well-defined black line on a white background. Those scratched onto a translucent layer of paint produced softer lines on a grey background similar in quality to the half-tones of a black and white photograph.[34] The range of graphic marks from soft masses of grey to black lines similar in effect to those found in etchings are visible in Corot's *cliché-verre*, *The little shepherd* of 1855 (plate 63). The influence of this graphic technique in turn upon Corot's oil painting is evident in a number of landscape paintings of the 1850s and 1860s in which large areas of foliage lose precise definition and are reduced to soft tonal masses. The feature is found, for instance, in Corot's treatment of the foliage in the *Souvenir of Mortefontaine* of 1864 (plate 131) and *The ponds at Ville-d'Avray, morning*

61
Antoine Barye
Tiger attacking a horse, early 1830s
Bronze, 124.4 x 38.1 x 16.1 cms

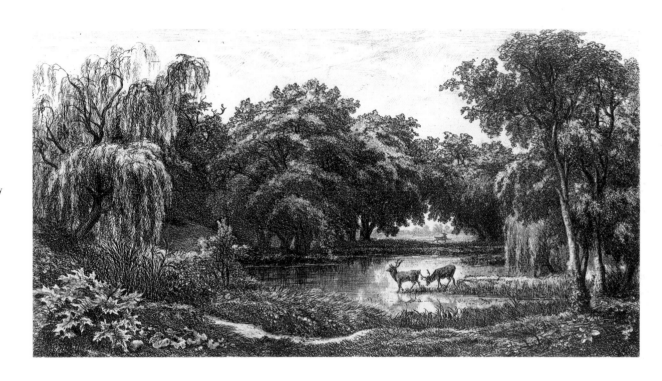

62
Charles-François Daubigny
Pool with stags, 1845
Etching

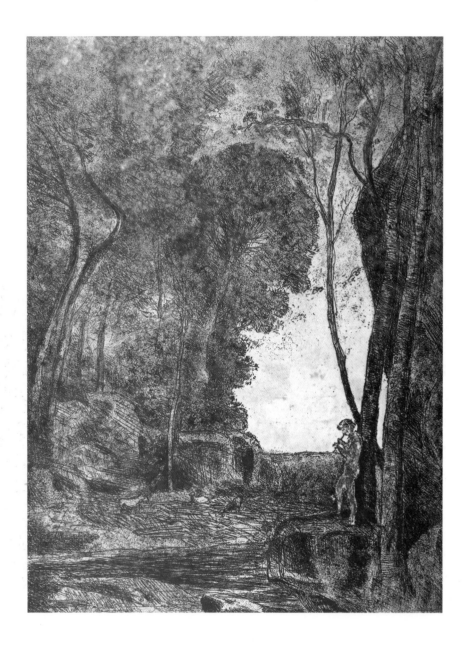

63
Jean-Baptiste-Camille Corot
The little shepherd, 1855
Cliché-verre

64
Jean-Baptiste-Camille Corot
*The ponds at Ville-d'Avray,
morning mist*, 1868
Oil on canvas, 102 x 154.5 cms

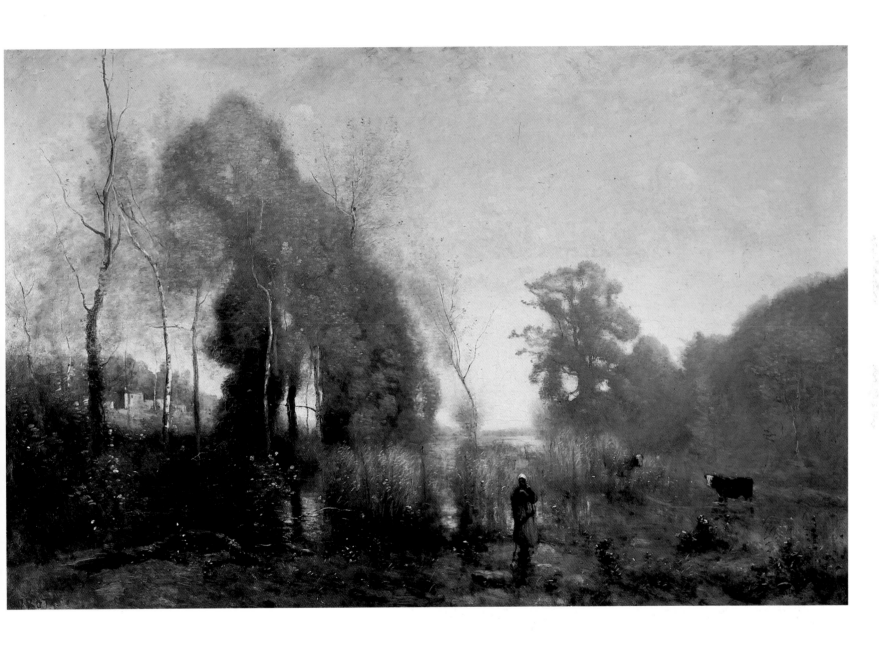

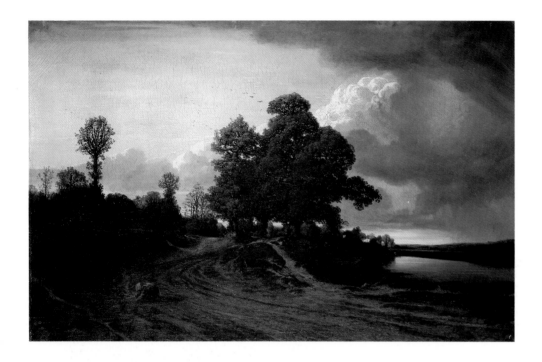

65
Louis Cabat
Pond at Ville-d'Avray, 1833
Oil on canvas, 73 x 113 cms

66
Jules Dupré
Willows with a man fishing,
undated
Oil on canvas, 21.6 x 27 cms

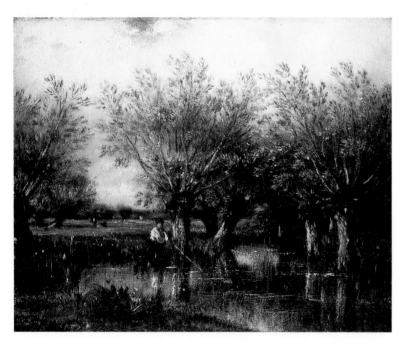

mist of 1868 (plate 64).

During the first half of the nineteenth century porcelain manufacturers, like the publishing industry, provided an important source of work for many painters. Some forms of porcelain decoration depended upon conventions established in the fine arts. The factory at Sèvres often employed artists to decorate lavish display pieces with subjects taken from famous paintings. Jean-Baptiste-Gabriel Langlacé, for example, was asked to transcribe a work by Poussin for the large Diogenes plaque and Abraham Constantin made decorations based on Raphael's frescos in the Vatican. Martin Drolling, Eugène Isabey and Evariste Fragonard, artists with well-established reputations at the Salon, were also hired to decorate porcelain with subjects broadly similar to those found in their easel paintings. In the mid-1820s, however, tastes in porcelain decoration shadowed those in landscape painting and classical themes began to give way to more naturalistic subjects. Langlacé's transfer-printed decorations for the *Service Forestier* (plate 67) serve as a good example of contemporary interest in naturalistic landscape decoration. The service, made for Louis-Philippe, is decorated with views from famous forests in France and abroad that are similar in conception to contemporary naturalistic landscape paintings. Images are taken from commonplace experience and are explained without recourse to stage-managed compositional techniques found in porcelain decoration of the late eighteenth century. It is also interesting to discover that each image is appended with an historical anecdote inscribed on the reverse. One large plate, for instance, is decorated with a cluster of trees and carries an inscription explaining that the plate shows a yew tree, 30 feet in diameter, that once cast its shadow over Henry VIII and Anne Boleyn.[35] Naturalistic landscapes are also found in the *Service départemental*, a series of plates decorated with scenes from regions of France made between 1824 and 1829. Here, there is a parallel between porcelain decoration and travel guides: each piece of the service carries a view of a given region of France and is accompanied by a short written explanation about the customs of its inhabitants.

The careers of many Barbizon painters began in the ateliers of porcelain manufacturers and show the extent to which porcelain decoration and landscape painting were linked in the early nineteenth century. The painter Camille Flers worked for the Nast factory, one of a number of porcelain factories set up in the Paris region in the late eighteenth century, while simultaneously studying as a landscape painter. He continued to work in the fields of the fine and applied arts until the mid-1820s. Flers' pupil, Louis Cabat, also trained as a porcelain decorator in the

67
Jean-Baptiste-Gabriel Langlacé
Plate from the Service Forestier (Woodlands Service), 1835
Porcelain, 24 cms diameter

mid-1820s first with M Gouverneur and later working for the Nast factory. Like Flers, Cabat pursued two careers simultaneously, one decorating porcelain and the other producing and selling small landscape paintings similar in composition and finish to *The pond at the Ville d'Avray* of 1833 (plate 65). Constant Troyon was actually born at the Sèvres factory in 1810; his grandfather, father and brother were employed at the factory as painters, his mother was employed as a burnisher. Troyon himself was trained as a decorative landscape painter by M Riocreux, his godfather and director of the factory, with the aim that he should eventually succeed his father. He too sold landscape paintings while working at the factory and appears to have tackled similar themes in both aspects of his work. In 1827, for example, Troyon was contracted by the Sèvres factory to make drawings of views of Sicily and France, and similar subjects appear in his landscape paintings shortly afterwards. In 1833 he made his début at the Salon with three *vues*, one of Saint-Cloud, the two others, appropriately, of Sèvres.

Landscape and porcelain painters not only depicted similar subjects, they also rendered these subjects in a similar formal style. Jules Dupré trained originally as a porcelain decorator in the atelier of Arsène Gilet and was often praised by critics for the meticulous finish of his easel paintings, a finish that is similar both in colour scheme and in the jewel-like quality of the painted surface to much early nineteenth-century porcelain. Close examination of Dupré's *Willows with a man fishing* (plate 66) reveals passages of jewel like colour and a finely worked picture surface in which the material fabric of the paint is all but invisible. In fact, Regine Plinval de Guillebon has linked the rapid decline in the porcelain industry during the July Monarchy to changes in contemporary landscape painting. In the early 1820s, when highly finished landscape paintings were fashionable, the porcelain industry thrived. The moment that tastes changed, however, and more gestural, impulsive landscape painting came into favour, the fortunes of the industry took a turn for the worse. The brisk application of coarsely encrusted paint, a feature of much landscape painting in the 1830s, evident, for example, in the more impulsively painted landscape of 1838 by Dupré (plate 68), was all but impossible to translate into the meticulous craft of porcelain decoration and the industry fell into decline. Some 4,000 porcelain decorators active in 33 factories were recorded in 1816; by 1850 there were just 158 decorators working in 17 factories.[36]

Paintings of the 1820s and early 1830s traded on images found in popular culture; the portrayal of nature found in landscape paintings recurred in panoramas, dioramas, travel guides, prints, decorative porcelain and the very re-invention of nature itself in the form of the Jardin des Plantes. An understanding of the visual conventions found in popular culture casts Barbizon painting in a fresh light. It is possible to see Rousseau's brooding representations of the forest of Fontainebleau in the context of similar observations found in written accounts of the district; painted images of '*tristesses*', the desolate wastelands in which the spectator's gaze casts laterally across the horizon can in turn be linked with the similar visual experience of the panorama. Some caution, however, is needed in the way in which landscape painting of the period is classified. Many of the images that are now confidently passed off as fine art may, in fact, have been seen more as a decorative commodity.[37] Dealers of the 1820s and 1830s often sold small landscape and genre paintings in galleries displaying luxury commodities such as prints, books and bronzes, rather than in galleries devoted exclusively to fine arts. In some instances, paintings were rented out or kept by amateurs for only a brief period, rather than cherished in a permanent collection. It is possible that the aesthetic sentiments bound up in the appreciation of a small finely worked landscape by Dupré were essentially similar to those bound up with the appreciation of a decorative plaque from Nast. In the 1830s, however, small-scale, naturalistic landscape painting began to shed its ambiguous status, and emerged not as decoration but as a serious vehicle for artistic intent containing a body of aesthetic ideas that stood in opposition to academic landscape painting. The following chapter charts this process of development.

68
Jules Dupré
Crossing the bridge, 1838
Oil on canvas, 49.5 x 64.8 cms

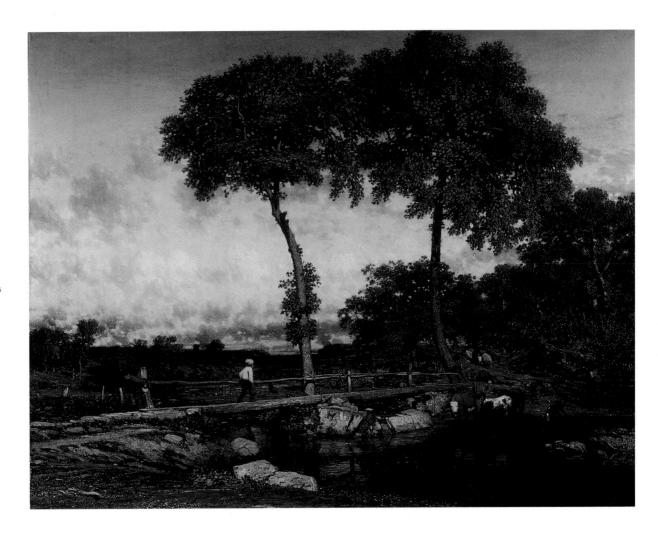

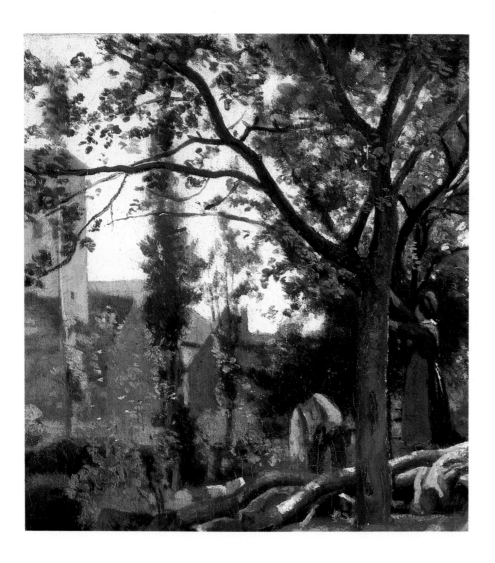

Jean-Baptiste-Camille Corot
Peasants under the trees at dawn (detail of plate 87),
early 1840s
Oil on canvas, 28.2 x 39.7 cms

Art and politics in nineteenth-century France were linked to such an extent that the ascendancy or demise of a social class, the advent of a revolution or a restoration invariably generated new ideals, anxieties and aspirations which, in turn, affected the production and consumption of painting and sculpture. The liberal revolution of July 1830 was no exception. The end of a conservative administration and the advent of a new liberal regime presaged well for those painters and sculptors working outside the conservative, academic mainstream. Many independent artists, writers and critics hoped that the new regime would display its liberalism in a more democratic, less dogmatic *laissez-faire* attitude towards the arts and, to some extent, these hopes were well-founded. Naturalistic landscape painting, hitherto upstaged by history painting and historical landscape, was shown in far greater quantity at the Salons of the 1830s. Landscape painting suffered less from the aesthetic prejudices of the art establishment and was bought with enthusiasm by the aristocrats, industrialists and financiers that supported the new administration of Louis-Philippe. In order to trace the evolution of landscape painting between 1830 and 1848, it is important to examine the aspirations and opinions fostered by the July Revolution and the social groups that supported it.

The aspirations underpinning the July Revolution were many and often ill-defined. Tallyrand, on seeing the tri-colour raised above the cathedral of Nôtre Dame de Paris, knew that the regime of Charles X was foundering but was hard-pressed to say what was about to take its place.[1] The revolution was prompted by widespread dissatisfaction with the constitutional excesses of Charles X rather than any cogent political alternative on the part of his opponents, and those that supported the uprising of July 1830 proposed a variety of substitutes for the Bourbon administration. The artisans and tradesmen who had played so active a part in the uprising cherished the ideals of liberty enshrined in the revolution of 1789 and called for the formation of a republic. Some members of the middle classes, Eugène Delacroix among them, were alarmed by the prospect of a republic and the possibility of another bloody revolution, and were keen to revive the nationalist ideals of the Empire. Other sections of the bourgeoisie struck a more moderate note and proposed the succession of Louis-Philippe d'Orléans. A member of a minor branch of the Bourbon dynasty, Louis-Philippe became all things to all factions. In many respects he was a candidate ideally suited to fill the vacancy left by Charles X. For the bourgeois businessman in search of political stability, he was a bona fide monarch, but at the same time he was not tainted with the absolutist pretensions that had led to the downfall of Charles X. One such businessman, a cabinet minister and director of the Banque de France Paul Casimir-Périer,

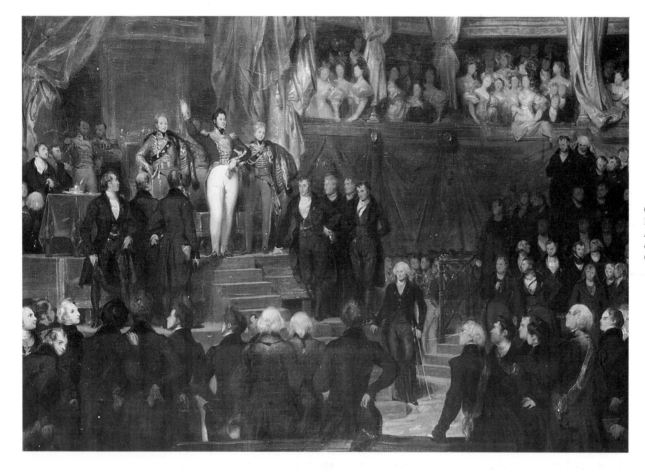

69
Eugène Devéria
King Louis Philippe taking the oath on 9th August, 1830
Oil on canvas, 77 x 110 cms

was keen to pass off the new regime as a continuation of the old, insisting that there had not been a revolution in 1830, merely a change in the '*chef d'état*'. The sentiment was echoed by the Duke of Broglie who encouraged the new King not to take the innovative name of Louis-Philippe but rather Philippe VII. For the republican and Bonapartist, however, the new King could assume a different political hue and trade on his reputation as the revolutionary hero of the battle of Jemappes and one of the signatories to the death warrant of his uncle Louis XVI.[9]

The new order, despite Orléanist claims to the contrary, was very different from the old. Contemporaries called the regime a bourgeois monarchy; a monarch remained as head of state but power and influence within it was increasingly contingent upon bourgeois wealth rather than traditional aristocratic privilege. In Eugène Devéria's commemorative picture of Louis-Philippe's coronation (plate 69) the King is shown bare-headed, swearing an oath to uphold the constitutional Charter before the Chamber of Deputies, an event far removed from the elaborate ceremony held at Rheims cathedral by Charles X five years earlier. This new administration could count on support from a wide constituency of the middle classes, from the newly enfranchised members of the bourgeoisie, keen to dabble in speculative ventures in industry and finance, to powerful industrialists, many of whom were either Protestant or Jewish with strategic interests in combinations of finance, banking, heavy industry, textiles, transport, printing and politics. These powerful financiers and industrialists included men such as Casimir-Périer; Eugène Schnieder, owner of the iron-works at Le Creusot and his brother Adolphe, a fellow director and a member of the Chamber of Deputies from 1842; Isaac and Emile Pereire, railway magnates and the founders of Crédit Immobilier; the Duke of Morny, an investor in the sugar beet industry; the banker Eugène Sellière; Frederick Hartmann, an Alsatian textile magnate; Benjamin Delesserts, a senior official of the Banque de France; Adolphe Thibaudeau, a director of the Compagnie des Chemins de Fer de l'Ouest, and, not least, the Rothschilds, members of a respectable and well-established finance house dating back to the eighteenth century. These men were important. Wealthy and powerful, passionate and eclectic art collectors, they provided a vital means of support for a number of Barbizon painters during the 1840s and after.[5]

Art and the July Revolution

The July Revolution had a number of effects, both direct and indirect, on the fortunes of painters in the early 1830s. There was a clear link in the minds of many artists and critics – whether Legitimist, Orléanist or Republican – between the state of politics after the July Revolution and the state of the arts. In the early 1830s, for example, a number of disaffected Legitimist critics were keen to point out that Louis XVIII and Charles X had been generous patrons of the arts and that the July Revolution had dispensed not only with the monarchical bath-water but also the baby in the form of a valuable source of patronage. An authoritarian monarch was seen by conservatives as indispensable to well-financed and well-informed patronage, and the tastes of patrons such as Pope Leo X and Louis XIV were cited to prove the point. By contrast, Louis-Philippe, a citizen-king nominated to represent the interests of the bourgeoisie rather than the aristocracy, would, it was believed, have little need for the rhetorical *grande peinture* that had been an integral part of Bourbon court culture since the mid-seventeenth century. Auguste Jal, writing in the *Causeries du Louvre*, an extensive survey of the Salon of 1833, worried that art in the service of the middle classes would become utilitarian; devoid of informed taste, it would merely gratify the material needs of a bourgeois patron. Jal noted that he had no political dislike for the new regime but nonetheless believed that the 'current form of government presents a great obstacle to the grand ventures in the arts.' 'Constitutional art', he maintained 'is art on the cheap'.[4] The sentiment was endorsed by the critic Gustave Planche who saw the annual Salon as a bazaar, no more than a branch of the art dealers Susse or Giroux. To some extent Jal and Planche were right. Many of the works that found their way into the Salons of the early 1830s were the small, highly saleable genre or landscape paintings. Stripped of classical allusion and depicting anecdotal subjects or views of the everyday countryside, they were ideally suited to a middle class rather than aristocratic frame of reference. The subjects were easy to understand and were often painted with meticulous care; they were, moreover, relatively inexpensive and small in size, so were also well suited to the more modest finances and scale of the bourgeois home.[5]

Artists and critics were attentive not only to changing patterns of patronage during the early days of the July Monarchy but also to the bonds between political ideals and aesthetic principles. The demise of an authoritarian regime and the succession of a new monarchy, whose political ideals were based upon the principles of individual liberty, hardly presaged well for the academy and its conservative doctrines. Those artists that flouted academic rules in favour of the liberty of personal expression were, by extension, seen as the natural allies of those that upheld similar ideals in the field of politics. Quatremère de

Quincy, a conservative in politics and a staunch supporter of the Académie, saw the Revolution of 1830 as a clear triumph for romantic painters. He observed that romantic painting rejected the tried and tested code of established rules too readily and replaced it with ill-defined ideas which acknowledged only the value of the artist's subjective inclinations. Quatremère made a sharp distinction between true originality, a gift afforded only rarely to artists, and innovation, a vogue for novelty in painting, inspired, he maintained, by a mixture of democracy and commercialism.[6]

The poet and dramatist Victor Hugo, around whom a number of landscape painters gathered in the late 1820s, also made explicit links between political and aesthetic liberalism. Writing as an advocate of the liberal ideals of romanticism in the preface to the Hernani, Hugo writes:

Romanticism is only liberalism, the principal of Sovereignty, that is the Sovereignty of each individual involved in the fine arts. Everyone does as they wish letting themselves be directed by chance rejecting all of the rules of the past without substituting any in their place.[7]

Artists were now able to abandon an established canon of rules, a significant event for landscape painters who, as the liberal journal *L'Artiste* pointed out in August 1831, no longer needed to follow the example of Poussin but could depend on their own intuition. This emphasis upon individualism, the personal insight of the painter as opposed to the institutionalized agenda that informed neo-classical landscape, prompted artists both to paint in a more idiosyncratic and personal style and to select a wider range of subject matter. Landscape painters of the 1830s, for example, frequently used coarsely applied pigment leaving momentary traces of the painter's own brush; the painted mark thereby became an analogue for the personality of the artist. Subject matter, similarly, called attention to the individual insight of the painter. The younger generation of landscape painters abandoned the institutionalized subjects of classical and biblical myth and embraced a broader repertoire of themes – forests, mountain ranges, lonely wastes – that drew greater attention to the personal selection and interpretation of the artist. Paul Huet's *Sunset behind an abbey in the woods* of 1831 (plate 79) is a characteristic example of these new departures executed by a painter who was widely assumed by many critics to be in the vanguard of new developments in landscape painting.

The notion that art offers a reflection of the individual personality of its maker is so commonplace today that it is virtually taken for granted. It is important, however, not just because the origins of modernism partly spring from the spirit of liberalism tied up with the July Revolution but also because an emphasis on the artist's individual insight is a key component of Barbizon painting. It is evident, for instance, in the way in which Paul Huet applied broad swathes of paint and Diaz de la Peña or Michel used dramatic weather conditions to express personal feeling. Emotion and meteorology meet in the broadly brushed pigment that articulates the dramatic effects of a setting sun in Diaz's *The ferry crossing at sunset*, of 1837 (plate 46). Similarly, in Rousseau's *Under the beech trees* (plate 71), a sense of romantic isolation is created through the detailed flecks of paint that appear to be the result of the artist's sustained concentration on one natural motif.

Some artists aligned with the romantic faction saw the revolution as an opportunity not only for a new style of painting to flourish but also for widespread reform in the administration of the fine arts. In September 1830 a group of painters and sculptors formed a general assembly and demanded that the powers of the Crown and Insitut as patrons of the arts be limited. In the name of political and aesthetic liberalism, equality and the independence of individual genius, the group insisted that artists should be given much greater say in the selection of teachers at the Ecole des Beaux-Arts and in the dispensation of academic prizes and important state commissions. The administration of the fine arts should be rationalized, some painters insisted, and co-ordinated under the direction of one authority rather than the three main sources of patronage – the Crown, the Académie and the director of Museums. Radical and liberal organizations such as the Société des Amis des Arts, the Cercle des Arts and independent exhibition societies such as the Salon Libre, many of them organized by Barbizon painters, flourished during the July Monarchy. They draw attention both to the perceived opportunities for reform offered by the 1830 revolution and to the radical opinions that often went along with romanticism in the visual arts. Immediately after the revolution, for example, Decamps, Scheffer, Gros, Hiem, Isabey, Barye, Ingres and Abel de Pujol were signatories to a petition demanding that Salons be held annually. The Salon was the main environment in which reputations and careers could be made, and only five Salons had taken place during the past 15 years. Some of these demands were met. Salons were held annually after 1833 but petitions submitted to the government and independent exhibition societies continued to flourish, a reflection not only of the political ambitions of some romantic painters but also an indication of the increasingly conservative mood of

Salon jurors during the 1830s. From the middle of the decade many artists believed that the academicians responsible for selecting works and awarding prizes were both inconsistent in their judgement and prejudiced against any style of painting that departed from a neo-classical party line.[8]

Landscape painting during the 1830s

The paintings on show at the Salons of the 1830s came in a variety of styles and presented art critics with a bewildering image of current trends in the arts following the revolution. History painting was less in evidence and many critics agreed that the old ideals of 'truth' and 'beauty' had been shaken, but few were able to see clear signs of a new aesthetic order. Art in post-revolutionary France was thought either to be in a state of decadence or in a state of crisis and transition.[9] Despite their confusion, however, critics began to pass comment on both the increasing number of landscapes on display at the Salon and the emergence of a progressive new 'school' of landscape painting staffed by a younger generation of artists. Critics were less than consistent about the exact nature of this new school, its main characteristics and its membership. Gustave Planche maintained that the principles of this new school of landscape painting 'are not yet clearly established but they will inevitably unseat M M Watelet, Bertin and Bidault', the mainstays of academic landscape painting.[10] Other critics were also sensitive to the increasing importance of landscape painting in the early 1830s, equating the genre with a new-found confidence and progress in the arts: Théophile Gautier recognized a 'revolution' in landscape painting; Charles Lenormand praised the progressive march of the genre in France, and Eugène Palletin stated that 'landscape is truly the painting of the age'.[11]

Despite the wide and sometimes conflicting critical responses to new developments in landscape painting in the early 1830s, observers increasingly began to recognize some affinity between the works of Huet, Aligny, Corot, Louis Cabat, Camille Flers, Dupré and Rousseau, many of whom made their début at the Salon in 1831. And it is at this point that a specific school of naturalistic landscape painting started to emerge in France. One of the most conspicuous features of the work of this group of painters is the attention given to native landscape. Italy was largely abandoned as a source for subject matter and Scotland, Spain and far-flung corners of France, the stock-in-trade of romantic painters, were also markedly less popular. They were replaced by motifs found closer to home: England, Normandy, stretches of river along the Seine, Picardy, the forest of Fontainebleau, the parks of Saint-Cloud and Compiègne, the outskirts of Paris and provincial cities of France. Early examples of this interest in the less dramatic, more familiar local countryside can be found in Huet's painting of *Rouen seen from the Mont de Malades* shown at the Salon of 1833 (plate 70), Dupré's *View of England* seen at the Salon of 1836 and Rousseau's *Plain of Tartas*. In each example the spectator is presented with a more mimetic account of the visible world transcribed onto paper or canvas with less attention to the rhetorical tricks with light and composition typically found in academic or romantic landscape painting. The convention in which the eye is led around the picture through a sequence of carefully placed screens and passages of light and shade was also abandoned. Motifs – clusters of trees, grazing cattle, clearings in the forest – were increasingly placed in the middle of the picture to be framed by a compositional device similar in format to the printed *vignette*. In some instances, compositions consist of little more than a simple horizontal division between earth and sky. Rhetorical conventions are abandoned to such an extent that it is sometimes hard to discern much of a subject at all, a comment made by the usually progressive magazine *L'Artiste* about one of Flers' entries to the Salon of 1836. Many of these new subjects in landscape painting were, moreover, transcribed onto canvas before the motif, and there is an obvious link between the depiction of the more accessible subject matter of the local environment and a first-hand, documentary method of recording it.

L'Artiste of 1836 refers to Dupré's *'tableaux'* of the Limousin, finished works ready for exhibition that were made entirely from nature.[12] From the 1830s direct confrontation with the subject became an increasingly common point of interest in Salon criticism, and frequent reference is made to the way in which the new school of landscape painters depended upon *'la nature extérieure'* and to *'la profonde vérité'* evident within their work.

Although a new repertoire of subject matter was one of the defining characteristics of the 'new school', art critics of the 1830s had relatively little to say about the content of landscape painting, a curious omission given that literary subject matter was one of the main features of *paysages historiques*. Many critics had, it seems, a blind spot in their awareness of subject matter and looked straight through images of Saint-Cloud, Compiègne or the forests of Fontainebleau, mistaking such motifs perhaps as familiar images like the landscapes found in prints, on pottery or in Netherlandish painting of the seventeenth century. The subjects were seen only as 'exterior nature' and were perhaps felt to be so commonplace that the wider cultural significance of such motifs, so conspicuous to a modern

audience, simply escaped them.

Art critics may have had little to say about subjects but they had much to say about paint and how it was used to record nature. Paul Huet, often cited as the leader of the school, was either criticized or praised for his use of thick paint by conservative and progressive critics respectively. His main point of departure was thought to be a commitment to '*la nature extérieure*', executed in an indistinct manner that sacrificed individual details for the overall general effect of the composition. Similar features were recognized in the painting of Huet's contemporaries. During the 1830s and 1840s Rousseau, Dupré, Diaz, Decamps, Constant Troyon and Millet were each taken to task by critics for unconventional painting techniques that departed from the well-finished facture used by academic landscape painters.

These new conventions in painting developed and spread through an informal federation of landscape painters working in one or more of the picturesque locations outside the capital or in the nearby provinces. They did not constitute a 'school' in the twentieth-century sense of the term. They had no formal artistic manifesto and unlike Renoir, Pissarro, Monet and Degas were never part of a Parisian café society in which the principles of Impressionism were thrashed out in the early 1870s. Many members of the School of 1830, as they later came to be known, appear to have been shy and reclusive and were slow to make friendships. When the School convened as a group, they often did so to protest about art administration rather than to formulate new ideas about painting. They crystalized as a school through contacts in industrial ateliers, personal liaisons, friendships and chance meetings in Paris or on painting expeditions in the provinces, not least around Fontainebleau. Decamps, Diaz, Rousseau and Huet were habitués of the Estaminet du Cheval-Blanc in Paris in the early 1830s; Cabat and Flers went on painting expeditions around the outskirts of Paris and along the banks of the Seine during the same period. Dupré and Flers worked together in Normandy in the mid-1830s. Troyon painted in the Berry in 1833 with Dupré, and in the following year worked alongside Huet at Compiègne. Rousseau and Huet met in Normandy in 1831, and again in 1835. In May 1836 Rousseau and Dupré painted together on the banks of the Seine, and later that year Rousseau met Caruelle d'Aligny and Diaz at Barbizon. By the end of the 1830s a new school of landscape painting had clearly come into being: it existed both in the writing of critics, whether friendly or hostile, and in the form of a network of painters working in the villages and countryside around Paris and in other parts of France. Not least, the new school found shape in terms of

70
Paul Huet
Rouen seen from the Mont-aux-Malades, 1831
Oil on canvas, 195 x 225 cms

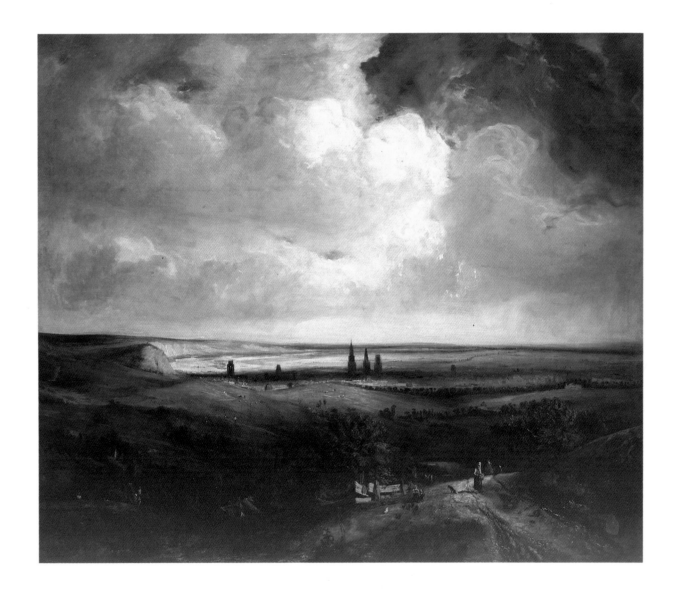

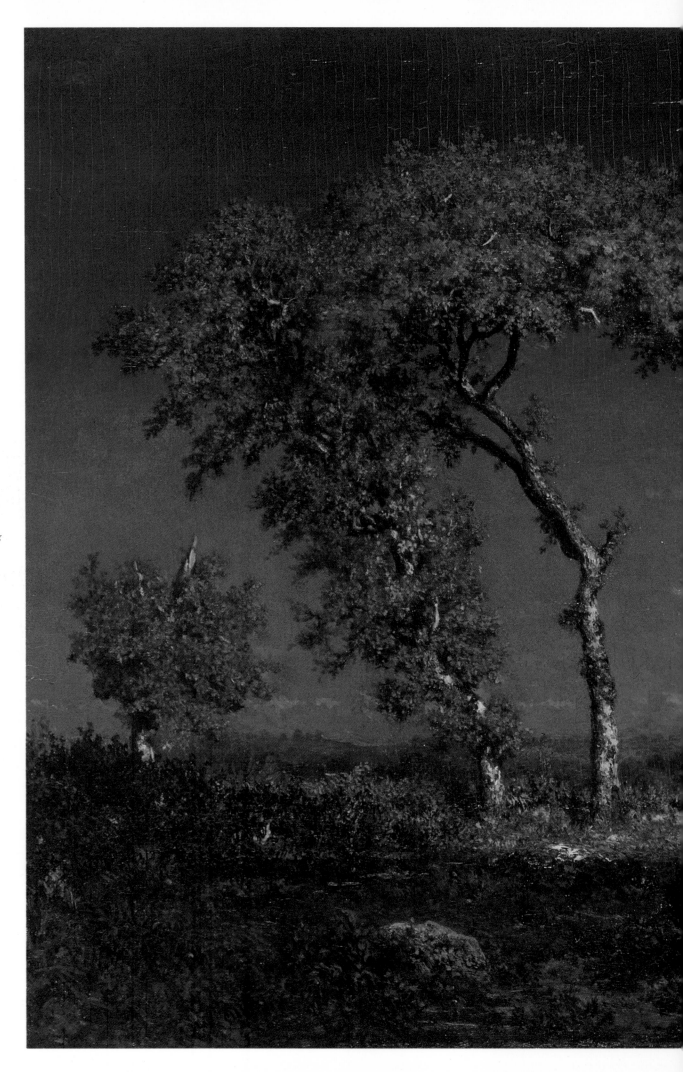

71
Théodore Rousseau
*Under the beech trees, evening
(The parish priest)*, 1842–3
Oil on panel, 42.3 x 64.4 cms

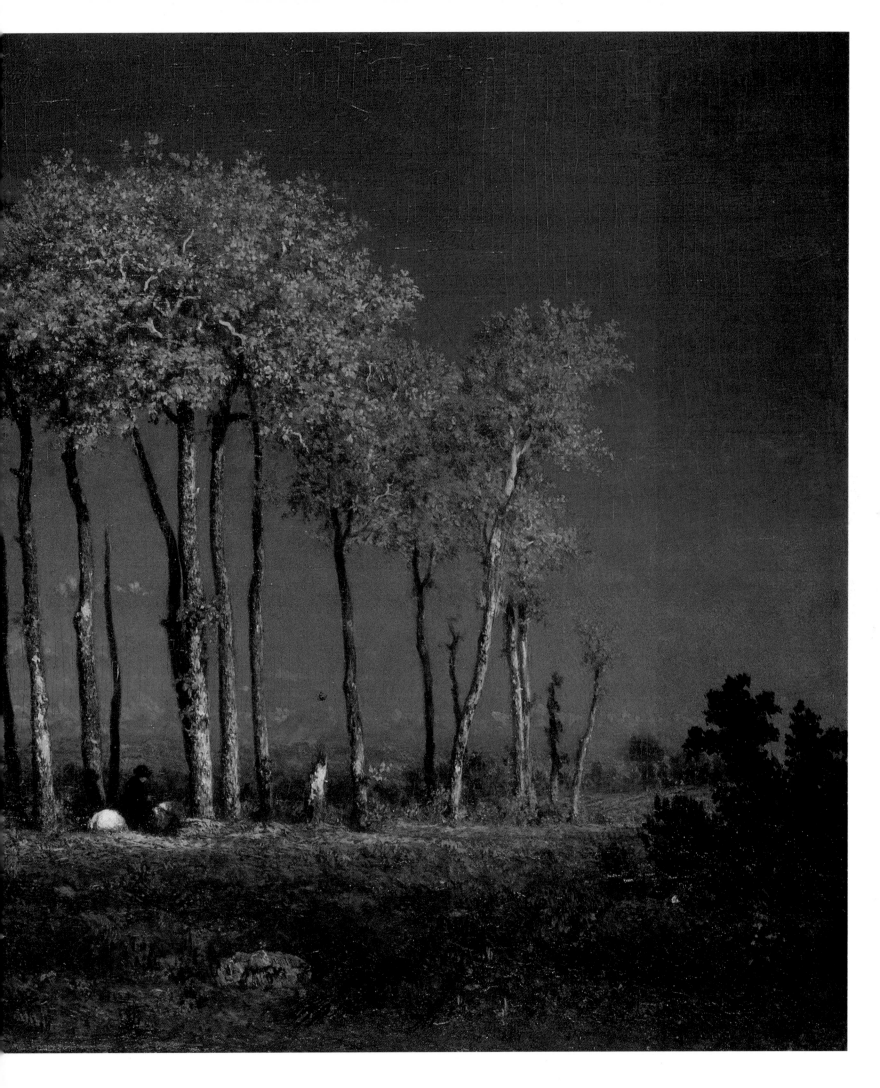

a new attitude to landscape painting itself, especially in its dependence upon working before the motif and depicting often understated images of the local countryside in a more painterly manner.

Le Grand Refusé and Barbizon painting in the 1840s

From the middle of the 1830s Théodore Rousseau emerged as one of the most important figures in the new school of landscape painting. If only his pictures were shown at the Salon, several friendly critics argued, he would clearly be the leader of the school. Rousseau's paintings were essentially naturalistic in that they reproduced native subjects – ponds, pools, forest clearings, clusters of trees – made on various excursions to the Berry, Fontainebleau, the banks of the Seine and the Ile d'Adam. Rousseau's concern with naturalism, however, was quite specific. He developed a technique of painting that was the result, not of a fleeting glimpse expressed in terms of rapidly applied strokes of paint, but rather of a gaze sustained often over a protracted period of time. He returned again and again to paint the same motif and was on sufficiently intimate terms with some trees in the forest of Fontainebleau to give them names. This feeling of what Alfred Sensier, his biographer, called 'deep knowledge', a form of intimacy gained through sustained concentration, was generated partly through his method of composition. Rousseau frequently painted a *vignette* in the very centre of the canvas. This device, popular in contemporary print-making, was used in this instance to focus the spectator's attention on the subject. In the same way that blurred peripheral vision frames an increasingly well-defined image in the centre of the human eye, so masses of ill-defined, dark foliage or darkened cloud in Rousseau's painting frame a well-defined, central motif. This compositional device can perhaps also be read as a pictorial re-invention of sustained looking, as a particular form of naturalism in which the depiction of the motif has been refined to such an extent that the artist is forced to paint not just the visible object in the exterior world but also the working of the eyes that are used to perceive it. In fact, Charles Blanc made a link between the formal characteristic of Rousseau's painting and the physiology of human vision in *L'artiste de mon temps*. Writing on the manner in which Rousseau left many of the foregrounds in his paintings unfinished, Blanc argued that to do otherwise would suppose that the viewer was looking at his feet or lying on the grass.[15] Thoré in his Salon of 1844 also spoke not only about Rousseau's selection of subject matter but also about the workings of his sight. His eyes are described as 'fixed and voracious'; Thoré emotively referred to images of Fontainebleau and the Pyrenees pass-

Fig. 4
Théodore Rousseau
Lithograph, 1868

ing before the vault of the artist's eyebrows.[14]

This compositional device is evident in *Pool in the undergrowth* and *The Pool*, both painted on a visit to the Berry in the early 1840s, and continued to be used throughout Rousseau's career. It is employed to powerful effect, for example, in the *Lane in the forest, storm effect* (plate 129). In this instance, Rousseau emphasized the *vignette* with touches of paint that radiate outwards from the central motif. In some examples of Rousseau's work the effect of a light centre set within a dark frame is inverted. The *Group of oaks, Apremont, forest of Fontainebleau* (plate 77) shows a centrally positioned cluster of oak trees treated as a silhouette against a bright sky.

This sense of intimacy with his subject matter is also emphasized by Rousseau's painting technique. In many paintings he no longer used traditional, academic methods in which a finished tableau would be the result of a number of painted and drawn preparatory studies, each made to resolve questions of light, colour, composition and perspective in the final picture. Instead, Rousseau began to resolve these formal aspects of his painting on the same canvas, often working on a single painting for several years. The one picture thereby became a repository of accumulated thoughts and reactions, and Rousseau compared the evolution of the painting with an image emerging from the mist, or the process of Creation itself.[15]

Rousseau showed work at the Salons of 1831, 1833, 1834 – the year in which he received a third-class medal – and at the Salon of 1835. In 1836, however, his *Cattle descending the Jura* (plate 72), a monumental canvas showing live-stock being brought down from the Jura mountains, was rejected from the Salon. The event marked a watershed in Rousseau's career and subsequent rejections from the Salons of 1837 and 1838 led to a self-imposed exile from the official art world which did not end until 1849. It was at about this time that he began to spend increasing amounts of time in the village of Barbizon. He worked during the autumn and winter, long after most other artists and visitors had left the area and began to use the image of the secluded forests as an analogue for his own alienation from the Salon. Sensier's described Rousseau's visit to the forests:

Alone in a sad, humble and cold woodcutter's cottage, alone with his forest, carried off in a whirlwind of sensations in which he loved to savour the rugged landscape or the imposing silence of the forest. He dreamt and he created without distraction with only the the passing crows and cows for conversation.[16]

72
Théodore Rousseau
Study for '*Cattle descending the Jura*', 1834–5
Oil on canvas, 115 x 60 cms

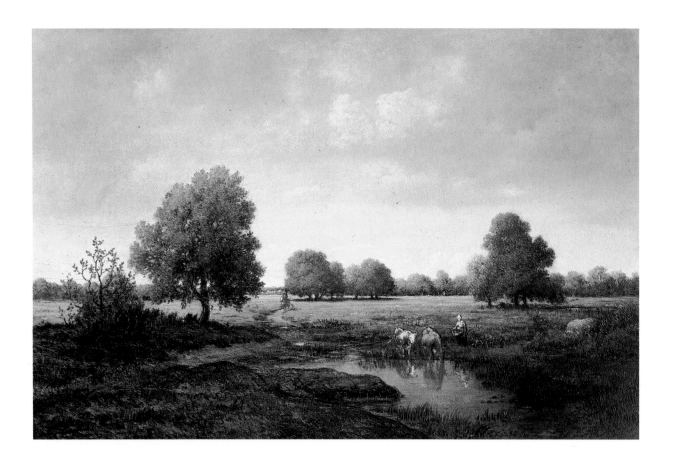

73
Théodore Rousseau
The watering place, undated
Oil on panel, 41.7 x 63.7 cms

74
Théodore Rousseau
The marsh, 1842–3
Oil on canvas, 41.5 x 63.4 cms

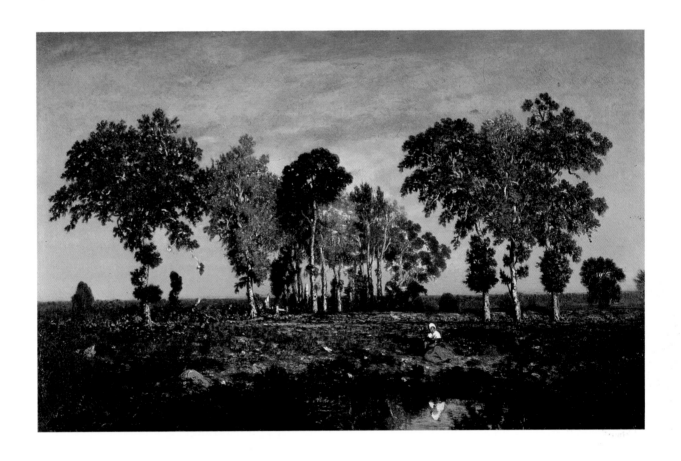

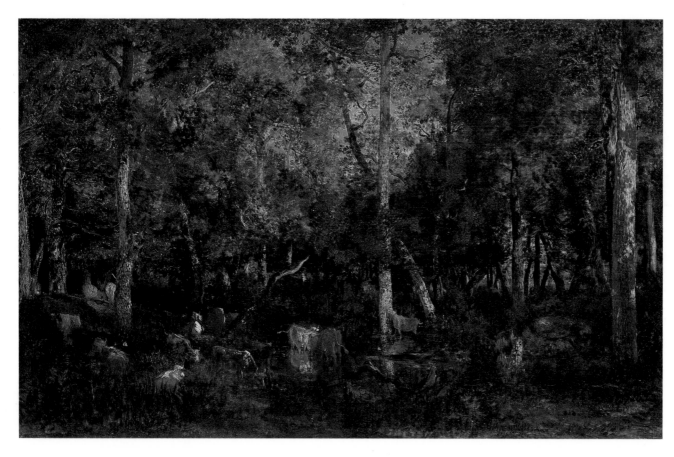

75
Théodore Rousseau
Le Vieux Dormoir du Bas-Bréau, forest of Fontainebleau, 1837–67
Oil on canvas, 65 x 103 cms

76
Théodore Rousseau
Mountain landscape (The fisherman), 1850
Oil on canvas, 84 x 136 cms

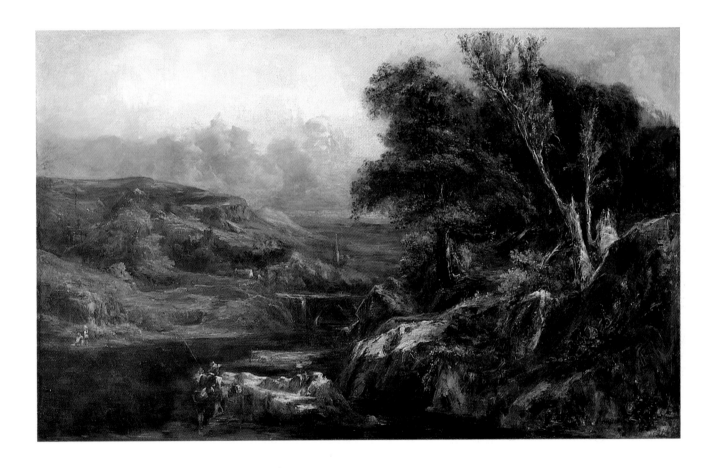

The persistent rejection of Rousseau's work from the Salon was thought to be the result of the obstinacy of the increasingly conservative Salon jury even before the rejection of *Cattle descending the Jura* in 1836. In a review of 1835, the year in which two of his landscapes were rejected, Charles Clément noted that, thanks to the jury, Rousseau was becoming conspicuous by his absence from the Salon. Planche, one of the few art critics to lend support to Rousseau after 1836, provided an explanation for the persistent rejection of his paintings: in short, the jury was incompetent. Salon judges were, he informs us, taken only from the ranks of academicians, representatives of middle-brow public taste. Alongside these 'mediocrities' sat the ranks of 'men who have had their day' and embittered painters who lacked the courage of their convictions. Rousseau, Planche suggests, could even take courage from the fact that his painting had been rejected by the academic landscape painter Bidault, 'an enemy of naturalism' and advocate of 'inanimate nature'.[17]

From the late 1830s Rousseau's persistent rejection from the Salon became something of a *cause célèbre* among independent landscape painters. Jules Dupré, for instance, exasperated by the rejection of his friend's work, began to revive the idea of a militant association of '*refusés*' in opposition to the jury. The association met at Dupré's home each week for the so-called '*diners spartiates*', a convention of a number of liberals, romantic militants and *refusés*, including Scheffer, Delacroix, Delaroche, Huet, Decamps, Barye, Troyon, Rousseau, the art critic Thoré and others, several of whom had fared badly at the hands of the Salon jury. Dupré, in an act of solidarity with his friend, persistently refused to submit work to the Salon and in 1839 formally protested to the authorities following the rejection of Rousseau's *Edge of the forest*. In 1840 Dupré also showed Rousseau's rejected *Valley of the Tiffagues* in his atelier. Scheffer had already shown the rejected *Cattle descending the Jura* in his studio in 1836 and the atelier was to become an increasingly important location for independent artists to show their work to clients and colleagues. In the same year Rousseau, Corot, Huet, Jeanron, Isabey and Cabat were also involved in the organization of an independent exhibition and had sought, albeit unsuccessfully, the support of both the Crown and the Chamber of Deputies. Rousseau's absence from the Louvre became increasingly evident and by the end of the 1840s many of his colleagues also refused to submit their works to the Salon. Thoré's Salon of 1845 referred to the way in which the Salon officials abused their authority, depriving the public of the opportunity of seeing works by Scheffer, Dupré, Troyon, Rousseau and others. The paintings of

77
Théodore Rousseau
Group of oaks, Apremont, forest of Fontainebleau, 1852
Oil on canvas, 64 x 100 cms

78
Théodore Rousseau
*The forest of Fontainebleau,
morning*, c. 1848–50
Oil on canvas, 98.1 x 134 cms

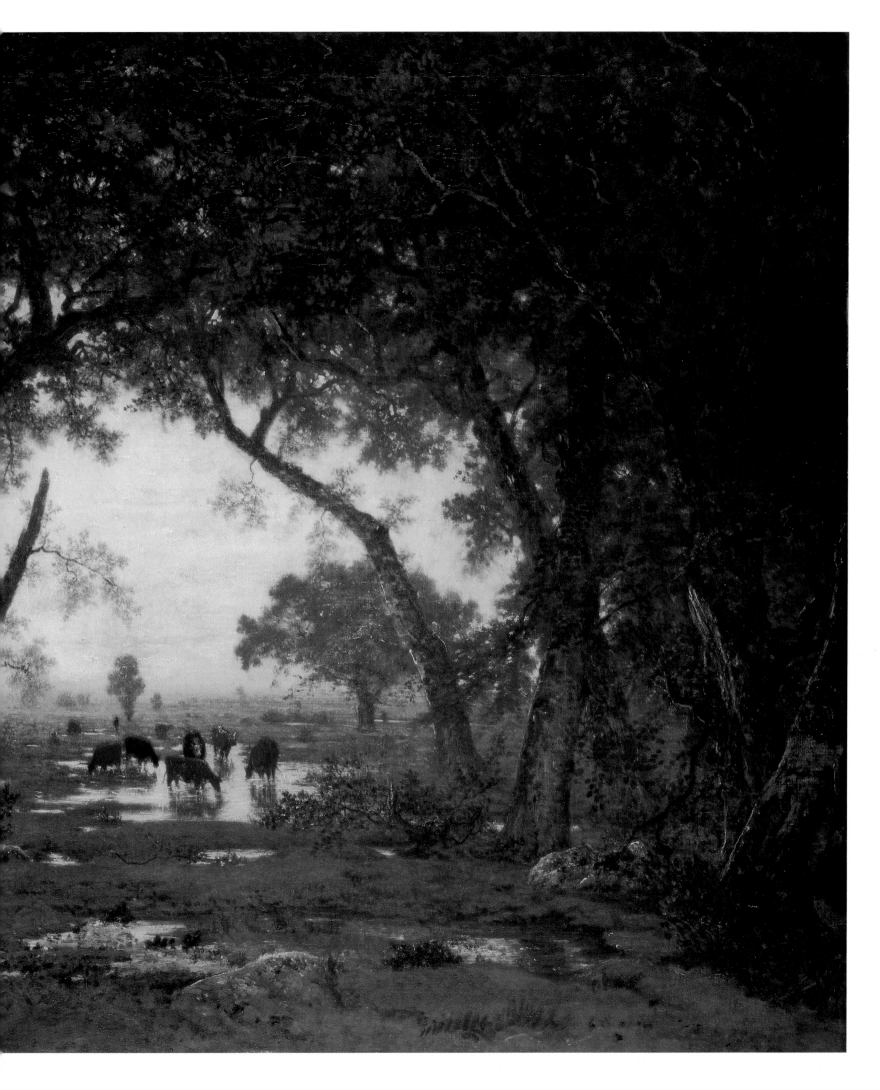

Dupré and Rousseau now went from the Pyrenees, Thoré maintained, 'straight into the collection of M Périer'.[18] In 1847, *L'Artiste* reported that Decamps, Scheffer, Rousseau, Dupré, Barye and Meissonier had each resolved never again to send work to the official Salon; and in the same year, supported by Paul Delaroche and Horace Vernet, several Barbizon painters, including Barye, Dupré, Decamps and Jacque, attempted to establish an independent Salon.

Peintres sans écoles: Diaz and Corot

During the late 1830s the critical battle lines between academic and naturalistic landscape painting became gradually clearer. Gustave Planche, for instance, spoke of Bidault as an enemy of naturalism and saw his work as standing in stark opposition to that of Rousseau. In 1838, *L'Artiste* articulated the main aims of Rousseau's work with some clarity: it was opposed to 'the old system of painting'; unlike academic art it was spontaneous, energetic, it had an insight into '*la nature extérieure*', a term used on many occasions to describe the subject matter of the 'new' or 'young' school of landscape painting. By the end of the July Monarchy Corot was placed at the head of this new school by Baudelaire; Rousseau, he said, would have been given the position had he exhibited.[19] During the 1840s art critics also began to recognize some common cause in the work of other painters associated with Barbizon such as Dupré, Huet, Flers, Decamps, Jacque, Diaz, Millet and Daubigny. It is important, however, to categorize the work of these painters with care, without rushing to tar all Barbizon painters with the same critical brush. Examination of the careers of some painters associated with Barbizon show that they were by no means exclusively landscape painters. They worked in a variety of styles or operated across several genres; their work was often thought by critics to defy definition, to be '*sans école*'. Diaz, for example, was often spoken about by contemporaries in the same breath as the genre painters Prosper Marilhat and Meissonier, and Corot was often compared by art critics of the early 1830s with Bertin and d'Aligny. The fact that both Diaz and Corot have subsequently been earmarked as mentors of the Impressionists reveals the fissures and disjunctions between art histories past and present.

Diaz de la Peña was greatly influenced by Rousseau; Sensier records his watching the artist from afar and tentatively asking Rousseau to explain the 'secret' of his palette. Diaz's landscape paintings, like those by Rousseau, frequently used the painted *vignette*, the centrally placed motif, and remote subjects that were painted on location in picturesque regions of France, not least the forest of Fontainebleau. Diaz visited the forest virtually every year

after 1835 and his debt to Rousseau in terms of composition and the dramatic handling of light is visible in *Stormy Landscape* (plate 81), *Cattle in the forest of Fontainebleau* (plate 83) and in the *Common at sunset* (plate 84). But it is essential to note that landscape painting is just one facet of the painter's work during the 1830s and 1840s. Like many artists who were trained as artisans outside the confines of the Ecole des Beaux-Arts and established ateliers, Diaz was acutely attentive to popular taste and painted a wide range of pictures, oriental genre pieces, flower paintings, paintings of banditti, religious pictures, nudes and sometimes landscape paintings. Salon *livrets* of the 1830s and 1840s give an interesting insight into the range of Diaz's subjects. Landscapes occasionally found their way into the Salon but Diaz was largely represented by small, historical genre pieces and figure paintings. These subjects were, moreover, immensely saleable and were snapped up by collectors and dealers. In 1843 Diaz began to make sufficient money not only to give financial support to friends like Troyon and Millet but also to collect the odd picture himself; in 1843 he bought Delacroix's *Bishop of Liège*. Two of Diaz's paintings on show at the Salon of 1844, *Bohemians going to a fête* (plate 82) and the small *Evil spell* were bought by Paul Périer for 1,500 and 500 francs respectively; at the sale of the Périer collection two years later the paintings had doubled in price. *Bohemians going to a fête*, a re-working of Rousseau's *Cattle descending the Jura*, shows a procession of gypsies winding down a steep path through a forest towards a pool at the very bottom of the picture. The figures, dressed in picturesque costume, are picked out with minute detail and the painting is typical of popular genre pieces made by Diaz and others in the mid-1840s. Paintings of bathers, often called 'Venuses', were equally popular with picture dealers in the 1830s and fall into a similar category. It is significant that when Diaz showed a large landscape painting at the Salon of 1847 (it was the largest of eight works submitted that year, seven of which were genre or figure paintings), its appearance was seen as a new departure for the painter. Diaz was not alone in working across several genres. Jean-François Millet, a painter often linked by critics with Diaz, frequently turned his hand to nudes and little genre scenes, and these too found buyers easily.

Critics writing in the 1830s and 1840s perceived Corot's work, like that of Diaz, quite differently from historians writing at the end of the nineteenth century. Corot was trained in the ateliers of Michallon and Bertin, a visitor to Italy (he made three visits in 1825, 1834 and 1843) and a frequent exhibitor of *paysages historiques* at the Salon, and his paintings can easily be understood within the struc-

79
Paul Huet
Sunset behind an abbey in the woods, 1831
Oil on canvas, 173 x 261 cms

80
Paul Huet
The undergrowth, 1834
Oil on canvas, 98 x 163 cms

tures of conventional rather than innovative practice in landscape painting. Various 'vues' and 'souvenirs' appear alongside a crop of deities, saints and mythological characters. A *Diana*, a *St Jerome* and a *Silenus* were shown at the Salons of 1837 and 1838. An indication of Corot's dependence upon traditional forms of landscape is his debt to Poussin, a debt noted by several critics in the 1830s and 1840s. Both the *Silenus* and the *St Jerome* (the model for which died of pneumonia as a result of posing naked for the artist) rework compositions originally created by Poussin. The former is based upon Poussin's *Silenus* (a copy of which is in the National Gallery, London); the latter, according to Hélène Toussaint, is taken from Poussin's painting of the same subject in the Prado in Madrid.[20]

Salons of the 1840s continued to see the exhibition of works by Corot that owed a great deal to neo-classical convention. The *Flight into Egypt* (plate 85), *Homer and the shepherds, Daphnis and Chloe,* shown in 1845, and a number of similar historical landscapes shown at Salons between 1840 and 1845, including *The Baptism of Christ* (plate 86), were subject to careful preparation. Compositions are stage-managed through a succession of planes, dark in the foreground, light in the middle distance, and assembled from a variety of sources. The oak, for instance, in the *Flight into Egypt* was based upon 'Le Rageur', a well-known tree in the forest of Fontainebleau; the foreground of the painting comes from Fontainebleau, the background from sites in Italy. More importantly, contemporary art critics faced with such submissions were generally clear about the theoretical traditions from which they emerged. Corot's debt to Poussin and Claude and the 'the so-called historical style' were frequently cited throughout the July Monarchy; Delécluze stated that Corot allowed himself to be too influenced by Poussin's ghost. Even during the early 1850s, Corot's official Salon paintings were often made in a style that was seen to have clear affinities with the past. Commenting on the *Morning, dance of the nymphs* shown at the Salon of 1850, Philippe de Chennevières, the director of the Musée de Luxembourg, thought the painting the most beautiful landscape on show that year and traced its lineage back through Lantara, Claude, Allegrain and Poussin.[21] Even during the Second Empire, when the aesthetic categories that divided landscape painting appeared to be more precisely defined, Corot's work still escaped precise critical definition.[22]

Despite Corot's clear debt to traditional forms of classical landscape painting, there were a number of significant departures in his work, particularly in the 1840s, that distinguish his work from *paysages historiques*. The critic of *L'Artiste*, writing about the *Diana surprised at her bath*

and *Roman landscape in winter*, shown at the Salon of 1836, noted that Corot belonged neither to the 'the classical nor to the Anglo-French school of landscape', nor was he inspired by the 'Flemish masters'. Here, the dominant note was one of uncertainty. Charles Blanc, writing in 1840, noted that Corot mixed 'reality' with 'the ideal' and that he followed his own individual direction, a point noted by the critic of *Le National* who stated that Corot had a style that was 'all his own'.[23] There was an awareness of his interest in naturalism and 'la verité', and an appreciation of his debt to tradition but critics often found it hard to reconcile these two approaches. It seemed as if a critical niche for his work had yet to be found.

One significant departure, and one which was to become of great importance to many of the Impressionists, was the emphasis Corot gave to painting in the open. Painting before the motif was an important part of a student's education. It provided a repertoire of observations that could be called up at will in the production of paintings made in the studio. Painting in the open tended to be less important to mature artists. Corot, however, continued to address the problem of painting in the open throughout the 1840s and applied *plein air* techniques in comparatively large paintings. Peter Galassi has drawn attention to paintings made by Corot at Volterra on his second visit to Italy in 1834 in which *plein air* conventions commonly found in small studies – large unbroken patches of colour and compositions stripped of neo-classical rhetoric – have been transferred to paintings on a much larger scale.[24]

A heightened sense of naturalism is also evident in many paintings made on Corot's third visit to Rome in 1843. Although the district is familiar enough, Corot's selection of subjects and the manner in which the sites are portrayed are unusual. The arch in the *Arch of Constantine* painted in 1843, for example, takes on little topographical importance. Skewed from sight, the structure presents an unprepossessing flank to the spectator and assumes no more importance than the buildings in the mid-ground. Similarly quirky compositional devices are found in the *Villa Doria Pamphili* painted in the same year. The villa has little architectural interest; it is set at the back of the painting and is partially obscured by a terracotta vase. There are other curious devices: a large, dark green hedge cuts diagonally across the lower section of the painting, behind it a row of classical statues recedes to the left. The apparently arbitrary compositions of the Impressionists in which motifs are shown at unusual angles make Corot's compositions look rather tame. In the mid-1840s, however, these devices were significant departures. They indicate Corot's interest in depicting a subject without recourse to compositional

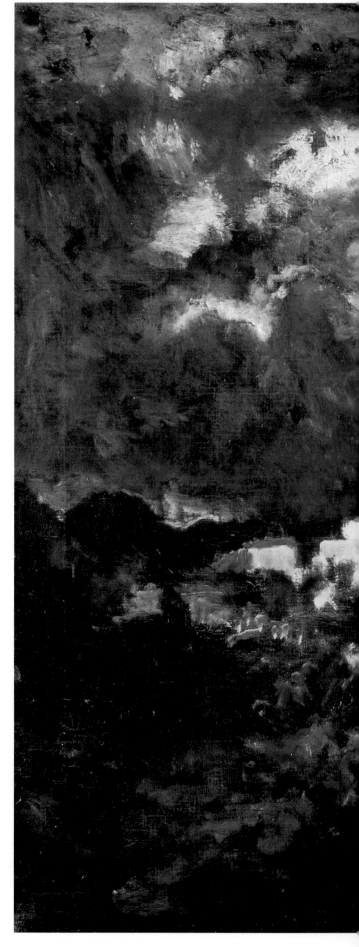

81
Narcisse Diaz de la Peña
Stormy landscape, undated
Oil on canvas, 97.8 x 130.5 cms

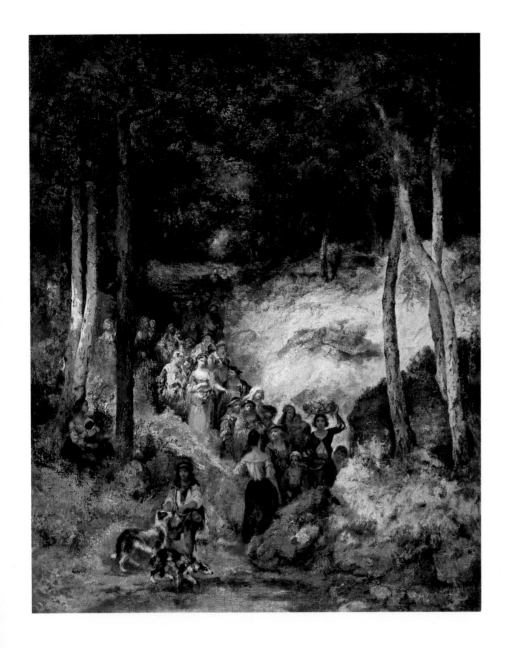

82
Narcisse Diaz de la Peña
Bohemians going to a fête, 1844
Oil on canvas, 101 x 81.3 cms

83
Narcisse Diaz de la Peña
Cattle in the forest of Fontainebleau, 1846
Oil on canvas, 70.5 x 130 cms

84
Narcisse Diaz de la Peña
Common at sunset (The fisherman), 1850
Oil on panel, 37.1 x 54.6 cms

conventions usually adopted by artists of the period. Corot intriguingly inverts the formulae of traditional subject matter depicted in an innovative style in the *Forest of Fontainebleau* (plate 88) shown at the Salon of 1846. Here, a site widely associated with *plein air* naturalism has been presented in a fundamentally traditional idiom. Corot, once more, mobilizes a sequence of screens, strategically placed rocks in the foreground, trees in the middle distance, a *vignette* in the background and a lone cow to the left to make up what is, in effect, a *paysage composée*, a highly stage-managed landscape. Only the classical or biblical heroes are missing; the painting is only a short step away from an historical landscape. *Peasants under the trees at dawn* (plate 87) by contrast is altogether different in conception and execution. There are few rhetorical devices to lead the spectator around the landscape. The figures, for instance, are fragmented by broken patches of paint and are lost in the shade of the central clustre of trees. The eye, moreover, follows no clear or specific route around the painting. The composition is clumsy and disordered. Mimetic pictures such as this may have been of interest to Pissarro, Monet and the younger generation of landscape painters who began their careers in the mid-1860s although in the minds of many conservative art critics, this type of painting had little to recommend it. Neither well finished not picturesque, it would have fallen within the very lowest category of landscape painting.

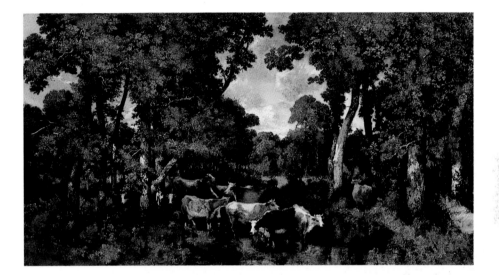

Critics and collectors

The July Monarchy saw a dramatic expansion in printing and with it an equally dramatic rise in art criticism. From the mid-1830s Parisians had access to several hundred professional journals, trade directories and reviews. Those aimed at artists and amateurs included: *L'Artiste*, one of the most consistent supporters of independent landscape painters; the *Journal des Beaux-arts et de la Litérature*; the *Journal des artistes*; *L'Annuaire des Artistes*; *L'Annuaire des Cercles des Arts*; Curmer and Gautier's *Les Beaux-arts*; Thoré's *Bulletin des Amis des Arts*; *La gazette universelle des Beaux-arts*; the middle-brow *Journal de Connaissance*; *Le Globe*; *Le Moniteur des Arts* and also longer, more detailed reviews of annual exhibitions known as *Salons*. The standard of art criticism varied enormously in the 1830s and 1840s. Reviews often consisted of little more than descriptive accounts of the year's most conspicuous exhibits, and critical judgments either re-hashed old arguments about finish and subject matter or consisted of a string of gibes. Charles Baudelaire drew attention to the general tenor of art criticism in the introduction to his first *Salon* in 1845 in which he referred to '...the lies and shame-

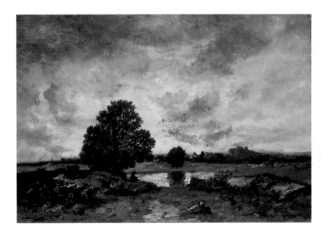

85
Jean-Baptiste-Camille Corot
Flight into Egypt, 1840
Oil on canvas, 146.5 x 196 cms

86
Jean-Baptiste-Camille Corot
The baptism of Christ, 1844-5
Oil on panel, 390 x 210 cms

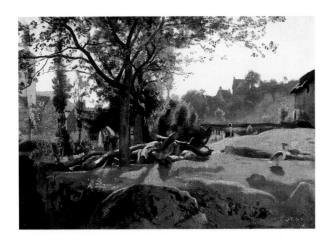

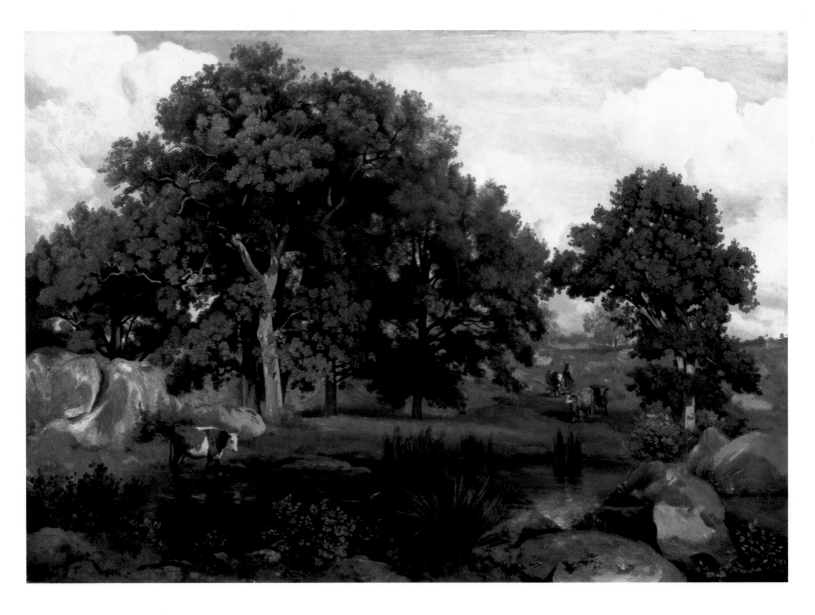

some instances, such criticism was so progressive that theory began to second-guess practice. This body of writing is especially important because it helps to understand the gradual accretion of meanings attached to Barbizon paintings in the 1840s. Two critics merit special attention: Théophile Thoré and Charles Baudelaire.

Thoré, who was later to emerge as an apologist for Courbet, Manet and Renoir, was one of the first art critics to offer an extended interpretation and defence of Barbizon painting. In his *Salon* of 1844 he explained that great landscape painting was not just a mimetic account of natural appearance but also a record of the insight of the artist. He distinguished between a daguerreotype, a mechanical record of visual appearance, and the degree of poetic, subjective vision brought to landscape painting by the artist. Thoré gave images of nature a moral inflection, presenting them as an antidote to the venality of the modern world. The French, he maintained, were preoccupied only with material interests and money had become the foundation of modern society. But 'there is', he maintained, 'nothing actual and real except for poetry and nature'. In essence, for Thoré, the best things in life were free: women, love, intellectual thought, dreams, the sky, seas, forests and flowers; the only things that had a financial value were, he insisted, the 'ridiculous inventions of men'.[26]

Most Barbizon painters get an honourable mention in Thoré's *Salons* of the late 1840s, but it is Théodore Rousseau who is singled out as the most able exponent of modern landscape painting. Although Thoré warned Rousseau of the dangers of losing contact with the everyday world while isolated in the countryside (unlike Gautier, Thoré was not an advocate of art for art's sake), he admired the way in which Rousseau could give such a powerful visible form to his own subjective insights. Writing an open letter to the painter in his *Salon* of 1844, he spoke of Rousseau's 'relationship with the exterior world'. It was he maintained:

...a positive and material liaison. You exert a dominance over nature and from this loving relationship, there comes a new being, a creation that reproduces the essence of the mother and the father, or Nature and the Artist.[27]

Thoré also began to draw increasing attention to the importance of the painted sketch as a means of recording a painter's response to nature. Although this is hardly remarkable in itself, he was one of the first critics to suggest that the sketch was an end in itself and not just a stepping stone towards a more complete work. He constantly called attention to the painted surface as a cipher for the

87
Jean-Baptiste-Camille Corot
Peasants under the trees at dawn, early 1840s
Oil on canvas, 28.2 x 39.7 cms

88
Jean-Baptiste-Camille Corot
Forest of Fontainebleau, c.1846
Oil on canvas, 90.2 x 128.8 cms

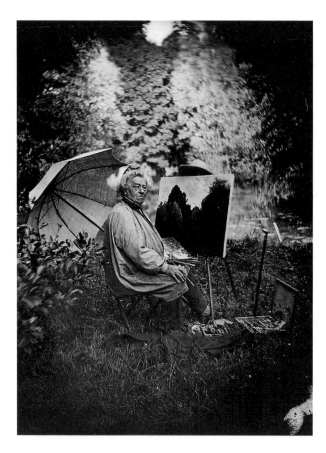

Fig. 5
Jean-Baptiste-Camille Corot
Photograph by Charles
Desavary

emotional impulse and the originality of the artist. To Thoré, a response to the natural world placed on the surface of the canvas with honesty and integrity could be termed finished even if the attention to detail was summary.[28] Baudelaire made a similar point in his *Salon of 1845*. He defended Corot's painting against '*demi-savants*' who had charged the artist with incompetence on the grounds of the apparent lack of finish to his work. Corot's critics had, he argued, failed to make a distinction between a work that is well-executed and one that is merely finished. Baudelaire, like Thoré, also thought that the quality of a painting was to be found in the way in which the impulsive gestures of paint served as a reflection of the artist's soul. The reason for the public's antipathy towards Corot's works was due, Baudelaire maintained, to its attachment to the neat, glistening and industrially polished morsels of genre painters.[29] The painted surface of such 'morsels' could be subjected to the most detailed examination and still the brush-strokes remained invisible, and this, for many members of the middle class Salon-going public, was the best proof of an artist's skill. Decamps poked fun at this widespread preoccupation with 'finish' in his painting *The experts* (plate 89). Here, a group of connoisseurs, monkeys in eighteenth-century costume, gather around a historical landscape to examine its surface with the aid of a magnifying glass. Emile Zola was later to complain about precisely such an attitude towards finish among the Parisian middle classes in the mid-1860s. The attitude, generated in part by an interest in value for money, expressed in terms of physical labour on the part of the artist, persisted throughout the century and helps explain contemporary responses not only to the work of some Barbizon painters but also to the impulsive facture found in Impressionist painting in the 1870s.

How was the work of the School of 1830 distributed and acquired by dealers and collectors? In the late eighteenth century art dealers fell into several quite distinct categories. On the one hand there were independent agents who acquired paintings on commission for individual connoisseurs. On the other there were restorers and tradesmen who stocked artists' materials, many of whom would occasionally buy and sell the odd painting. Many of the most eminent dealers of the 1840s – Durand-Ruel, Susse, Giroux and Cadart – began working as tradesmen in these fields and pictures often found their way into dealers' shops as surety against credit given for materials. *Brocanteurs* (generally down-market dealers in antiques and objects of curiosity) also traded in small pictures, buying works from down-at-heel artists often for no more than a few francs. Alfred Sensier recounts how a number of

works by Georges Michel were found by eager amateurs in precisely such shops.[30] In the wake of the economic boom of the 1830s, however, the art market expanded dramatically and there emerged a new category of art dealer in Paris trading from sites in affluent quarters of the capital, selling prints, paintings and bronzes to the *nouveau-riche* upper middle classes.

Shunning the area around the Ecole des Beaux-Arts, the traditional locale for dealers and artists' suppliers, these new dealers opened premises in the eighth or ninth arrondissements, near the Opéra and the Bourse or between the Madeleine and the Place Vendôme, the epicentre of *haute-bourgeois* finance and the Orléanist aristocracy. Durand-Ruel père, for example, separated his business into a stationers and an art gallery, the latter situated first in the Rue des Petits-Champs and subsequently in the Boulevard des Capucines and the Rue de la Paix. Other dealers in the district included Madame Hulin, Couteaux and Susse (both located on the Passage des Panoramas) and Giroux, all of whom kept Barbizon paintings as part of their stock. Some indication of the importance of this district of Paris to the fortunes of mid-century dealers is given in the memoirs of Paul Durand-Ruel. He refers to the strategic location of his father's newly opened branch on the Boulevard des Italiens, described as 'one of the busiest places in Paris, right in the midst of the gentlemen from the Stock Exchange and the tourists'.[31] Here, pictures and prints were exhibited in comfortable, well-lit galleries or formed part of elaborate displays behind large, plate-glass shop windows. At Giroux's gallery, for example, the display of paintings, prints and *objets d'arts* was thought to be so impressive that it rejuvenated and transformed the entire neighbourhood.[32]

Art dealers also used other means of selling pictures. Reputations at the Salon were enormously important and dealers were able to trade on those reputations when passing on pictures to amateurs. Many paintings that failed to sell at the Salon were often sold off at public auctions and *L'Artiste* complained that because of the prejudices of Salon jurors, the work of various eminent *refusés* now by-passed the public completely and went straight from the artists' ateliers directly into the dealers' showrooms. Salon reviews and newspaper articles were equally influential. A good review in a widely read newspaper or professional journal would do much to consolidate a painter's reputation and raise prices, and journals counselled the public not just to go to the Salon to see paintings but also to stroll though fashionable shopping arcades, to '*allez voir les passages*'.[33] In many cases art dealers continued to trade with a selected range of clients. Durand-Ruel records how his father's

gallery became the focal point of a group of enthusiasts, many of whom were associated with the Orléanist royal family. Hector Brame courted clients using sophisticated marketing strategies. An ardent supporter of Corot and Rousseau and an ex-stage performer at the Odéon, Brame bought work from artists at inflated prices and sold pictures to clients, promising to buy back the stock for an agreed sum should the painting not increase in value. In fact, throughout the 1830s and 1840s there were numerous complaints about the pernicious influence of dealers and their effect on the art market. Painting was seen to be in a constant state of flux and this, once more, was regarded by many critics as the result of the willingness of mercenary art dealers to gratify the bourgeois craving for novelty in the arts.[34]

Who bought Barbizon painting? Two main social groups, it seems, both of which were intimately connected to the administration of Louis-Philippe: *haute-bourgeois* industrialists and the Orléanist aristocracy. Perhaps one of the most conspicuous collections of modern painting belonged to the railway magnates and founders of Crédit Immobilier, the brothers Emile and Isaac Pereire. Like many mid-century amateurs, their collection included old masters, more conservative painters of the '*juste-milieu*' and independent landscape painters. By the late 1850s their collection had expanded to include paintings by Ingres, Meissonier, Cabanel, Bouguereau and Delaroche, together with works by Rousseau, Jacque, Diaz, Decamps, Scheffer and a substantial army of Dutch seventeenth-century paintings acquired from recently-sold English collections. It was, according to Thoré, the finest collection of paintings in Paris.[35] The Périer collection, sold in December 1846, revealed another impressive line-up of independent landscape painting, including three paintings and 15 drawings by Decamps, 11 paintings and one drawing by Diaz, three paintings by Dupré, three paintings by Rousseau and watercolours by Bonington. Located in the family residence in the Faubourg Saint-Honoré, the collection also included works by French, Dutch and Spanish masters of the seventeenth and eighteenth centuries. Other eminent collectors of the period such as Benjamin Delesserts, Rothschild, Frederick Hartmann, Louis Hottinger, Emile Foulds, Eugène Sellière, Louis Poutales-Gorgier (a collector of Le Nain, Hals and Velázquez), Jacques Lafitte and Adolphe Thibaudeau included landscape painting in otherwise broad-ranging collections. Thibaudeau, a railway magnate, was the author of the preface to Charles Blanc's *Trésor de la Curiosité*. A collector of Jacque and Brascassat, Blanc noted that Thibaudeau brought the same sense of daring and intuition to his

89
Alexandre-Gabriel Decamps
The experts, 1837
Oil on canvas, 46.4 x 64.1 cms

literary and artistic interests as he had to his business affairs. In the same way that the painter with spiritual integrity would produce sound work so, Blanc maintained, a good-hearted 'mecène', like Thibaudeau would collect it. Blanc maintained that Thibaudeau 'often supplemented an insufficiency of knowledge with intuition and came to be well- informed by the natural facility of his instincts'.[36]

Barbizon painters also received support from the Orléanist royal family. Unlike the King whose taste in art was essentially conservative, the younger members of the royal family were closely aligned with the romantic faction in art and literature, and were known as 'followers of Hugo'. The Prince Joinville, the Duke of Broglie and the Duke of Montebello owned works by Théodore Rousseau, and the Prince gave financial support to the painter in the mid-1830s. Works by Dupré were owned by the Dukes of Montebello and Montpensier; the latter had a reputation for dressing in old clothes before hunting out pictures in back- street brocanteurs, an important part of the process of collecting according to the art critic Champfleury. The Dukes of Nemours, Luynes and Montpensier collected bronzes by Barye, and owned paintings by Diaz. However, one of the most consistent aristocratic supporters of Barbizon painters was the Duke of Orléans. Known both for his liberal politics and his progressive taste in painting, the Duke commissioned works from Barye (on whose behalf he interceded following his rejection from the Salon of 1837); from Cabat following the Salons of 1834, 1837 and 1839; from Huet, who was given the honorary position of drawing teacher to his wife the Duchess, and from Dupré and Rousseau. The Duke also commissioned Charles Nodier to publish his diary, lavishly illustrated by Dauzats, Decamps and Raffet, and commissioned works from Scheffer, a family friend, and Ingres, shortly before the artist left to take up his post as director of the Academy in Rome.[37]

By the end of the July Monarchy the status of landscape painting had risen considerably. Its aesthetic merits continued to be contested by conservative academics and reactionary Salon jurors but landscape paintings were, as a cross-section of art critics noted, shown in large numbers at the Salons in the 1830s and 1840s. Landscape painting no longer needed literary references to give it substance. Naturalistic images of the French countryside – often culled from a set of visual references in popular culture – fought for serious critical attention alongside other genres. Moreover, liberal critics associated naturalistic landscape painting with innovative departures in the fine arts in France, and many liberals began to question the validity of the old hierarchical distinctions between the genres. In around

the mid-1830s, then, a new 'school' of naturalistic painting had begun to gel, although the exact nature of this school is hard to define – different critics listed different members and qualifications for membership. But critics are in no doubt – a new school of French landscape painting had come into existence during the first decade of the July Monarchy, characterized by an interest both in the natural world and in the creative personalities of the artists who painted it. Outside the Salon and the Ecole des Beaux-Arts, landscape painting, free from the academic casuistry of the Ecole, formed an important part of many aristocratic and haute-bourgeois collections and the stock of the expanding network of art dealers. Many of the bourgeois industrialists that supported the July Monarchy had little need for the high minded 'grande peinture' associated with the Restoration. They were ideologically more disposed towards pictures culled from experience than the round of literary and artistic references that gave paysages historiques their meaning. It is essential to tread carefully here; the links between social class and a pictorial style are inordinately complex, but several academicians and art critics of the period make quite explicit links between the social ascendancy of the middle classes and the rise of genre and landscape painting. During the July Monarchy landscape painting consolidated its position at an institutional level at the Salon and at a commercial level in the galleries and collections of art dealers and 'mecènes'.

In the 1830s and 1840s landscape painting carried relatively few overt political resonances. Paul Huet referred to the existence of 'paysagistes patriotes' – romantic landscape painters who were well disposed to the revolution of 1830 – but, for the most part, landscape painting was liked or disliked on aesthetic rather than political grounds. After the revolution of February 1848 this was no longer the case. Demographic changes, a working class uprising and the expansion of the franchise gave images of the countryside and its inhabitants new layers of meaning. A peasant tending cattle by a pond was no longer a simple means of introducing a note of pastoral tranquillity to a landscape; the peasant could be read as a refugee, a revolutionary, a buttress against the wicked machinations of wealthy landowners, or a symbol of rural tradition threatened by the juggernaut of industrialization. The following chapter examines the events of the 1848 Revolution and the new meanings that clustered around paintings of rural life produced in its wake.

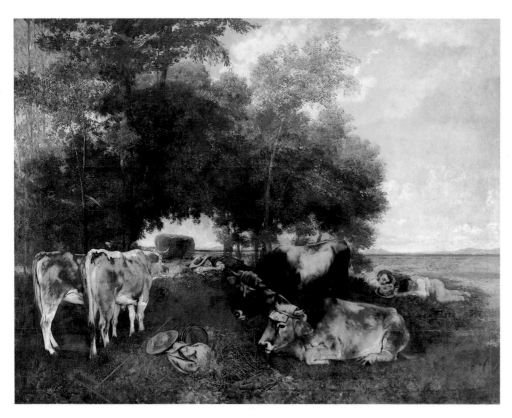

90
Gustave Courbet
*Siesta during the haymaking
season*, 1867–8
Oil on canvas, 212 x 275 cms

Chapter four
Rural images and the 1848 Revolution

In 1830 Louis-Philippe had played the part of a liberal, 'citizen king'. The July Monarchy, however, soon shed many of its liberal convictions and lurched steadily to the right. It is significant that Delacroix's heroic painting of the 1830 Revolution *28th July – Liberty leading the people* (plate 91), in which bourgeois, artisan and student fought alongside the figure of Liberty, was stored safely away from public view shortly after its acquisition by the state, its liberal sentiments were deemed to be out of step with the conservative mood of the government. For much of the 1830s and early 1840s, the increasingly reactionary July Monarchy was able to assuage its critics by pointing to the new-found affluence that had occurred in France in the wake of rapid economic expansion. Many middle class French citizens may not have been given the vote but they could comfort themselves with the fact that they were probably significantly richer than they had been a generation ago. In the mid-1840s, however, the climate of public opinion began to change. The government was compromised by a sequence of political scandals implicating figures close to centres of power. The King, moreover, was seen as increasingly autocratic, persistently refusing all calls for a further extension of the franchise. Many members of the middle classes, despite their new-found prosperity under the July Monarchy, now found that they had lost sympathy for a regime that persistently refused it the vote. Comparisons were even made between Louis-Philippe's ailing administration and that of the autocratic Charles X. Economic problems further enfeebled the regime: grain from Russia, imported to alleviate the poor harvests of 1846 and 1847, was sold in Paris at prices subsidized by high interest rates which, in turn, enfeebled an economy already beset by recession and widespread unemployment. By 1848 a wide cross-section of French society could list a range of political, moral, social and economic grievances against the Orléanist regime.[1]

There was a widespread presentiment, expressed by Alexis de Tocqueville, that some disaster or upheaval was soon about to overcome the nation – and the anticipated crisis finally occurred in February 1848. An organized meeting to be held in opposition to the government, the banquet of 22nd February, was banned. It was followed by a popular demonstration, the presentation of a petition to the Chamber of Deputies and the demand for the resignation of François Guizot, the Prime Minister. At first, the mood of the crowds, gathered in protest in the capital, was generally cheerful. Victor Hugo recalled how they marched around the streets of Paris encountering little opposition from troops or the National Guard. When the crowd reached the foreign ministry, however, a single shot was fired. Hugo continues the account:

91
Eugène Delacroix
28th July – Liberty leading the
people, 1830
Oil on canvas, 260 x 325 cms

At this moment a shot rang out, from which side is not known. Panic followed and then a volley. Eight dead or wounded remained on the spot. A universal cry of horror and fury arose: vengeance! The bodies of victims were loaded on a cart lit with torches. The cortège moved back amidst curses at a funeral pace. And in a few hours Paris was covered with barricades.[2]

The 1848 Revolution unfolded in several acts. The February revolution brought together a surprisingly broad-based alliance of Legitimists, Republicans, Liberals, Socialists, shop-keepers, artisans and labourers in opposition to the monarchy; the very breadth of the alliance is some measure of the unpopularity of the old regime. The new Provisional Republic, established on the 24th February 1848, was to have been managed by a cabinet of liberals, moderates and conservatives, but political pressure from the crowd gathered around the Hôtel de Ville led to the substitution of the more reactionary members of the cabinet with representatives from the left, among them Louis Blanc and the romantic poet Alphonse de Lamartine. From the outset the new Provisional Republic took on a distinctly radical hue: two days after its formation, national workshops were set up to alleviate the plight of the urban unemployed; slavery was abolished in the French colonies and on the 5th March universal suffrage was declared, expanding the electorate from around 250,000 to some 9,000,000 voters. In addition, there were attempts, most of which were largely unsuccessful, to set up a programme of public works. Capital punishment was also abolished and political prisoners released.

The broad-based alliance of February 1848 was never an easy one; the spirit of fraternity which had bound peasant, bourgeois, Republican and Legitimist together in united opposition to the government lasted only for a brief period and the next three months saw a series of power struggles between left and right in which many of the anomalies of February were resolved. One particularly acute aspect of this struggle was the battle for the hearts and minds of the new voters, which in an agrarian economy were, of course, mostly peasants. Although universal suffrage was a political ideal associated with the Republican left, those that would benefit from the extension of the franchise were socially prescribed by old feudal bonds towards landowners and the church and could by no means be relied upon to vote for the party that had ostensibly acted in their interests. Despite the best efforts of republican commissars sent out to the provinces to educate new voters, the peasantry remained subject to the influence of the clergy and landed gentry. On Easter Sunday 1848 the newly enfranchised peasantry was largely instrumental in returning a conservative assembly staffed by a core of conservative Legitimists and Orléanists. Demonstrations followed including an abortive coup d'état by the left on 15th May. In June 1848 the National Workshops, perceived by many liberals and conservatives to be dangerous centres of left-wing agitation, were abolished in an attempt to stem the tide of political protest. Single men registered with the workshops were required to enlist in the army; those with families were forced to leave the city. These measures prompted the start of the second act of the 1848 Revolution – the erection of barricades in the working class quarters of the capital and three days of bloody fighting. On one side of the barricade were the militant Parisian working classes; on the other was the large mass of the population eager to defend their interests and those of the nation against the insurgents.[3]

Despite some political gains by the left in the elections of 1849 and by-elections in Paris in March 1850, the two years following the June Days saw French politics move steadily, once more, to the right. In July 1848 press censorship was re-introduced. In 1849 Louis-Napoléon (known primarily as a candidate of the centre-left with Saint-Simonist leanings) was elected President. In October, however, he dismissed the elected cabinet of Odilon Barrot and replaced it with an extra-parliamentary ministry under his direction; in March 1850 the church, a bastion of conservativism , was given control of state education, and in May a law was passed ending universal suffrage. Other draconian measures followed: those that had lived for less than three years in a district and those with court convictions (among them many left-wing militants) were deprived of the vote. Soon after 1850, the revolutionary impress *Liberté, Egalité, Fraternité* was removed from public buildings. Louis-Napoléon began to emerge as a purposeful leader and the politician best qualified to offer France a degree of much needed political stability. In spite of riding roughshod over the liberal ideals of February 1848, he was able to capitalize on the wave of anxiety caused by the impending elections due in 1852. The constitution did not permit the President's re-election for a second term of office and many middle class citizens were alarmed by the prospect of yet another power struggle to find a successor. The problem was eventually resolved by an act which was at once deeply reactionary and essentially populist in character: Louis-Napoléon's coup d'état of December 1851 and the subsequent massive endorsement of the coup with a plebiscite. One year after the coup, Louis-Napoléon's political transformation was complete; he became the Emperor Napoléon III in December 1852.

Artistic policy during the Second Republic

How did the events of 1848 affect the the fortunes of
painters, in particular landscape painters? Throughout the
1830s and 1840s there were persistent complaints made
against the narrow tastes and inconsistencies of the Salon
jury and in 1847 many landscape painters boycotted the
Salon as a result. The revolution of 1848 and the end of
the July Monarchy was seen as a new dawn for the arts; the
journal *L'Artiste* hoped that the new spirit of liberty would
revive the arts in France; for Frédéric Henriet, the first
Salon after the revolution marked the 'emancipation of
the paintbrush'. Théophile Gautier thought that the
achievements of the new era would surely upstage those of
Periclean Athens and the reign of Louis XIV. Thoré, writ-
ing in *Le Constitutionelle*, anticipated that Delacroix was
about to commemorate the 1848 uprising with a second
revolutionary picture, a pendant to his *28th July – Liberty
leading the people*, now out of storage again and on show
to the public.[4]

One of the first acts of Alexandre-Auguste Ledru-Rolin,
the new minister of the interior under the Provisional
Republic, was to abolish the Salon jury. The Salon cata-
logue for 1848 announced that 'all the works sent this year
will be received without exception'. A commission elected
by 801 artists at a convocation held at the Ecole des Beaux-
Arts was established in early March to oversee not the
selection but only the hanging of the Salon. Eugène Isabey
and Paul Delaroche were elected president and vice pres-
ident respectively, and the remainder of the commission
included a curious mixture of conservatives, liberals and
radicals, among them Ingres, Delacroix, Decamps, Ary
Scheffer, Meissonier, Corot, Dupré and Rousseau. The net
result of the first open Salon was considered to be disap-
pointing. According to Thoré, the exhibition was 'an exces-
sively curious spectacle' in which good pictures were
swamped among generally much weaker paintings.[5] At
the following year's Salon Charles Blanc recommended
that a committee should be established to sort out the gen-
uine works of art from the 'unspeakable rubbish' that also
found its way into the exhibition. Ledru-Rolin was also
responsible for appointing independent artists to positions
of importance in the arts administration. Jeanron was put
in charge of the administration of museums and fine arts
and nominated both Jacque and Barye for appointments,
the latter as conservator in the department of sculpture at
the Louvre. Daubigny also applied for a post at the Louvre
to restore and clean works in its collection. The early days
of the revolution saw the foundation of a number of radi-
cal independent organizations in the arts. Delacroix and
Decamps, for example, were responsible for the direction

92
Théodore Rousseau
The fisherman, c. 1848–9
Oil on canvas, 20.6 x 30.5 cms

Over

93
Constant Troyon
The forest of Fontainebleau,
c.1848
Oil on canvas, 145 x 227 cms

134

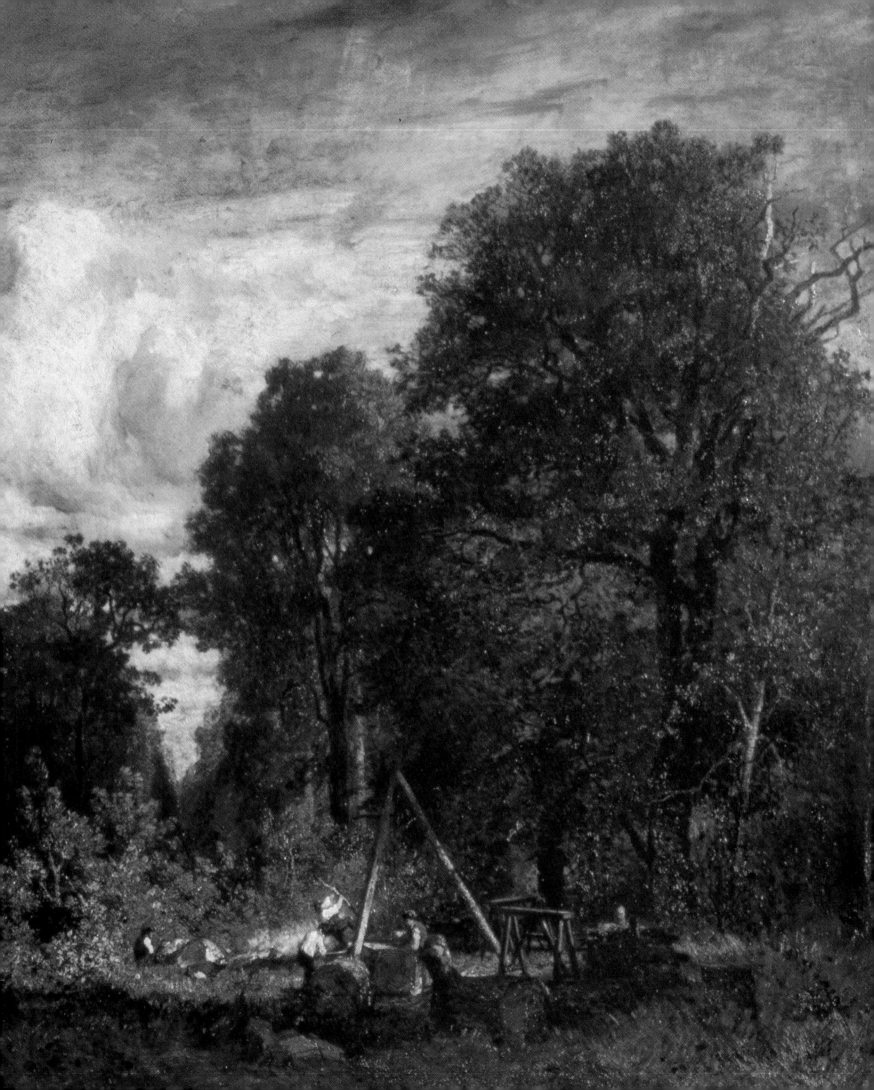

of a general assembly of independent artists. The aims of the assembly were ill-defined although one petition submitted under its auspices and signed, among others, by Diaz and Barye, argued for a form of workers' control in the arts, requiring that all officials who had influence over state patronage should be democratically elected by the artists themselves.

Although Charles Blanc, director of the Bureau des Beaux-Arts, refused to hand over the control of state patronage to artists, he was responsible for planning, and in some cases implementing, a number of elaborate schemes for public works offering contracts to independent artists. There was a proposal, for example, to decorate the Panthéon, newly re-consecrated as a museum of the people, with a history of mankind overseen by a virtually unknown painter Paul-Marc-Joseph Chenavard. The state also sponsored a competition to produce an allegorical image of the new Republic. There was a plan to decorate the Champs Elysées with 50 heroic statues, Barye was commissioned to decorate the Pont d'Iena with sculpted eagles, and various fêtes in celebration of the new regime were planned.[6] Art during this period was conceived, if not actually realized, on a grand public scale; the individualism inherent in romantic art was now out of fashion and was replaced by a more democratic art in which personal aesthetic whims were sacrificed for the greater public good.

Many of the Republic's grander schemes – Chenavard's murals and Barye's eagles – often came to nothing, but a number of the artists that had fared badly in the latter days of the July Monarchy began to receive official honours and lucrative commissions. Painters of landscape fared especially well during this period and received over half of all the prizes awarded at the Salon of 1848. Prize winners that year included Corot, Diaz, Troyon, Daubigny, Louis Français and Rosa Bonheur. Jules Dupré and Théodore Rousseau both received commissions from the state worth 4,000 francs. Rousseau submitted a landscape of the forest of Fontainebleau in fulfilment of the commission, and although he submitted nothing to the Salon of 1848, he showed three works the following year, *An avenue, Sunset, edge of the forest* and *Autumn landscape*, the first paintings by Rousseau seen at a Salon since 1835. The critic for the *Revue de Deux Mondes*, scenting a link between the ideals of the new regime and the belated recognition of landscape painters wrote: 'For my part, I am delighted that the arrival of a new order of things in the republic of arts has at last put M Rousseau in contact with the public.'[7] In 1848 the state also bought Antoine Barye's *Tiger eating a crocodile*. Originally shown in the Salon of 1831, the work

was bought in 1849 in compensation for the injustices suffered by the sculptor at the hands of the Salon jury during the last years of the July Monarchy. Three paintings by Huet were bought by Jeanron for 4,500 francs; Constant Troyon's *The forest of Fontainebleau* (plate 93), Corot's *Bathing shepherd* and Jean-François Millet's *The winnower* (plate 100) were also acquired for the state's collection of contemporary art at the Luxembourg together with Charles Jacque's *Cattle at the watering place* (plate 116). The Republican government supported many painters who had received little official encouragement in the final years of the July Monarchy. Moreover, it gave substantial support to landscape and genre painters and recognised the significance of more democratic subject matter – landscapes, peasant themes and genre subjects – in a period when political life itself was becoming more democratized. But it is important to see state commissions in context. T J Clark has pointed out that the state patronized painters and sculptors during a period when the art market was in deep recession. A number of commissions were, in effect, no more than acts of charity.[8] Even well-established artists were desperate to pick up the contracts and some petitioned the government directly. Both Daubigny and Jacque solicited for commissions from Jeanron during the first months of the Provisional Republic. Private ventures in the arts fared little better. Durand-Ruel's gallery was sublet after 1848. Few acquisitions were made during this period and paintings and drawings in the gallery's possession were rented rather than sold to cover expenses. In turn, works by artists that had once been popular with art dealers such as Diaz and Barye now sold for low prices. Pictures at a sale held in the studio of Diaz in 1848 fetched on average around 150 francs apiece, and Durand-Ruel relates that the market did not really pick up again until after Louis-Napoléon's coup d'état.[9]

The existence of a revolutionary style in French art of the mid-nineteenth century has been contested by historians. The period was dogged by economic recession, which was hardly conducive to innovative departures in the arts and many of the commissions that were handed out by the state were for relatively insignificant jobs such as the execution of altarpieces for churches or copies of paintings for government offices in the provinces. Furthermore, the period of the Second Republic was characterized by different political programmes at different moments. If a revolutionary art exists it would be characterized not by one but by several styles, each coinciding with various political phases of the republic between February 1848 and December 1852. The existence of a revolutionary art is further called into question by the fact that

the artists of the period that were well disposed to the revolution, among them Delacroix, Dupré, Huet, and Delaroche, were by no means bound together by their aesthetic interests. Although the 1848 revolution failed to produce a body of politically tendentious art with a clear aesthetic and political programme, the period saw a number of significant changes in the way in which the countryside and those who worked the land were represented in painting. Moreover, these changes were given an added and acute resonance by recent political events: the Provisional Republic may not have actually sponsored the painting of revolutionary art but when images of peasants appear in greater quantity following a workers' uprising it is easy to appreciate how they could be seen as carrying some revolutionary message.

Rural imagery during the Second Republic and after
In the mid-1840s new forms of rural imagery began to appear in painting. For the most part, the landscape paintings of the School of 1830 kept agriculture at arm's length and presented an image of nature all but untouched by human activity. When peasants and domesticated animals appear, they rarely have a social or economic identity and remain a homogeneous part of a romantic *vignette* set at some distance from the viewer. The figure in Rousseau's landscape *The fisherman* of 1848–9 (plate 92) animates the landscape but has no overt social role; the landscape is, in effect a re-working of pictorial conventions used in numerous landscapes by the artist made since the early 1830s. This approach is evident in the paintings of some of the of Barbizon painters throughout the 1850s and 1860s. Around the middle of the century, however, some painters used other modes of representation. In some instances, the figures within landscape paintings have a much greater prominence and begin to dominate the composition; they often take on a perceptible psychological identity and have a specific role within their surroundings. The paintings themselves were often significantly larger than the landscapes of the School of 1830, serving to emphasize the new-found interest in the rural working classes in the 1840s and early 1850s. In the *Forest of Fontainebleau* (plate 93) shown at the Salon of 1848, Constant Troyon made a number of tactical amendments to landscape conventions used by members of the School of 1830. In this instance, the figures in the painting are not just passive observers of a rural scene but play a specific, and somewhat contentious, role felling and cutting trees in a clearing in the forest. Visitors to the Salon of 1848 would have immediately been able to read the significance of such images; the forest's potential as a resource for timber and stone

had been hotly debated throughout the 1840s and was to continue during the Second Republic. Troyon's painting of the forest, moreover, is exceptionally large for a landscape painting, measuring almost a metre and a half by over two metres. The majority of landscape paintings made by the School of 1830, by contrast, were modest in size, their dimensions often carefully-tailored for sale by art dealers.

Perhaps one of the earliest nineteenth-century paintings to underscore the importance of those that formed part of the landscape rather than the landscape itself was Jeanron's *Peasants from Limousin* made in 1834 (plate 95). The figures, shown in local costume, are conceived on a large scale – they measure between 40 and 50 centimetres, about half the vertical height of the canvas – and are set in the foreground of the painting. Comparable paintings appear in larger numbers in the late 1840s. The brothers Leleux, for example, specialized in images of provincial rural life and traded on the wave of interest generated by popular accounts of provincial France. *Physiologies*, encyclopaedic, illustrated accounts of various occupations and professions from the city and provinces, were enormously popular and sold cheaply in Parisian bookshops. They included such works as Alexandre Bouet's *La Galerie Bretonne* published in 1835, an account of the life and customs of a Breton peasant, and Achille Allier's *Art en Province*, an attempt to give the French peasant the picturesque status enjoyed by his Italian counterpart. In some cases, painters supplemented their income by illustrating *physiologies*. Jeanron and Meissonier, for example, both contributed to Léon Curmer's much imitated *Les français Peints par Eux-mêmes*. Other forms of popular imagery also informed representations of the rural poor. Almanacs and calendars often illustrated with wood-engravings showing agricultural tasks, each associated with one of the seasons, were common and formed part of a pictorial tradition dating back to medieval books of hours. Many of these popular images depended upon simple, well-defined graphic forms placed centrally on a page, a compositional tool picked up by a number of painters of the 1840s and 1850s and evident in the work of Bonvin, Jeanron, Jules Breton and Millet.[10]

The rural irritant: Courbet and Millet
The large-scale migration of unemployed peasants from the provinces into Paris in search of work led to rising crime, vagrancy and to an increased demand on the capital's charitable institutions. The problem became especially acute after the failed harvests of 1846 and 1847. Despite these problems, few paintings of peasants made

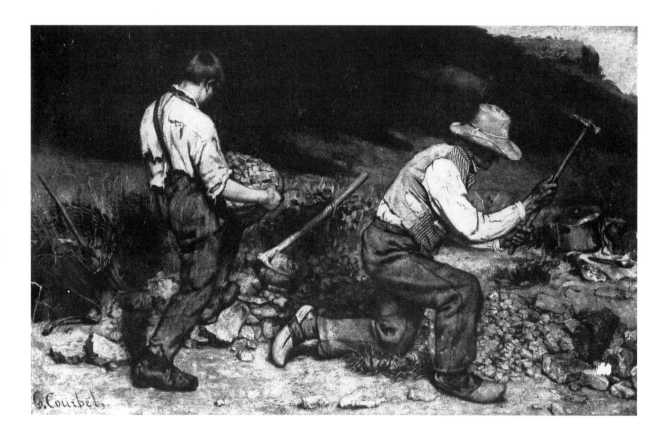

94
Gustave Courbet
The stonebreakers, 1849
Oil on canvas, 190 x 300 cms
Destroyed in Dresden during
World War Two

95
Philippe-Auguste Jeanron
Peasants from Limousin, 1834
Oil on canvas, 97 x 130 cms

before the revolution seem to have provoked much critical comment in the press. Images of the rural poor from provinces such as the Limousin and the Savoy formed part of a well-established tradition in French art. Watteau was among the first to depict picturesque images of the itinerant *Savoyard*, the name given to children from the Savoy who came to Paris and provincial cities each summer to earn their living by begging, and it is possible that mid-nineteenth century paintings of similar subjects were perceived as an extension of this tradition. After the 1848 revolution, however, paintings of peasants took on a very different form.

Courbet and Millet's images of rural life frequently touched a critical nerve. Courbet made his début at the Salon of 1844 and showed again in 1848 and 1849. It was not until the Salon of 1851 and the exhibition of three paintings, *Peasants at Flagey*, *The stonebreakers* (plate 94) and the monumental *Burial at Ornans* (plate 96), however, that he became notorious. The *Burial*, originally named with the portentous title *Tableau de figures humaines, historique d'un enterrement à Ornans*, attracted the most attention. The painting shows a well-to-do peasant funeral set against the backdrop of the artist's native Franche-Comté. The figures are depicted frieze-like across the picture and the space is limited to two distinct planes, the line-up of figures in the foreground and the hills in the distance. The most conspicuous feature of the painting, however, was its size. The picture measures over three metres in height by just under seven metres in length. Conceived on a smaller scale, the painting might have escaped censure; but here the size of the picture gave a heroic status to a humble cast more usually associated with smaller genre pieces. But unlike much genre painting found in mid-century Salons, the *Burial* appeared to contain no clear message or overt moral sentiments and was felt to be nothing more than a confusing and uninspired account of an uninstructive commonplace event.[11] Etienne Delécluze drew attention to the picture's mimetic qualities by comparing it to a bad daguerreotype. An artist's ability to rise above the mechanical qualities found in a photograph and to impose upon an image a degree of insight and interpretation were often considered to be essential ingredients of good painting. Few of these ingredients could be found in Courbet's painting. Some critics, in fact, thought that the artist had not just painted a factual account of an ordinary event but had deliberately gone out of his way to exaggerate the truth and to paint especially ugly subjects, a charge which was to be levelled at Millet in the early 1860s.

Other pictures followed the *Burial. The young women from the village* of 1852 was as roundly attacked by the

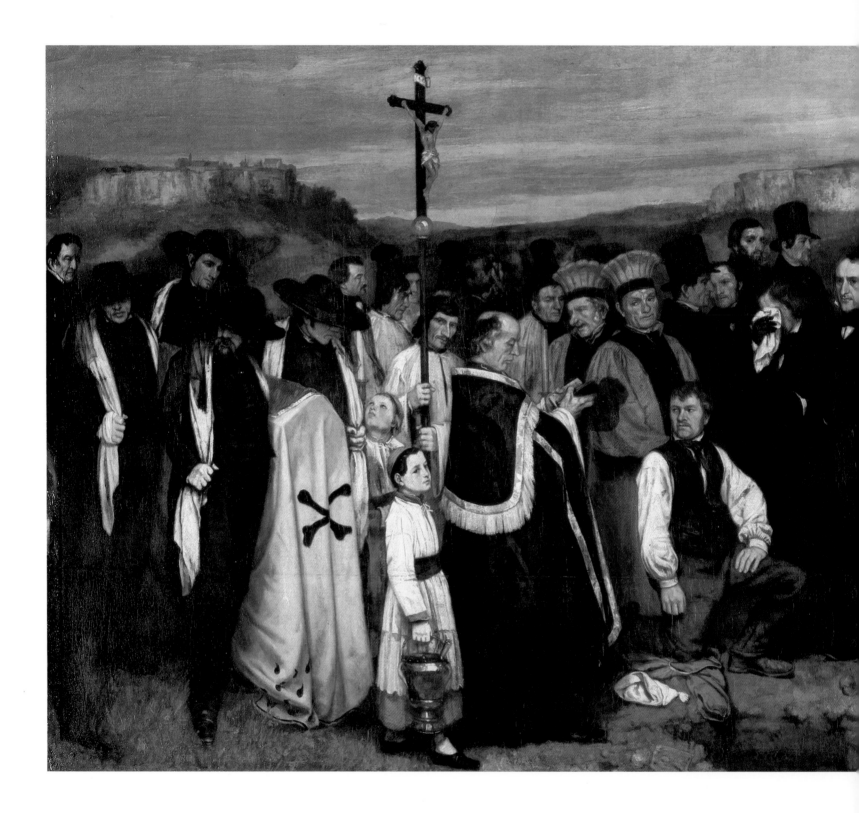

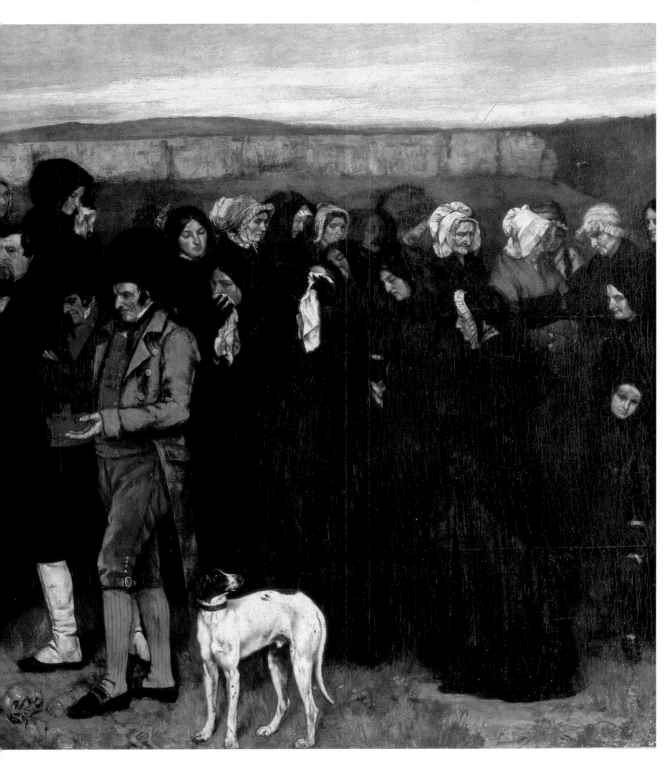

96
Gustave Courbet
Burial at Ornans, c. 1849–50
Oil on canvas, 311.5 x 668 cms

Fig. 6
Gustave Courbet
Photograph by S P Ziolo

critics despite Courbet's claim this time to have produced 'something gracious', and *The Bathers* (plate 97), shown at the following year's Salon, was subject to a swipe by Napoléon III's riding crop after the Emperor had made a special visit to the Salon to see Rosa Bonheur's much fêted *The horse fair* (plate 111).[12] The *Burial* was shown again alongside *The winnowers* (plate 98) at the *Pavillon de Réalisme*, a theatrical spectacle of 40 paintings by Courbet shown with the official Exposition Universelle of 1855. There was a predictable chorus of outrage and support, respectively, from journals on the right and left. Critics on the left generally admired Courbet. Champfleury, for example, writing to George Sand who had questioned the validity of the realist creed, explained that Courbet's work and its exhibition at the *Pavillon de Réalisme* was a call for total liberty in the arts.[13] Several critics on the political right were largely indiscriminate in their attacks and predictably complained about the vulgarity of the subject matter and the artist's technique.[14] It was the more contemplative writers, however, neither apologists nor critics, who articulated some of the real points of confusion presented by Courbet's paintings.

In short, the problems were manifold. There was nothing wrong with painting peasants or genre pieces as long as the paintings observed the aesthetic conventions, the basic pictorial good manners followed by artists like Félix Cals, Adolphe Leleux, Bonvin, Meissonier, Isidore Pils and Léopold Robert. Convention demanded that genre pieces were generally smaller, well-finished and underpinned by a morally instructive story; peasants must be picturesque, amusing or provincial curiosities from far flung corners of France, Italy, Spain or the Near East. Rules, of course, could be broken. Aesthetic daring was an essential ingredient of a Salon spectacle during the Second Empire and made good copy for the mid-century *salonniers*. Courbet, however, was thought to have broken too many of these conventions; he had exchanged a well-established repertoire of social types, similar to those used in *physiognomies* and genre paintings, with ambiguous images of rural labour, of prosperous peasants and the rural bourgeoisie. An attempt to interfere with established conventions in painting, especially with peasant subjects, was inevitably read not only as aesthetic wilfulness but also as a political provocation. Besides, Courbet had broken other rules – the paintings were very large, they were aggressively painted with coarsely encrusted pigment and unusual compositions – and, moreover, he was a self-confessed radical. He went out of his way to bait the establishment, both exhibiting his work directly to the public and supporting it with a politically tendentious apologia for the

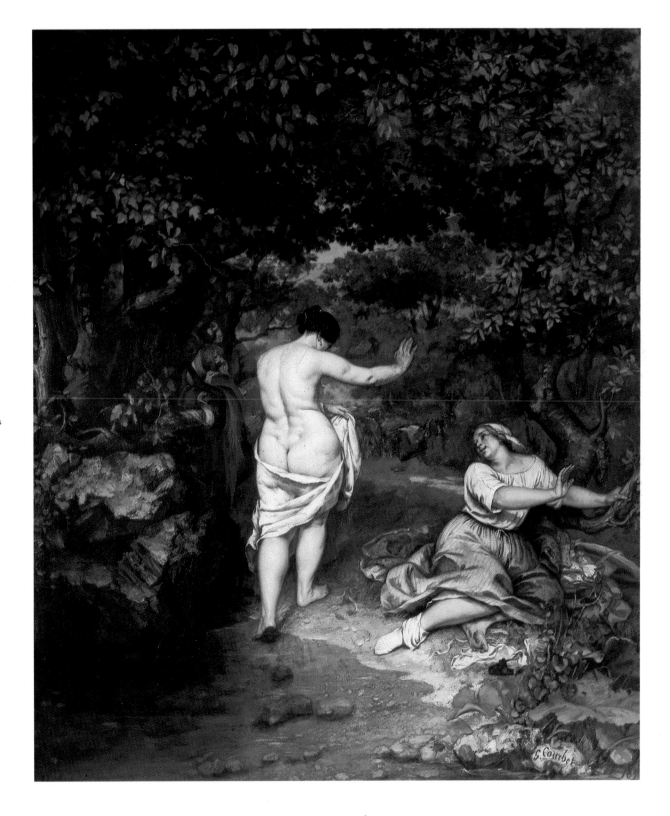

97
Gustave Courbet
The Bathers, 1853
Oil on canvas, 227 x 193 cms

exhibition in the form of a pamphlet on sale to visitors for ten centimes. Many critics and spectators, it seems, found too few points of reference in Courbet's paintings and mistakenly assumed a dangerously radical political intent.

Courbet was largely self-taught. Millet's career, however, followed a more conventional path. He studied with two painters from his home town of Cherbourg, Bon Dumouchel and a copyist, Lucien-Théophile Langlois, before enrolling in the atelier of Paul Delaroche. After having competed unsuccessfully for the *Prix de Rome* in 1834, Millet left Delaroche's atelier and tried his hand at a variety of types of painting: pastoral scenes, portraits, religious and classical subjects, in the hope of making a sale. He showed at the Salon of 1840 and again in 1844, and was seen by several critics as a follower of Diaz de la Peña. A cursory glance at Millet's subjects during this period – an *Oedipus* submitted to the Salon of 1847, *The winnower* (plate 100) and *The Jews captive in Babylon* shown in 1848, *Hagar and Ishmael*, the proposed submission in fulfilment of his 1,800-franc commission for the Provisional Republic, a *Seated peasant* and *Rest*, submitted to the Salon of 1849 – indicates that, like many painters of the period, he was prepared to turn his hand to any one of a variety of genres in order to sell his work.

Millet had painted images of rural labour as early as the mid-1840s. *The quarriers* (plate 107) of 1846 shows two labourers working one of the many quarries to be found in the countryside just beyond the capital's suburbs, which, since the mid-1840s, had been largely populated with itinerant peasant workers seeking work around the city. Rural imagery, however, began to dominate Millet's work towards the end of the decade. The London version of the *The winnower* painted between 1847 and 1848 presents a full-length monumental image of a peasant in which all details are eliminated in favour of coarsely trowelled deposits of pigment. The picture clearly touched a critical nerve. Thoré thought the work audacious in its technique and reminiscent of the work of Diaz with 'a bit of the Spanish and a lot of Le Nain'. Théophile Gautier was also taken aback, more by the use of coarsely applied paint, it seems, than the subject. 'The painting', he wrote, 'has everything to horrify the middle classes.' Gautier continues:

He trowels onto his canvas great walls of colour using no turps, so dry that no varnish could quench its thirst. Nothing could be more rugged, ferocious, bristling and crude.[15]

In June the following year Millet moved to Barbizon to escape political unrest and the outbreak of cholera that followed the 1848 Revolution. A drawing by Millet of 1853

98
Gustave Courbet
The winnowers, 1854
Oil on canvas, 131 x 167 cms

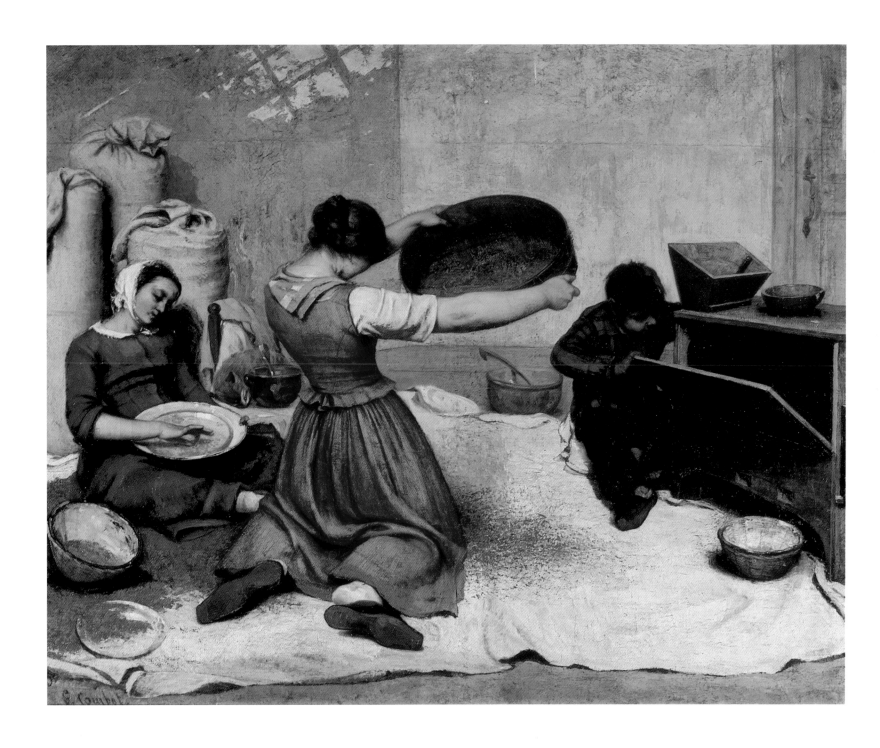

99
Jean-François Millet
The 'Porte aux Vaches' in snow,
1853
Pen and ink on paper, 28.2 x
22.5 cms

100
Jean-François Millet
The winnower, 1847–8
Oil on canvas, 100.5 x 71 cms

Fig. 7
Jean-François Millet
Photographer unknown

101
Jean-François Millet
Millet's garden at Barbizon,
c. 1853
Black crayon on paper,
29.7 x 37.2 cms

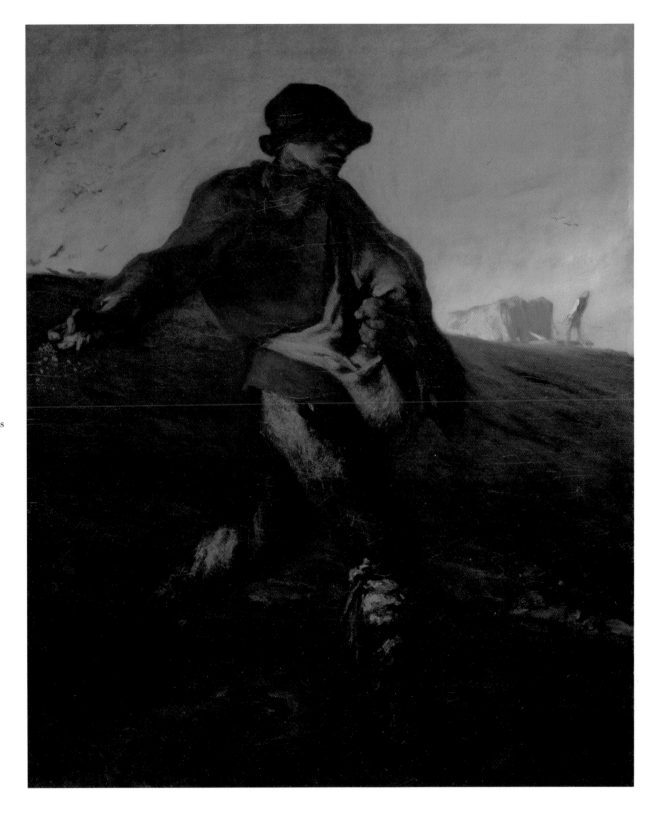

102
Jean-François Millet
The sower, undated
Oil on canvas, 101.6 x 82.6 cms

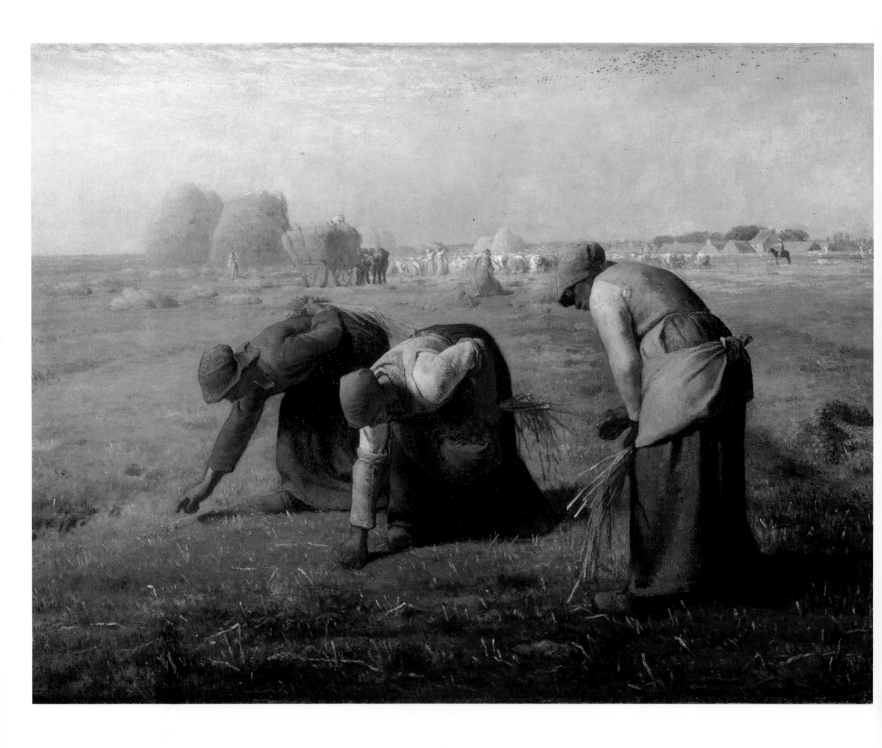

103
Jean-François Millet
The gleaners, 1857
Oil on canvas, 83.5 x 111 cms

(plate 101) shows the garden of his house in the centre of the village. More paintings and drawings of peasant subjects and landscapes followed. During this period Millet and Rousseau became firm friends; evidence of Rousseau's influence on Millet's work is visible in a small study for the unfinished *The 'Porte aux Vaches' in snow* (plate 99). The preparatory drawing with its open, central vista and horizontally banded, linear composition formed by the trees in the background owes much to Rousseau's landscapes and, like Rousseau, Millet called attention to the intrinsic sadness of the district in winter. Despite Millet's melancholic insights into the landscape, it was around the early 1850s that commentators began to scent dangerous political affinities on the part of the painter. Two pictures attracted critical flack following their exhibition at the Salon of 1850, *The hay trussers* (plate 108) and *The sower* (plate 102). One writer noted that 'the painter's critics attach a political slant to his painting, they accuse him of wanting to inspire a horror of work by showing the ragged clothes of the peasants, and in painting their misery'.[16] The left-wing critic Sabatier-Ungher, writing on *The sower* thought the figure a 'modern Demos' and the painting an overt political comment on the plight of the rural poor expressed in the style of Michelangelo. 'Come' he writes, 'sow, poor labourer, throw wheat onto the earth in handfuls! The earth is fertile, it will provide, but next year, like this, you will be poor and you will work by the sweat of your brow, because men have so arranged it that work is a curse...'.[17]

Political interpretations of Millet's work were commonplace from the late 1850s. The art critic Paul de Saint-Victor had once admired the artist for his capacity to 'translate into patois the writings of Homer', in essence to give a realistic everyday inflection to the timeless ideals of classical Greek literature. *The gleaners* (plate 103) shown at the Salon of 1857, however, was considered pretentious. The figures were 'the three fates of pauperism'; moreover, they had no faces and looked like scarecrows. The execution of the painting was thought weak and even Millet's technical shortcomings were seen to have a political resonance: 'M Millet', Saint-Victor writes, 'seems to think that a lack of finish is suitable for paintings of poverty...'. Links with the art of the high Renaissance were now thought inappropriate; Saint-Victor continues: 'These poor creatures do not move me; they have too much pride; they too clearly betray the claim that they are descended from Michelangelo's Sybils.'[18] One critic, writing for *Le Figaro*, saw in the painting intimations of the French Revolution, the 'rioters' pikes and the scaffolds of 1793'. Far from being seen as painting in a realistic idiom, Millet, like Courbet before him, was accused of exaggerating the plight of the

104
Jean-François Millet
Woman pasturing her cow,
c.1858
Oil on canvas, 73 x 93 cms

105
Jean-François Millet
Man with a hoe, 1860-2
Oil on canvas, 81 x 100 cms

rural poor and distorting the true image of the provincial French peasants summed up, for many, in the work of rural genre painters. Similar charges were often directed at Charles Jacque, Millet's neighbour at Barbizon. Around the mid-1850s, the date of Jacque's *Ploughing* (plate 115), the Goncourt brothers earmarked two trends in landscape painting: the picturesque and sanitized tendency on the one hand and the more overtly aggressive on the other. *Ploughing* fell, the critics felt, clearly in the second category. Charges of didacticism continued with the exhibition of *Woman pasturing her cow* shown in 1859 (plate 104). The painting was criticized by Baudelaire for its pedantic peasants 'who have too high an opinion of themselves', a sentiment endorsed by the critic Louis Demensil who thought Millet '...an artist-philosopher who makes his canvas talk like a book...'. Castagnary, writing from the vantage point of the left, admired the picture of the '*pauvre créature*' for its capacity to document the oppression of the rural poor. 'She is held there oppressed,' Castagnary writes, 'she will never break free, she will never attain conscious thought or liberty.' [19]

Millet was often accused of searching out and politicizing the very worst aspects of the rural environment. By the early 1860s, however, Courbet's work was thought to have shown signs of reform. He had, for the most part, abandoned overtly provocative subjects. *Stream in the forest* of 1862, probably influenced by Corot's landscapes of the early 1860s, shows a charming, delicately painted forest glade. Like Corot, Courbet painted the foliage in the centre of the picture and the reflection of the trees in the pool with delicate passages of carefully worked thin paint where one colour merges with another. In this instance, Courbet abandoned peasant themes in favour of three deftly painted, picturesque deer approaching the pool to drink; the one on the far right poses winsomely to look at the spectator. Pictures of this type were made in some quantity and may have been designed with the art market in mind. Even Courbet's peasant subjects had lost much of their political edge. His last monumental painting of peasant life, *Siesta during the Haymaking season*, (plate 90) made in 1867, presents a tranquil image of farm workers resting alongside passive cattle. Critics were less than enthusiastic about the painting following its exhibition at the Salon of 1867 but few, it appears, could find any trace of political radicalism in the painting.

During the late 1850s and early 1860s, however, Millet's paintings were increasingly disliked by critics. Paul de Saint-Victor observed that one would have to look for a long time before one found a living example of his *Man with a hoe* (plate 105), shown at the Salon of 1863. 'Similar

types', he wrote, 'are not even seen in a mental hospital.' [20] When, in 1864, Millet came up with an image that conformed more to a traditional rural ideal, he received the seal of approval from Saint-Victor. The painting, *The shepherdess and her flock* (plate 106), was looked upon without '*horreur*'; it had just the air of melancholy and poetry expected from images of rural life seen from the vantage point of Second Empire Paris. When that melancholy air was abandoned, as it was in many subsequent Salon exhibits, Millet was accused of returning to a 'rural madhouse'. [21]

The sources of irritation found in Millet's work were a reflection on his technique, his choice of subject matter and changing perceptions of the French countryside in the middle of the nineteenth century. Millet protested that he was not a socialist and persistently called attention to the biblical rather than contemporary references in his work. Adopting the accent of a yokel, a risky affectation for which George Sand was taken to task, Millet denied charges of Saint-Simonism.[22] Sensier maintained that Millet had no stomach for the political upheavals of 1848 when he left the capital to paint at Montmartre and Saint-Ouen. He also declined to take part in Courbet's left-wing Fédération des Artistes, founded during the Paris Commune of 1871. It is worth noting, however, that in many of Millet's paintings labour is depicted as painful, whether as a fatal curse handed down after Adam and Eve's expulsion from Paradise or, as some liberal and left-wing critics guessed, the result of human cruelty and exploitation. The paintings were open to a variety of interpretations depending upon the political slant of the viewer, but they invariably revealed the physical and spiritual toll endured by their subjects. Furthermore, Millet's paintings document the work of the very poorest of the rural communities around Barbizon and record traditional activities that were increasingly threatened by government legislation. Woodcutting, the grazing of cattle and sheep on tracts of ground on the very edge of the forests a scene depicted in *The seated shepherd* of 1850, the gathering of faggots of dry wood and the gleaning of scraps of grain after the harvest, had been subject to debate both in the press and in the Chamber of Deputies. In order to bring these images into sharper focus, it is necessary to examine them not from the vantage point of debates about art but rather debates about mid-nineteenth century rural life.

The literary and agricultural perspective
Paintings and travel guides frequently portrayed the forest of Fontainebleau as a tract of primordial landscape littered with myths and distant folk memories. The forest was

106
Jean-François Millet
The shepherdess and her flock,
1862-4
Oil on canvas, 81 x 101 cms

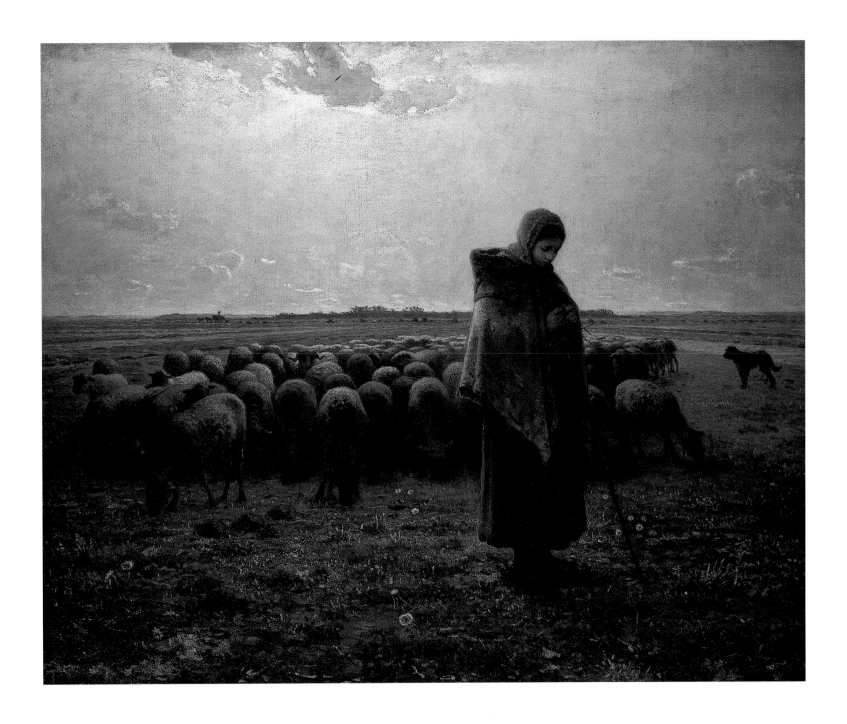

107
Jean-François Millet
The quarriers, c. 1847
Oil on canvas, 73.6 x 59.6 cms

108
Jean-François Millet
The hay trussers, 1850
Oil on canvas, 54.5 x 65 cms

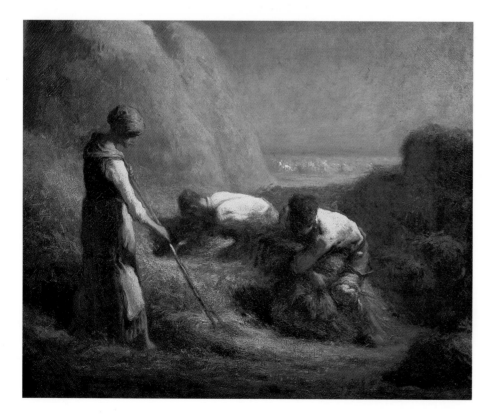

untouched, calm, stately, spiritually refreshing, over-whelming and terrifying; just about every visitor who passed comment on the district between 1830 and 1870 uses at least one of these descriptions. This image of the forest may have informed the work of those Barbizon painters that painted idealized images of nature untouched by human activity. However, the work of those artists that painted agriculture, men and women working the land, cutting trees, extracting rock, gathering scraps of grain or bundles of dry wood, was influenced not by travel guides but by literary, statistical and historical accounts of peasant communities in France in the late 1840s and early 1850s.

The forest of Fontainebleau had been administered by the state and its agents, the Bois-d'Hyver family, since 1827 and was subject to a legal charter, the *Code Forestier*, governing many aspects of its maintenance and use. For example, harsh restrictions were placed on many of those who depended upon the forest for a living; peasants were forbidden to leave the highways running through the district and enter into the forest with wood-cutting implements, machinery or transport; they were not allowed to open workshops for the sale or processing of wood; nor could they light fires, graze sheep or goats, not least, cut down trees. Moreover, much of this carefully regulated landscape was far from 'natural'; the mid-nineteenth century saw a revolution in forest management and frequent efforts were made during the 1840s and 1850s to make the area more productive. Various methods were used. Trees were grown in coppices, cut after a decade or so and subsequently left to sprout when, on maturity, the process would begin again. Another common method of cultivation was to cut a percentage of a wood and to leave the remainder to protect newly planted saplings. Once those saplings were well-established the remainder of the old crop could then be cut and the process would begin again. A wide variety of trees was planted but pines were most commonly used because of their rapid growth rate. The merits and shortcomings of such management methods, and their effects on the forest, were debated at length in the press, and Parisians took a keen interest in what was at once a leisure facility, a subject for landscape painting and an economic resource. By 1852, the date of a special commission on the forest and its maintenance, the extent of the cultivation was considerable with some 70 per cent of the forest being used for industry.[23] The extent of the cultivation alarmed Théodore Rousseau. In a letter to Napoléon III he demanded that the forest be protected against the profit-mongering of both timber merchants and the tourist industry.[24]

The forest provided other resources which also had an effect on its appearance. The high percentage of sand in the soil in some areas of the forest made it suitable for use as mortar, for porcelain paste and for glass although the district was primarily known for its reserves of sandstone taken from quarries for use in the building industry. The extraction of stone was undertaken by teams of itinerant labourers many of whom worked for part of the year as agricultural workers, masons or wood-cutters. Pay for this type of work was high at around three and a half francs per day, some three times higher than the average rate for manual labour. Domet records that quarry workers, many of whom had a reputation for radical political opinions, were fiercely independent they were 'completely their own masters and enjoyed an independence of labour that they could never have found in any other occupation'.[25] But the disadvantages associated with this job were many. Workers were rarely known to live past the age of 45 and suffered from chronic respiratory disorders as a result of dust and disabling physical injuries caused by hard labour.

The plains around Chailly to the west of the forest of Fontainebleau provided large quantities of cereal, mainly for consumption in the capital. Farms in the district were generally highly productive and from the 1830s enjoyed many of the benefits of industrialization. The developing network of railways enabled stocks of fertilizers to be transported to the countryside with comparative ease. Around the 1830s the first chemical fertilizers were used; guano became increasingly common around 1840 and from the mid-1840s supplies of superphosphates, extracted as a by-product from steel plants in the northeast of France, were used in increasing quantity. New methods of crop rotation also increased productivity; winter wheat, spring wheat and root crops, particularly beet, were planted, avoiding the need to leave tracts of ground fallow. Industrialization also made ploughing, sowing, harvesting and threshing easier and more productive. The first metal ploughs were used in the Seine et Marne around 1850 and the first steam-drawn ploughs around Mélun in 1857. Machinery also had a dramatic effect on patterns of rural labour; in 1830 some 25 to 30 workers would be required to cut one hectare of cereals in a day. During the Second Empire the same area could be harvested by one machine and ten *ramasseurs* to collect and bind the crop. The maintenance of the crop, however, continued to depend on substantial quantities of manual labour and it was common for those seeking work to gather in the squares of nearby towns such as Mélun and Bray and to be contracted by local farmers for specific, seasonal tasks.

Changes in agriculture in the Seine et Marne around the mid-century place the pictorial image of gleaning into

context. The collection of stray remnants of grain after the harvest was an agricultural ritual in which poverty and plenty met head on. The right to glean the highly productive plains was extended only to the very poorest members of the commune, usually women, children, the elderly and disabled. In the early 1850s, however, these rights had recently been the subject of debate in the Chamber of Deputies and in the press. Many landowners, especially those that owned only small tracts of land, saw the tradition of gleaning as an outmoded form of charity and one that was frequently abused. *Garde-champêtres*, local officials employed to oversee the activities of gleaners, were appointed to ensure that only the indigent were admitted to restricted fields, that gleaning commenced only once the harvest had ended and that the gleaners themselves kept well away from grain stacks. It is significant that Millet's gleaners pick only modest sheaves of grain and do so at a safe distance from the harvesters in the very background of the picture working on one of the highly productive farms in the district.

Those that worked the land were subject to a variety of social and moral readings in mid-nineteenth century France, but they fall, in general, into two distinct categories: the peasant as the traditional symbol of a natural feudal order, now threatened and in some instances brutalized by the modern industrial world, and the peasant as an icon of redundant tradition and a drain on the aspirations of modern France. Such responses cut right across literature and social surveys and, by extension, contemporary readings of paintings. The novelist George Sand, an ardent apologist for the plight of the rural poor, is an especially important point of reference. She was an associate of the radical group of independent painters that gathered around Dupré and Rousseau; she was a socialist (at least before 1849) and contributed to Thoré's journal *La Vraie République*. Moreover, several mid-century art critics faced with rural imagery at the Salon, interpreted it in terms of Sand's writing, and Sand herself often reciprocated by using copious pictorial similes and metaphors in her novels.

One book by Sand stands out as particularly important: *La Mare au Diable* published in 1846 and reprinted in a popular edition in 1852. The novel presents an intensely sympathetic portrait of rural life. Peasants are shown as being subject to a relentless round of back-breaking toil which is relieved only by death. We have on the one hand the alienated labourer, toiling in the fields for a crust of black bread; on the other 'The man of leisure who comes for a stay in the country to find some fresh air and health, then returns to spend the fruits of his vassals' labour in

109
Charles-François Daubigny
The harvest, 1851
Oil on canvas, 135 x 196 cms

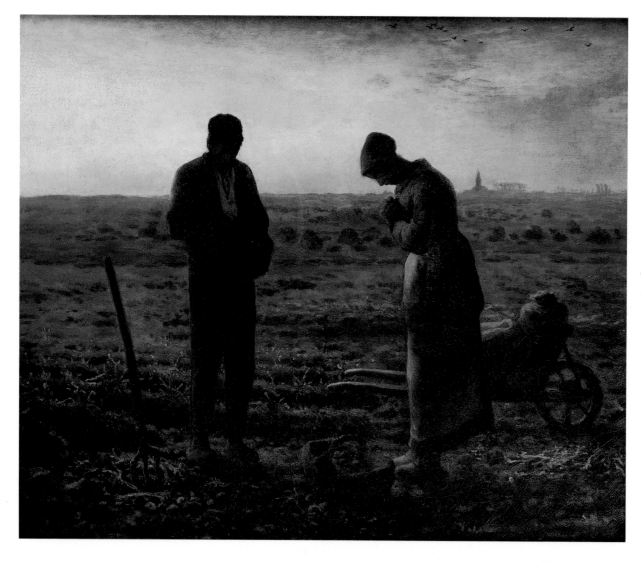

110
Jean-François Millet
The Angelus, 1859
Oil on canvas, 55.5 x 66 cms

the big cities'.[26] But, despite many hardships, the peasant also symbolised a permanent and stable part of a rural environment ordained not by the chicanery of capitalists but by divine providence. Nature is fundamentally good, Sand insists, happiness is part of the peasant's rural patrimony, and if only society was organized more equitably the peasants' lot would be a happier one. Sand explains:

Happiness is where the spirit, the heart, and the body work together under the eye of Providence, a sacred harmony will exist between God's bounty and the ecstasy of the human soul.[27]

Sand's perspective has a counterpart in the work of the writer and social historian, Francis Wey, an associate of Courbet, a freelance journalist and regular contributor to *L'Artiste*. Wey explains the plight of the rural poor in France in terms of the shortcomings of the free-market policies of successive Bourbon and Orléanist administrations. He cites in particular, problems caused by the 'feudalism' of the industrialists who had amassed large quantities of money at the expense of the long-term prosperity of the countryside, a theme also found in Sand's novel. Writing in the *Dictionnaire du Droit et de Devoirs* of 1848, he explains that, unlike the industrial nations of Europe (he means England and Germany) the economic well-being of France is to be found in the countryside; the French are the heirs of La Fontaine's peasant; '*la veritable richesse de la France*', Wey argued, '*est dans les entrailles de la terre*'. Industry, by contrast, was described as '*factice*', somehow alien to the spirit of France; its products always cost more than those from other nations. If only France would throw itself into 'the arms of agriculture' all would be well. The national wealth would increase and 'abnormal' industry would decline. The main task for France was to 'restore the honour of agriculture, to clear the towns of unemployed peasants and to give a sense of ease and well-being back to the countryside'.[28]

Balzac's account of rural life stood, as George Sand herself was aware, in stark contrast to that outlined in *La Mare au Diable*. Balzac's *Paysans*, published in 1845, presented the rural poor as incontinent savages, no different from the redskins in the novels of Fenimore Cooper. Here there is little hope of redemption for the peasant; master and labourer are locked in eternal enmity; the one is rich and has everything, the other poor and has nothing. For Balzac, the act of gleaning, for example, was seen as nothing other than wanton vandalism. The *garde-champêtre* in Bonvin's painting of the gleaners was a fundamentally benign force; he oversaw this traditional right of the indigent. In Balzac's *Paysans*, however, a *garde-champêtre* stalks an elderly peasant woman only to find that she has stolen wood and cleverly vandalized saplings to resemble the damage caused by animals, then covered the damaged crop with leaves to store the cache until dry. Gleaning, in turn, is described by Balzac as an outmoded act of legalized theft in which women are compelled by an irrational impulse to abandon well-paid work in the fields to go off in search for free scraps of grain.[29]

Sentiments similar to those expressed by Balzac inform Eugène Bonnemère's *Histoire des Paysans* of 1848. Bonnemère, unlike Wey, passionately upheld the case of the town, a symbol of progress, against the country, a symbol of outmoded tradition and superstition. The urban worker, he maintained, is happier than the peasant. He lives in cities with conveniently wide streets and in apartment blocks where all social classes live together in an economic harmony, where each can find his proper station in an economic order sustained by *laissez-faire* capitalism. The staircases in such apartment blocks were like inverted Jacob's Ladders, Bonnemere insists, where each man can fall or rise according to his wealth or social position. (It was common in mid-century apartments for residences at the top to be much cheaper that those lower down in the building. Rousseau and Thoré occupied the upper stories of an apartment in the Rue Taitbout.) Peasants, in contrast to city dwellers, are brutal and ignorant; they are malnourished, ill-educated, intemperate and beat their children. And their children, having no one else to brutalize, beat their animals.[30]

The rural palliative: Bonheur, Troyon and Breton

In the early years of the Second Empire a number of painters began to celebrate the idealized images of peasant life similar to those set out by Sand, Wey and others. Moreover, this endorsement of rural life no longer carried quite so many dangerous political connotations. Around the mid-1850s it was possible to paint sympathetic images of peasant communities without being charged with having socialist leanings. Several Barbizon painters fell into this category.

The work of the landscape painter and sculptor Rosa Bonheur had been well received by art critics since her début at the Salon in 1842 and continued to receive accolades both during the Republic and throughout the early years of the Second Empire. The liberal and left-wing press were enthusiastic about her work. Landscape and genre pieces, as we have seen, had a much higher profile following the 1848 Revolution and were thought to embody the democratic aspirations of the new regime. In fact, Rosa Bonheur herself confessed some left-wing sympathies; she

was an ardent admirer of George Sand, and Raymond, her father, was a republican and a follower of Lamenais, sympathies which she herself shared. Rosa Bonheur's work continued to be accorded praise, however, even after the political climate had changed and swung markedly to the right in the early 1850s. It was well received, moreover, by a surprisingly wide cross-section of critics from Delacroix to Napoléon III. We also find that Bonheur's paintings fetched high, sometimes embarrassingly high, prices. In 1853 the Duke of Morny paid 4,000 francs for *Cows and sheep* and the monumental *The horse fair* (plate 111) eventually sold for ten times that figure. The sum seems to have been sufficient to embarrass the artist into providing the buyer with a free copy of the picture which, itself, was later sold for 25,000 francs.[51]

In the 1850s the paintings of Constant Troyon, an *animalier* and landscape painter with whom Bonheur was often compared, were also well received by art critics and the professional establishment. He was made a Chevalier of the Légion d'honneur in 1849 alongside Dupré and Flers, and in 1855 was elected a member of the admissions jury for the Exposition Universelle. Troyon's paintings, the most popular of which were frequently copied by the artist to order, fetched good prices with finished tableaux exchanging hands for around 5,000 francs. His pictures were also shown regularly in galleries, in Paris Salons and in provincial exhibitions in Rouen, Marseilles and abroad. By the late 1850s Troyon's work was so popular than many paintings had found buyers even before the pictures had been started.

What was the secret of Bonheur and Troyon's success? Again, good aesthetic manners seem to have been an important factor. It is interesting to note that time and time again in the 1840s Troyon was taken to task for his use of coarsely applied pigment and the inappropriately large scale of his work. In 1841 Gautier complained about the thick paint used in *Tobias and the angel* (plate 117), a charge that was repeated in various forms by many critics through the decade. Five years later, following the exhibition of three paintings at the Salon of 1846, one of which, the *Valley of the Chevreuse*, measured three by two metres, Champfleury argued that one could be as good a colourist in a picture measuring two feet as one could in one measuring 15 feet. Painting on such a large scale should, the critic warned, be left to the likes of Delacroix; here, again, is the assumption that heroic scale is the preserve of intrinsically heroic subject matter.[52]

From the late 1840s, however, Troyon's work began to change. The paint, although by no means smooth in its application, was now applied in comparatively smaller

111
Rosa Bonheur
The horse fair, 1853–5
Oil on canvas, 244.5 x 506.8 cms

Over:
112
Rosa Bonheur
Ploughing in the Nivernais, 1849
Oil on canvas, 134 x 260 cms

touches; the technique is evident in *Landscape, forest of Fontainebleau*, shown at the Salon of 1848. Writing in 1853, following the exhibition of the two paintings of the *Valley of the Toques* and a third of a Norman landscape, the critic of *L'Artiste* noted:

If you have not forgotten M Troyon's beginnings you must also remember his method of working, of how lavish he was with impasto and heavy touches. However, bit by bit, he has rid himself of this system.[33]

The painting, he adds:

Reminds one of those lush Normandy pastures where the animals sink knee deep in thick, fresh grass. This scene exudes an abundance of life, a fresh flowing sap, that I cannot over-praise.[34]

By 1860 Troyon has settled into a wildly popular but by that date largely conventional style of landscape painting. *Watering cattle* of 1860 (plate 119) is meticulously finished and recycles many of the pictorial conventions of earlier Barbizon painters. It was this uncomplicated, bountiful image of rural France, remote from the real political, industrial and demographic crises of the period, that seems to have been the key feature in an acceptable rural image. Gautier, writing in response to Rosa Bonheur's *Ploughing in the Nivernais* (plate 112), shown in 1849, thought its author the best animal painter in France. Here, Gautier stated, we are in the opening pages of *La Mare au Diable* in which Sand paints a vivid picture of the peasant struggle with a team of oxen pulling a plough. There is little to horrify the bourgeois in this picture either in terms of subject matter or technique there is only the wholesome image of majestic animals with lustrous muzzles 'dragging the plough that tears the brown breast of the land, the inexhaustible mother earth'.[35] Rosa Bonheur's paintings were also often very big. *Haymaking in the Auvergne* (plate 114) mesures over three by six metres; *Ploughing in the Nivernais*, in turn measured 170 by 260 centimetres; hanging in the Salon Carré, it was thought to look like a diorama. Such eccentricities often attracted critical flak; Gautier noted, for instance, that Bonheur's *The horse fair* of 1853, measuring over two and a half by four metres, went well beyond the bounds of genre painting. Others felt that this element of aesthetic wilfulness added an extra frisson to the painting and a number of commentators were especially intrigued to see that so large a painting had been made by a woman. But enough of the conventions of genre and landscape painting remained intact for critics and spectators to understand Bonheur's painting. The pictures may have been inordinately large but the

113
Rosa Bonheur
The artist's studio in the rue de l'Ouest, c.1849
Lithograph

114
Rosa Bonheur
Haymaking in the Auvergne, 1855
Oil on canvas, 313 x 654 cms

115
Charles-Emile Jacque
Ploughing, undated
Oil on canvas, 86.4 x 165.1 cms

116
Charles-Emile Jacque
Cattle at the watering place,
1849
Oil on canvas, 90 x 116 cms

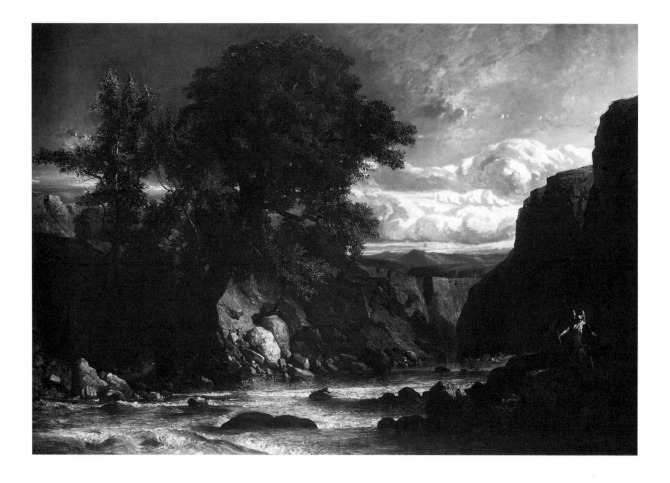

117
Constant Troyon
Tobias and the angel, 1841
Oil on canvas, 166 x 240 cms

118
Constant Troyon
Forest path (Road in the woods), c. 1844–6
Oil on canvas, 58.1 x 48.3 cms

119
Constant Troyon
Watering cattle, c. 1860
Oil on canvas, 123.8 x 163.8 cms

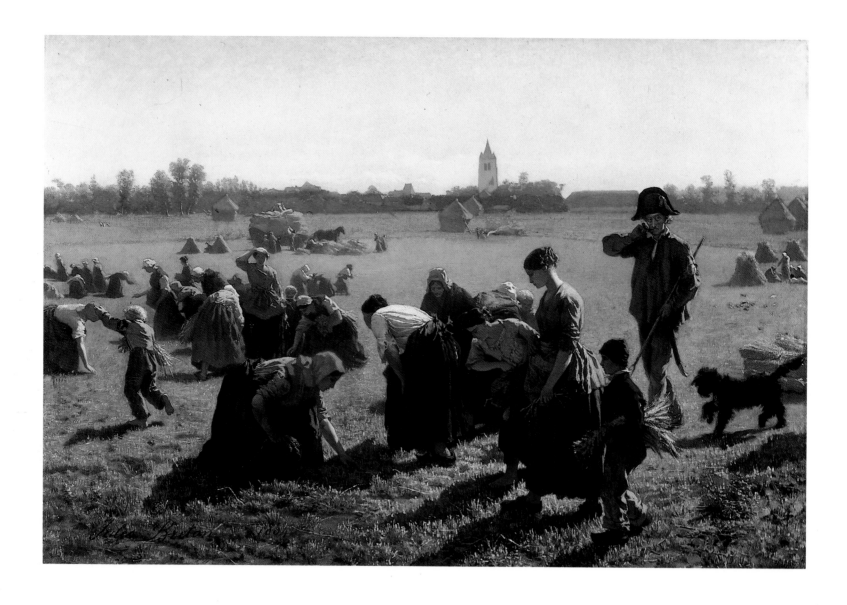

120
Jules Breton
The gleaners, 1854
Oil on canvas, 93 x 138 cms

121
Jules Breton
The recall of the gleaners,
undated
Oil on canvas, 90 x 176 cms

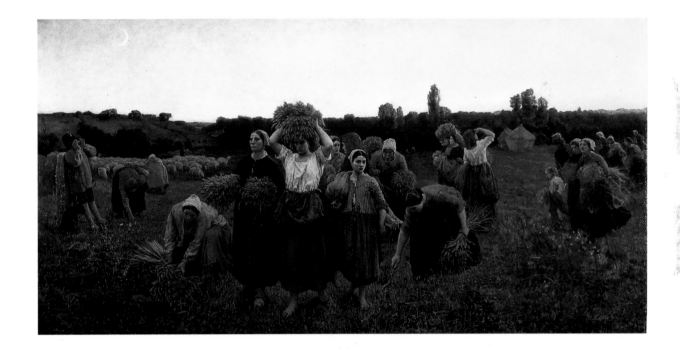

subjects was familiar. It was treated in a wholesome manner, showing the peasant going about his lawful business taking part in some timeless activity, and it was painted with care and attention to detail.

T J Clark has drawn attention to some of the radical connotations of Millet's paintings of faggot-gatherers and gleaners, but it is worth noting that even these activities could, in some cases, be tamed and adapted to suggest that the French countryside was both stable and well-disciplined.[56] Jules Breton's *The gleaners* of 1854 (plate 120), far from causing offence, was shown at the 1855 Exposition Universelle and was generally well liked by critics, earning the artist a third class medal. A subsequent image of gleaning, *The recall of the gleaners* (plate 121), shown at the Salon of 1859, was bought by Napoléon III for 8,000 francs and in 1862 was sent to the Luxembourg to form part of the state's collection of contemporary art. Both pictures show the act of gleaning as a well-ordered, feudal example of charity taking place under the benign auspices of the *garde-champêtre*. For Breton the act of gleaning, far from being a contentious image of rural poverty, had both picturesque and religious overtones. He writes:

Nothing could be more biblical than this human flock – the sunlight clinging to their rags, burning their necks, lighting up the ears of wheat, luminously outlining dark profiles, tracing on tawny golden earth flickering shadows shot with blue reflections of the zenith.[57]

Throughout the 1840s and 1850s the image of the peasant and his or her place in a rural environment remained a point of contention not only in painting but also in literature and social surveys. Attempts to industrialize the economy, migration from the country to the city, a working-class uprising and the new-found political importance of the peasant following the extension of the franchise ensured that the representation of rural life would inevitably excite some response. In short, rural imagery as a subject was clearly loaded with political connotations. Following the revolution, the image of the countryside as an uncomplicated playground for bourgeois fantasy, or as an abstract analogy for artistic retreat, was more difficult to sustain. Around the mid-1840s a new spectrum of responses to the countryside was gradually set into place. The peasant was either presented as a social anachronism or became the symbol of a wholesome and timeless moral order eroded by industrial progress. The peasant as a social anachronism was a relevant and useful image in the 1840s when industrialism was a novelty – leave the country, says Bonnemère, and find a place on the Jacob's Ladder of prosperity in the city. By the early 1850s, too

many peasants had followed Bonnemère's advice it seemed. By the end of the decade over half of Paris had been razed to accommodate the expanding population; long, straight boulevards and modern, high-rise accommodation had been constructed. The city was no longer a symbol of unbounded progress; life in the countryside began to have a greater appeal and orderly visual representations of it were fêted by critics at the Salon. By 1889, the year of the centennial celebrations of the French Revolution, a year in which the French reviewed the cultural achievement of four revolutions, a restoration, three monarchies, two Empires, and two republics, rural imagery was much in demand, a palliative for wave after wave of political and social traumas over the past 100 years. Millet's images of *The gleaners* (plate 103) and *The Angelus* (plate 110) became symbols of longed-for peace and stability, and France fought with an American collector for ownership of pictures by Millet which only 30 years before had seemed so dangerous. When France faced Germany again in 1914, *The gleaners* – adapted in the form of a recruitment poster – was used to call a nation to arms.

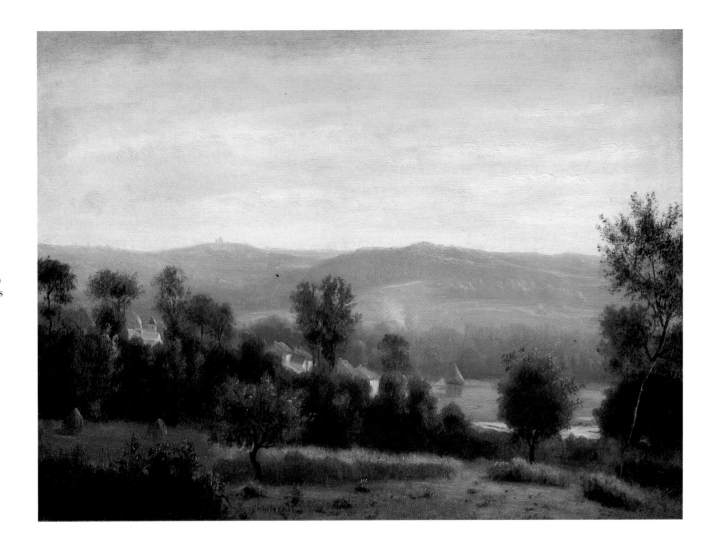

122
Antoine Chintreuil
Morning landscape, c. 1850
Oil on panel, 29.2 x 38.8 cms

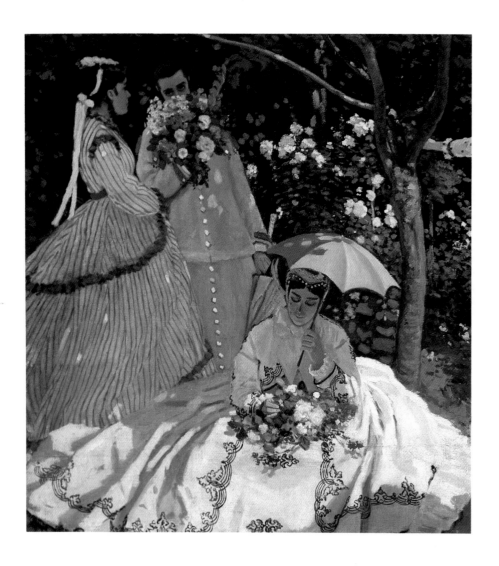

Claude Monet
Women in the garden (detail of
plate 148) 1866-7
Oil on canvas, 255 x 205 cms

By the end of the 1880s several critics had already begun to assemble a history of French landscape painting that cast the Impressionists as the heirs of Barbizon painters. The line of succession, running from Michel through to Rousseau and Corot and ending with Monet and his contemporaries, is a familiar one and has remained in use for much of the twentieth century. George Moore, writing two years after the last Impressionist show in May 1886, explained that the 'history of Impressionist art was simple'; the style of Fragonard and Watteau gave way to that of Ingres. 'Then the Turners and Constables came to France, and they begot Troyon and Troyon begot Millet, Courbet, Corot and Rousseau and these in turn begot Degas, Pissarro, Madame Morisot and Guillaumin.'[1] The centennial celebrations of 1889, in which France reviewed its cultural achievements since the Revolution of 1789, brought together a similar line-up of painters. Paul Mantz, writing an extensive account of the exhibition of French landscape painting in the *Gazette des Beaux-Arts*, picked out a broadly similar historical succession. 'Nature's re-awakening' started at the end of the reign of Charles X, he explained, the point at which the crumbling 'cardboard temple' of historical landscape painting was replaced with the 'humble peasant cottage' of romanticism.[2] The painters responsible for this re-awakening included Michel, represented by two paintings, Huet and Corot, the latter represented

by 44 works. A definite distinction is made between Corot the historical landscape painter and Corot the naturalist. Mantz writes: 'It is clear that the Corot of earlier times is not at all the same as the Corot who has charmed us later and who has supplied the centennial exhibition with so many pages of deeply felt poetry.'[3] Other painters on show included Charles de la Berge, Rousseau, Chintreuil, Daubigny and Diaz de la Peña. Diaz was represented at the exhibition with genre pieces and landscapes but, as Mantz observed, 'For us, it is the landscape that counts'.[4]

The history of nineteenth-century French landscape painting is not entirely dependent upon the machinations of art critics and writers eager to construct a neat linear succession, and there are certainly several clear affinities between the Barbizon painters and the Impressionists. The older generation of landscape painters were generally well disposed to the younger artists. In 1865, for example, Corot and Daubigny, both Salon jurors, argued against the rejection of a painting by Renoir; three years later Daubigny was held largely responsible for admitting 'les jeunes' – Monet, Bazille, Degas, Renoir, Morisot and Sisley – into the Salon, and in 1870 both Corot and Daubigny resigned as jurors after a work by Monet was rejected. Moreover, in 1867 Bazille was able to pick out Diaz, Corot and Rousseau as fellow travellers and likely contributors to his proposed independent exhibition of painters excluded from

the Salon. The critic Edmond Duranty saw Corot and Chintreuil as precursors of the 'new painting' (a term we now take to mean Impressionism); the intimate relationship between Berthe Morisot and her sister with 'père' Corot is a commonplace in the early history of the movement; Pissarro claimed to be Corot's pupil in the Salon catalogue of 1864 and numerous other Impressionists cited him as an influence on their work. Diaz, in turn, offered financial support to the young Renoir; Daubigny was responsible for introducing Monet to Durand-Ruel, and the first instinct of Bazille, Monet, Sisley and Renoir, when in search of suitable motifs in 1866 and 1867, was to follow in the footsteps of the older generation of landscape painters and head for Fontainebleau. The litany of historical links between the two movements is extensive.

Despite the obvious ties between the two generations of painters the development of landscape painting in the period running up to the first Impressionist exhibition is by no means straightforward. Duranty may have earmarked Corot, Chintreuil and Courbet as precursors of the 'new painting', but so too intriguingly was Ingres! There are crucial differences between the two generations and the one did not necessarily foster the enthusiasm of the other. It is interesting, for example, to discover that Monet thought Corot 'a swine' and maintained that the masters of 1830 did little to encourage the younger generation of landscape painters.[5] Moreover, when Constant Troyon gave advice to the young Monet he recommended a conventional academic education based upon drawing the human figure. Some years later Monet was prepared to credit the influence of Courbet and Millet but had doubts about aspects of Rousseau's work, in particular his selective rendition of nature and the 'dryness' of his technique. In 1868, six years before the first Impressionist exhibition, Emile Zola was able to detect a clear difference between the interests of the Barbizon painters and the younger generation of landscape painters. He writes:

In the country Claude Monet prefers a view of an English park to a corner of the forest. He takes pleasure in discovering traces of humanity everywhere, he wants to live continually in a human environment. Like a true Parisian he takes Paris with him to the countryside, he cannot paint a landscape without including well-dressed men and women.[6]

Zola was quite right. The repertoire of subjects depicted by Monet and by his peers is often very different from those picked out by Barbizon painters. The former tended to be preoccupied by modernity and the city, the latter by the appreciation of raw Nature. Stéphane Mallarmé's

123
Antoine Chintreuil
Path through the apple trees,
undated
Oil on canvas, 35 x 72 cms

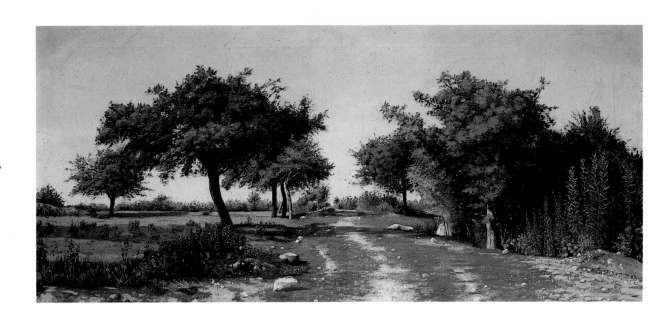

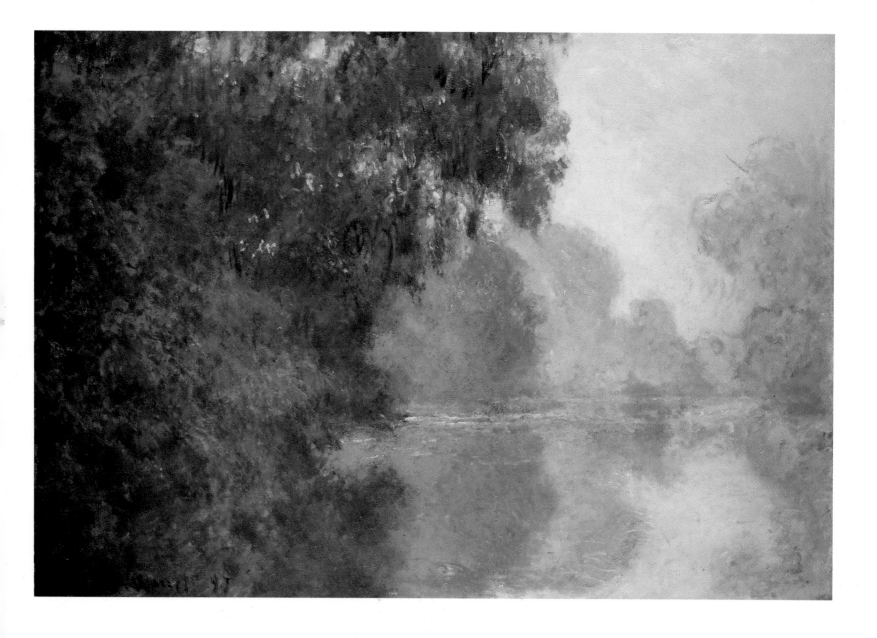

124
Claude Monet
Early morning on the Seine,
1897
Oil on canvas, 84 x 110 cms

125
Jean-Baptiste-Camille Corot
A nymph playing with Cupid,
1857
Oil on canvas, 78.5 x 57 cms

126
Alfred Sisley
Avenue of trees near a small
town, c. 1865
Oil on canvas, 45 x 59.5 cms

127
Charles-François Daubigny
The banks of the Seine, 1851
Oil on canvas, 70 x 105 cms

article 'The Impressionists and Edouard Manet', published in 1876, also saw clear distinctions between the two generations of painters. The Romantics, he maintained, were 'dreamers', their painting motivated by introspection; the Impressionists, by contrast, were energetic workers struggling to represent the material stuff of the modern world.

In order to understand the way in which the work of Barbizon painters leads on to Impressionist painting it is important to look not at one but at several conventions in landscape painting, and to examine the changing status of landscape during the last years of the Second Empire. It is necessary, for example, to reconcile the introspective works of Rousseau and Diaz and the *plein air* paintings of Daubigny with the much more ambitious bids for public recognition made by Monet, Bazille and Renoir in the mid-1860s. A painting such as Monet's monumental *Le déjeuner sur l'herbe* has an important place in the history of landscape painting although it is informed by ideas, aspirations and influences quite different from those which underpin many small-scale naturalistic landscapes. To make sense of the changing conventions in landscape painting, it is necessary to begin by looking at government policy on the arts in the 1860s.

Government policy on the arts during the Second Empire

Napoléon III was not much interested in the arts. His taste was thought to be ill-informed and political expediency often set the tone of state patronage. During the Second Republic Charles Blanc had handed out numerous state commissions to landscape and genre painters. The Empire that followed in its wake sought initially to use the arts to glorify its own image and that of the Catholic church, its principal ally in the coup d'état, and in the 1850s there was a renewed interest in the authoritative power of *grande peinture*. Few genre and landscape paintings were bought by the state after about 1853 and those that were acquired often had Imperial associations. Not only art but also art institutions had a political function; in return for its support for Napoléon III, the Académie des Beaux-Arts was given back many of the privileges it had lost in 1830. The Salon jury was once again under the government of academicians rather than exhibitors, and exhibitions were now held every two years rather than annually, greatly restricting the opportunities of independent painters to show work in public.[7] Not surprisingly, many artists, landscape painters among them, began to worry about the new-found power and influence that the conservative Académie would have upon their careers.

Throughout the 1850s, but especially in the 1860s, the

Empire had a strong populist flavour and was prepared to recognize a broad constituency of political and cultural interests. In fact, this spirit of eclecticism was roundly criticized after 1868 when press censorship was relaxed and the fine arts administration was accused of meekly following popular opinion in the arts rather than forming it.[8] Something of this liberal, eclectic approach found its way into state policy on the arts. In 1855, for example, the Emperor was able to sanction the exhibition of Delacroix's *Liberty leading the people* on the grounds that the picture's aesthetic merits outweighed its dubious political content. Eight years afterwards the government met a chorus of protest following the rejection of over 60 per cent of paintings from the official Salon of 1863, not with a reproof but by establishing the Salon des refusés which enabled the public to see works rejected by the official jurors and to judge the quality of the pictures for themselves. That the public, egged on by a conservative press, laughed helplessly at the likes of Manet's *Le déjeuner sur l'herbe* (plate 140) does not undermine the essentially populist nature of the exercise.[9]

The more liberal cultural climate of the 1860s saw a marked shift in the relationship between the government and the Académie. The Académie was thought to be anachronistic and increasingly out of touch with popular taste in the arts, and November 1863 saw the publication of an Imperial decree announcing the wholesale reorganization of the fine arts. Stripped of most of its responsibilities, the Académie lost control both of the Ecole des Beaux-Arts and the Academy in Rome. At the same time, the role of the Ecole was extended to cover not only drawing, traditionally deemed by academicians to be the most important part of the curriculum, but also practical techniques, art history and a public education programme in which a wide cross-section of artists were invited to speak. The decree also announced restrictions on academic competitions, in particular the abolition of the *Prix de Rome* for historical landscape. The reforms were encouraged by a number of Barbizon painters. Daubigny, Barye, Huet, Chintreuil and Troyon were signatories to an open letter to the Emperor published in *Le Moniteur* praising the reorganization. Paul Huet was especially pleased about the abolition of the prize for landscape painting and wrote to the Count of Nieuwerkerke, the minister for fine arts, to congratulate him. In effect, the reforms marked the end of the authoritarian, classical approach of the Académie and of the style that had gained its official approval. Thereafter, the Ecole increasingly recognized the importance of originality in painting and the personal identity of its maker. By challenging the authority of the Académie and

recognizing the role of individual creativity in the arts, the Second Empire had recognized and given official approval to the taste of the bourgeoisie. In the 1830s this was seen as either revolutionary or mercantile; conservative critics frequently referred both to democracy and to the 'art of the *bon marché*' when searching for ways of describing the shortcomings of middle class taste in the period of the July Monarchy. During the Second Empire, however, bourgeois taste was, as Théodore Duret observed, broader in scope; it covered anything from the erotic classical Venuses of Alexandre Cabanel and Amary Duval to the meticulously finished genre scenes of Léon Gérôme, Decamps and Meissonier.[10] History paintings continued to be produced but these were now more likely to describe recent events such as Imperial victories rather than subjects from classical antiquity. Some indication of the standing of genre painting in the 1860s is revealed by the torrent of official and critical recognition accorded to the work of Meissonier and to the awards given to artists following the Exposition Universelle of 1867. Only one of the eight *médailles d'honneur* was awarded to a history painter, Alexandre Cabanel, a favourite of the Emperor. The remaining seven were presented to genre painters.

Landscape painting during the 1860s
Barbizon painters had fared badly after the collapse of the republic. In the more liberal climate of the 1860s, however, the fortunes of landscape painters began to improve. By 1867 history painting, after ailing for 30 years or more, was now thought to be dead, along with Ingres its principal exponent. It was, therefore, against the aesthetic standards of genre painting that landscape was now frequently judged and Rousseau was taken to task not so much for his subject matter – the countryside was no longer deemed to be that offensive – but for the short-comings of his technique. Get close enough, says the critic Ernst Chesnau and the painting looks like a crude fabric.[11] The crude, fabric-like appearance is found in a number of late examples of Rousseau's painting. The Louvre *Lane in the forest, storm effect* (plate 129), for example, painted between 1860 and 1865, uses broken brushwork and freely applied paint to articulate the effect of the setting sun through the broken clouds and passages in the middle distance.

From the mid-1860s, however, Barbizon painters began to receive official and critical recognition and a measure of financial security. The majority of Barbizon painters were represented at the 1867 Exposition Universelle and by about 1870 works by Diaz, Corot, Dupré, Rousseau, Daubigny and Millet were commanding good prices in sales. Rousseau, now widely acknowledged as the leader of

the school of French landscape painting, was invited to one of the cultural soirées held by the Imperial family at the Château de Compiègne in the winter of 1865. In 1867 he was elected president of the jury for painting for the Exposition winning one of the four *grandes medailles* at the exhibition, and later that year, along with Charles Jacque, he was awarded (albeit belatedly) the Légion d'honneur. Chintreuil's paintings appeared regularly at the Salon; examples of his work were acquired by the state in 1864, 1868 and 1869. He too was invited to Compiègne in 1868 and was elected a member of the Salon jury for 1870. Even Millet received official recognition: he was represented in the 1867 Exposition with nine paintings including *The gleaners* and *The Angelus*, was awarded a first class medal, and in August of 1868 was made a Chevalier of the Légion d'honneur. Paul Mantz, writing that year in the *Gazette des Beaux-Arts*, was able to reassure his readers that the works of Millet were now appreciated by most people with taste and that the future of the painter was now secure.[12]

From the late 1860s Barbizon paintings began to exchange hands for substantial sums. Daubigny was particularly successful, with individual works selling for around 5,000 francs, and he received lucrative commissions from the state and the Imperial family. Diaz and Dupré seldom showed at the Paris Salon and received few official favours but were widely sought after by collectors and dealers such as Goupil, Brame, Durand-Ruel and George Petit. Diaz held private sales of his work throughout the 1860s. At first pictures seldom fetched more than 500 francs, but by 1867 the art dealer Brame was prepared to pay 8,000 francs for one painting and it was estimated that Diaz could make about 50,000 francs a year in picture sales. Dupré, another absentee from the Salon, also showed work in his studio and exhibited through art dealers. Durand-Ruel was prepared to pay between 1,000 and 3,000 francs for his work in the mid-1860s; in 1873, however, he bought *View of Southampton* for 42,000 francs. Durand-Ruel and Brame also bought Rousseau's work in some quantity; 40,000 francs were paid to the artist for work he had yet to finish, and a further 100,000 francs were paid for a collection of sketches made over the previous three decades. The sum is significant. It not only points to the standing of the artist's work among collectors but also to the rising status of the painted sketch in specialist circles during the 1860s.

In some respects the reputations of Barbizon painters went from strength to strength. Georges Michel, Millet and Rousseau were each the subject of a monograph by Alfred Sensier, an associate of Paul Durand-Ruel. The stud-

ies did much, as Christopher Parsons and Neil McWilliam have indicated, to promote the reputation of the painters and to raise the price of their work.[13] From the early 1880s works by Barbizon painters were sought after not only in France but also abroad. Paintings were collected and promoted in Britain, Holland and Belgium , where naturalistic images of the countryside were part of a well-established pictorial tradition dating back to the early seventeenth century. They were also collected in the United States where images of the land and the moral integrity of those that farmed it had a particular appeal to a young nation weaned on notions of God, democracy, individualism and self-sufficiency. The American painter William Morris Hunt, a student of Millet, returned to the United States with a collection of Barbizon paintings and was partly responsible for promoting the school in Boston society. The collector Harry Havemeyer bought works by Diaz de la Peña on the advice of the American Impressionist painter Mary Cassatt.[14] Aided by Paul Durand-Ruel, he later added paintings by Rousseau, Corot and Millet to his collection. In 1893 Havemeyer bought two works by Troyon and Dupré, paying sums of $45,000 and $25,000, substantially more than the prices fetched for perennially collectable genre paintings by Meissonier. The American industrialist George Sevey was also interested in work by Barbizon painters. The sale of his collection in 1885 raised over $400,000, and over one-quarter of a million dollars was raised by the sale of Albert Spencer's collection in 1889. The paintings were sold to raise cash to buy examples of Impressionist painting newly launched in the United States by Durand-Ruel following his successes with Barbizon painters.

However, just at the moment when Barbizon painting began to receive wide recognition from the public and the state, many of its conventions began to be challenged by younger painters and critics. Emile Zola picked out some of the differences between the two generations of landscape painters in his *Salon* of 1866. Writing on Rousseau's paintings, he complained that the execution was too delicate; one could see each leaf. In his review of the Exposition Universelle, 'Nos peintres au Champ de Mars', Zola went on to explain that:

He [Rousseau] approaches nature in a despotic mood as a tyrant whose whims are laws; he has a fine little theory for every occasion and he views his world through prepared glasses that show him just as much as he wants.[15]

The 'theory' to which Zola refers finds form in the subjects and compositions used by Rousseau and his peers.

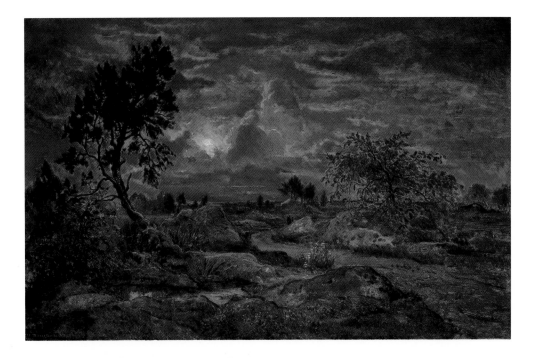

128
Théodore Rousseau
Sunset near Arbonne, c.1863
Oil on panel, 64.2 x 99.1 cms

129
Théodore Rousseau
Lane in the forest, storm effect,
c. 1860–5
Oil on canvas, 30 x 51 cms

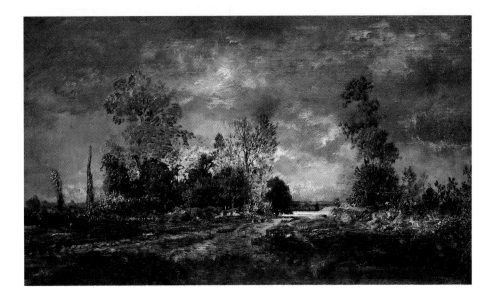

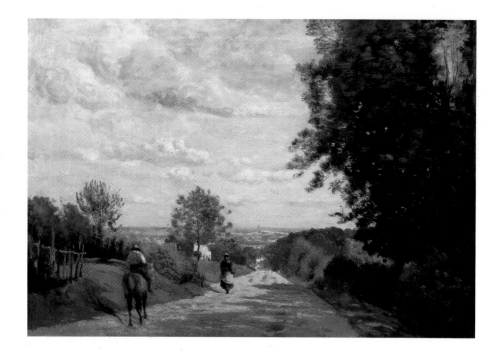

In the same way that the academic conventions, the depictions of classical temples and the actions of Greek and Roman gods were increasingly thought to be outmoded in the 1830s and 1840s, so the use of setting suns, mysterious landscapes and strategically placed passages of light and shade, evident, for instance in Rousseau's late landscape *Sunset near Arbonne* of 1863, began to appear somewhat old-fashioned to many younger landscape painters. A new repertoire of subjects had appeared and with it a new approach to depicting them.

Painting in the open

For Zola, Rousseau's paintings placed too great an emphasis on the subjective insight of the painter. The style of the '*nouvelle phalange*' of younger landscape painters, however, was thought to be less subjective and more scientific in its approach, though personal subjectivity was not abandoned altogether (if it was, Zola explained, paintings would be reduced to the level of mere photographs). In 'Le moment artistique', published in the journal *L'Evénement* in 1866, Zola explained that there were two complementary elements at work in the creative process: one was nature, a fixed element, and the other, the personality of the maker.[16] In the early 1860s, both Zola and Champfleury began to indicate that nature was substantive, that it had a material reality and that the artist should struggle to capture an 'impression' of it before it vanished. When caught, that 'impression' of nature should be recorded directly in an even-handed, objective manner without the visual conventions used by the older generation of landscape painters. The results of this new approach might well produce some unusual, seemingly clumsy painting but the style would at least record the natural world with integrity.[17]

Zola's interest in a more scientific approach to the study of nature explains his admiration not for Corot's more lyrical landscape paintings but rather for studies made before the motif in which the the artist was said to be 'face to face with powerful reality'. The two approaches to landscape – the lyrical and the mimetic – can be seen by contrasting three works by Corot: *The concert* of 1844 (plate 59), the *Souvenir of Mortefontaine* (plate 131), made over two decades later, and *Sèvres-Brimborion, view towards Paris* of 1855-65 (plate 130). In 1868 Barthold Jongkind was similarly praised by Zola for the accurate representation of nature in his seascapes. Zola writes:

His manner of painting is just as unusual as his way of seeing. He uses astonishingly broad sweeps, the highest degree of simplification. His work seems like rough sketches put down in haste for fear of losing the first

130
Jean-Baptiste-Camille Corot
Sèvres-Brimborion, view
towards Paris, 1855-65
Oil on canvas, 34 x 49 cms

131
Jean-Baptiste-Camille Corot
Souvenir of Mortefontaine, 1864
Oil on canvas, 65 x 89 cms

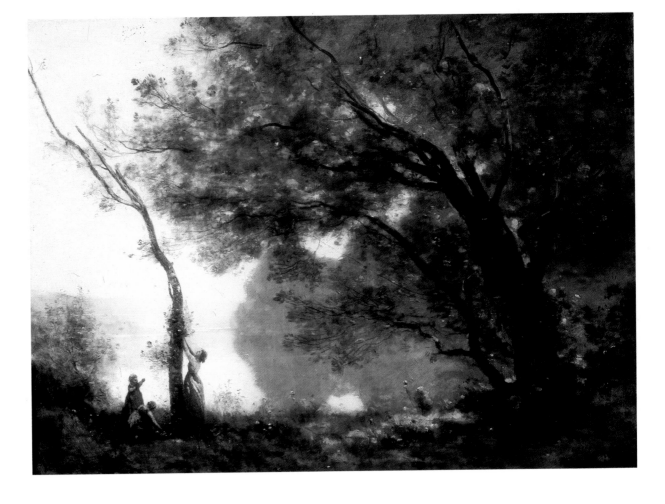

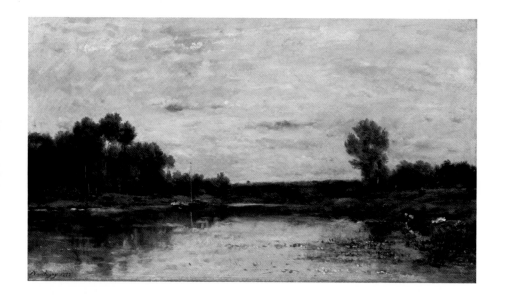

132
Charles-François Daubigny
View on the Oise, 1873
Oil on panel, 38.7 x 66 cms

133
Charles-François Daubigny
Sunset over the Oise, 1865
Oil on canvas, 39 x 67 cms

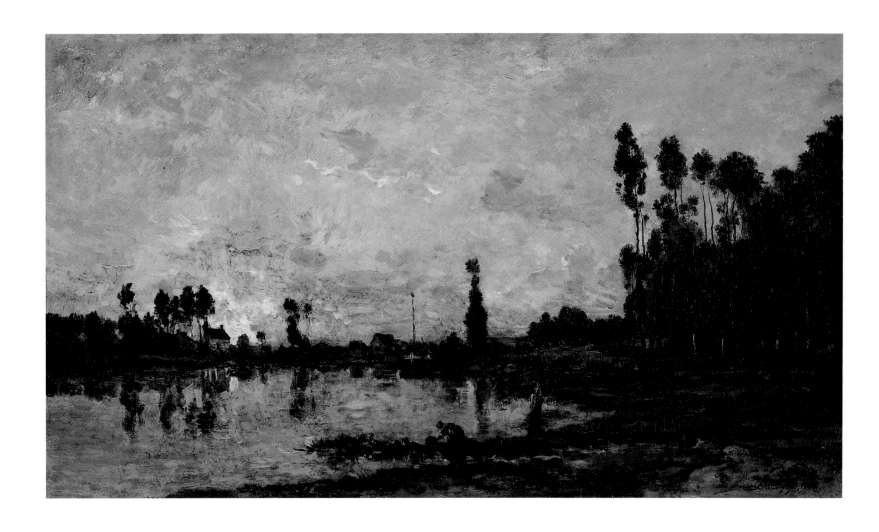

impression. One feels that the entire phenomenon takes place in the eye and hand of the artist. He sees a landscape at a glance, in the reality of its general effect and he interprets in his own way, conserving the truth and conveying the emotion he has experienced.[18]

The transition between the style of the School of 1830 and that of the *'jeune école'* of landscape painters that followed in their wake was thought by many critics to be apparent in the work of Charles-François Daubigny. In *View on the Oise* (plate 132) painted in 1861, Daubigny painted in a style similar to that used in the 1850s. The painting was detailed and executed in a fairly high chromatic key. Around the early 1860s, however, his manner changed. Théophile Gautier explained that the artist had begun to work in a 'lazy style' and was too easily satisfied with a simple 'impression'. Daubigny has been 'possessed', explained the critic of *Le Moniteur des Arts* in 1865: 'Alas', he writes, 'why has M Daubigny changed his style, no one could question his talent, which is undeniable, but an evil demon hinders him now.' *Salonniers* often found it hard to describe the exact nature of these changes and found it easier to pick out what was missing rather than what was apparent in his work. In short, Daubigny's works were without 'style', he ran the risk of becoming 'unintelligible' and was thought to have simplified his work to such an extent that the subjects became 'insignificant'. Some friendly critics fixed upon precisely the same point, the ostensible absence of any recognizable visual rhetoric in his work. They variously speculated that he was attempting to be systematic, conscientious, child-like and naive in his transcription of the landscape through *'l'impression'*, and used both the terms *'réalisme'* and *'naturalisme'* to describe his manner of painting.

Around the 1860s an alternative critical discourse began to emerge and was used to explain new departures in the work of Daubigny and his followers. Greater attention was paid to the central role of nature, and fewer references were made to the creative insights of the painter; when reference was made to the personality of the artist it often centred on the painter's willingness to abandon any stylistic programme and to submit to the authority of nature. The extent to which this romantic rhetoric had been abandoned is visible in Daubigny's *The harvest* of 1851 (plate 109) and in the *Alders* (plate 134) and *Sunset over the Oise* (plate 133), painted over 20 years later. In each instance, light is more evenly dispersed across the picture, the compositions are relatively simple and depend primarily on the use of horizontal bands. The earlier *Harvest* is more meticulously finished with details on the horizon described with minute touches of paint. The later

134
Charles-François Daubigny
Alders, 1872
Oil on mahogany, 33 x 57.1 cms

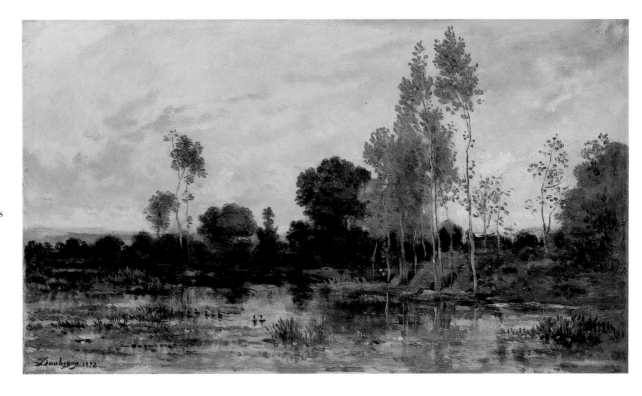

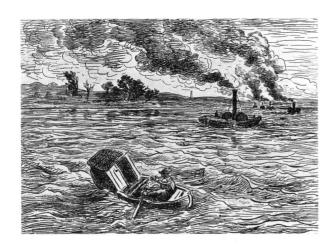

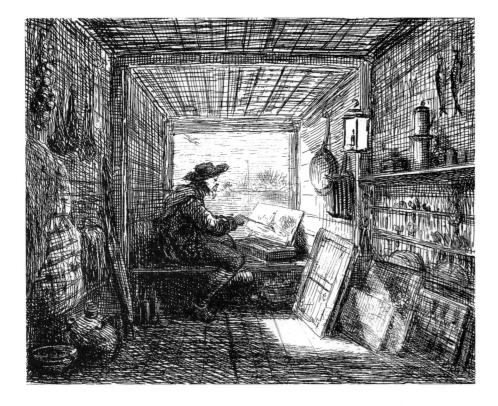

135
Charles-François Daubigny
The 'Botin' and steamboats
from *Voyage en Bateau*, 1862
Etching

136
Charles-François Daubigny
The floating studio from *Voyage en Bateau*, 1862
Etching

Alders and Sunset over the Oise, however, are handled in a much broader manner: in each instance the subject being captured through rapidly applied, broken patches of paint. This manner of painting resembles Impressionist painting of the 1870s but there is little emphasis placed upon the primacy of the modern world, particularly the city, and the range of colours used in Daubigny's work is sombre in comparison with those used by Monet and his contemporaries. Daubigny had, however, identified nature as the most important subject for painting relegating the artist to the status of the honest, even-handed, disinterested observer.

The role of the artist as disinterested observer of the natural world led to an increased dependence upon painting before the motif. Artists had worked *en plein air* throughout the nineteenth century. Daubigny, however, gave far greater prominence to a more direct and sustained confrontation with nature which, in turn, led to a greater simplicity in his work. Paintings made on board 'le Botin', a specially converted ferry-boat launched in 1857 designed for painting in the open, are made up of gestural licks of paint laid on the canvas in response to a momentary 'impression'. Henriet described the process in 'Les campagnes d'un paysagiste' in which the artist struggled to record the transient effects of a moving, cloudy sky, working rapidly on his picture before the weather conditions changed. The subjects, caught and transcribed on canvas in an instant, were largely depicted without the use of the compositional *vignettes* and romantic pyrotechnics found in earlier works by Dupré, Diaz, Rousseau and others. Compositions were based on the use of simple horizontal bands interrupted by an arbitrary sequence of vertical trees, settlements, cattle or figures. John House has called attention to a parody of this approach found in the etching by Daubigny of his floating studio (plate 136). A small landscape painting propped up in the corner shows a monotonous row of evenly spaced trees between which are inscribed individual letters to make the word 'realism'.[19]

Daubigny's techniques of painting *en plein air* have long been part of the mythology of early Impressionism. Etienne Moreau-Nélaton and Frédéric Henriet have both written near burlesque accounts of the perils he encountered painting in the open. Moreau-Nélaton recounts, for example, how a painting by Daubigny nailed to a post before the motif was left in the open, prey to the pranks of children and to damage by livestock.[20] On another occasion, Daubigny was reported to have stepped back to examine one of his studies, quite forgetting he was on board his floating studio, and fell overboard. A similarly light-hearted note is struck in a suite of etchings by Daubigny, *Voyage en Bateau, Croquis en Eaux-Fortes*, published in 1862 by Cadart, an account of the trials of an expedition on 'le Botin'. The etchings record lunch on board the boat; an interior view of the floating studio; a scene of near-shipwreck as 'le Botin' catches the wash of a passing steamboat; a cosy night on board, and the incident when an oar breaks sending the oarsman head over heels into the prow. The three final scenes show fish rejoicing at the departure of the cabin boy, Daubigny's son Karl, the departure on the train and, lastly, 'tales of the adventures' in which the family gather around to hear the adventures of the expedition. Little of this burlesque flavour found its way into Daubigny's paintings of the period and critical responses to such works are serious rather than light-hearted in tone. In fact, critics implied that there was much at stake; Daubigny's lazy manner, they insisted, ran the risk of compromising an otherwise impressive talent.[21]

During the 1860s *plein air* painting was also associated with a community of marine painters based around the Normandy coastline between Trouville and Honfleur. Like Fontainebleau, it had a popular *auberge*, the Ferme Saint-Siméon, run in this instance by Madame Toutain and, like Fontainebleau, it also suffered from the effects of tourism. The painter Charles Mozin, one of the first artists to take up permanent residence in the district, regretted the extent to which the influx of painters had prompted a similar invasion of tourists eager to see the picturesque coastline for themselves. The Ferme Saint-Siméon was visited by most of the School of 1830 and also by Jongkind and Boudin, the latter a resident of Honfleur. This community of painters is important in the development of Impressionist painting. Boudin and Jongkind, like Corot, Daubigny and others, had a marked influence on the younger generation of landscape painters, particularly Monet. Sponsored by Troyon and Couture, Boudin won a scholarship to study at the Ecole des Beaux-Arts but returned to his native Honfleur disillusioned with his experience of the capital. From the 1850s he began to produce small pastel and watercolour sketches made in the open. Although they were often used as detailed notes for more finished studio pictures, the sketches were notable for their spontaneity. Charles Baudelaire emphasized precisely this point in his *Salon* of 1859.[22] He was especially taken by the extent to which Boudin's sketches had accurately captured the fleeting effects of the changing weather. The studies, he noted, were so precise that they were even marked with the date, the time of day and the direction of the wind. Finished paintings of the late 1850s and 1860s were worked up in the studio but still retained much of the freshness of preparatory studies. The beaches, skies

137
Claude Monet
The beach at Trouville, 1870
Oil on canvas, 37.5 x 45.7 cms

138
Eugène Boudin
Beach scene, Trouville, 1873
Oil on panel, 15.2 x 29.8 cms

139
Edouard Manet
Monet working on his boat,
1874
Oil on canvas, 82.5 x 100.5 cms

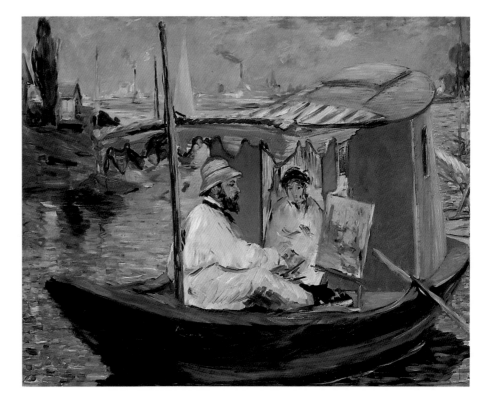

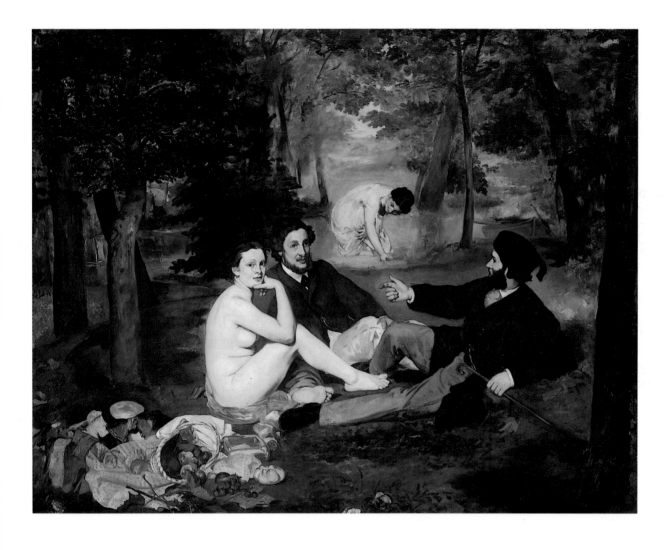

140
Edouard Manet
Le déjeuner sur l'herbe, 1863
Oil on canvas, 208 x 264 cms

and figures were articulated with small, broken patches of paint, serving to emphasize not individual details but a general unified effect, a feature common in small-scale, naturalistic landscape painting of the 1860s.

The broken brushwork in Boudin's painting generates not only a sense of immediacy but also suggests a degree of cultural and psychological distance between the spectator and the subject. Figures lose much of their individual identity; faces, crinolines, bonnets, the beach and sky dissolve into a unified network of dabs of paint. This sense of alienation between the subject and the spectator is augmented by a compositional device in which the figures are organized in intimate groups but are firmly projected into the middle distance of the painting. The spectator looks on at a scene of some intimacy but is denied any sense of psychological community with the subjects both through their implied distance from the picture plane and the way in which the clusters of figures take shape in paint. It is difficult to determine Boudin's attitude towards his subject matter, but writing to a friend in the early 1860s, he expressed doubts about the effects of tourism on the district, describing some of the visitors as 'gilded parasites'.[23]

The Impressionists at Fontainebleau

While an increasing number of art critics recognized the strength and originality of contemporary French landscape painting, the genre could never claim anything like the attention, albeit often pejorative, given to large paintings such as Courbet's monumental canvases of the 1850s and Manet's notorious *Le déjeuner sur l'herbe*. When the art critic Paul Mantz praised the virtually unknown Claude Monet in his Salon review of 1865 he described him as a 'talented new-comer' within the relatively minor league of marine painting.[24] In the mid-1860s, however, Monet, Renoir and Bazille made a sustained attempt to step out of the narrow confines of small-scale landscape painting and began to paint large canvases depicting figures and different facets of contemporary urban life. In fact, the suggestion that painting should record human actions, manners and customs was made by Charles Baudelaire in his *Salon* of 1845. During the Second Empire the demand was re-stated by a number of left-wing and liberal art critics. Prudhon, for instance, argued for the depiction of men and women in a domestic and civic context, and Castagnary's *Salon* of 1861 noted how naturalistic landscape painting was gradually being supplanted by a concern for the accurate depiction of human activity. Monet, Bazille and Renoir also made an attempt to align themselves more directly with radical avant-garde painting. Landscape painting was not short of its detractors but the criticism

heaped upon the School of 1830 and their successors was modest in comparison with the critical vitriol directed at Courbet and above all Manet. By basing their paintings on infamous works by the *enfants terribles* of modern French art, Monet, Bazille and Renoir were trying to jump from the backwaters of landscape and marine painting into the avant-garde mainstream. The forest of Fontainebleau, its association with bourgeois culture and its renown as a locale for landscape painters played an important role in this process.

Monet, Bazille, Renoir and Sisley worked in the forest of Fontainebleau in 1865 and 1866. Sisley's landscapes of the period were modest in scale and intention. The *Village street, Marlotte* (plate 141) painted in 1866 is relatively small; it measures less that one metre in width and shows an undemanding subject, a wood-cutter at work in the village to the south of the town of Fontainebleau, executed with the disinterested touch found in many other examples of naturalist painting. The work of Sisley's contemporaries, however, was much more ambitious. Monet, Bazille and Renoir each attempted to raise the stakes of naturalism by working on a much larger scale and introducing figures into their compositions. Perhaps the most important painting of this period is Monet's *Le déjeuner sur l'herbe at Chailly* planned for the Salon of 1866.[25] The final painting, known now only by two large surviving fragments (plates 143 and 144), a large preparatory study and sketches, originally measured over 20 feet in width. The sheer scale of the painting indicates that Monet, like Courbet before him, was making a concerted bid for public recognition. Although *Le déjeuner sur l'herbe* took its lead from Courbet in terms of its heroic scale, its title was taken from Manet's notorious picture shown at the Salon des Refusés of 1863. Unlike Manet, however, Monet attempted to use light in his painting in a far more naturalistic manner. The full-scale painting was preceded by several preparatory landscape studies of the area around the Bas-Bréau road near Chailly among them *The Bodmer Oak, Fontainebleau,* (plate 147) and *The road to Chailly* (plate 146), the latter shown at the Salon of 1866, and a number of preparatory figure studies for which Bazille and Camille, the artist's wife, posed in the open air. The penultimate version of the final painting clearly shows the extent to which these preparatory figure studies finally enabled Monet to integrate the figures with the surrounding landscape. In Manet's painting the three main figures stand out in sharp contrast to the background. In Monet's riposte, at least in its generative phases, the conventions of the preparatory smaller-scale *plein air* paintings, in which the central motif is dissolved by broken brushwork, are used on the larger version fragmenting the individual

141
Alfred Sisley
Village street, Marlotte, 1866
Oil on canvas, 64.7 x 91.4 cms

142
Alfred Sisley
Louveciennes – rue de Sèvres,
1873
Oil on canvas, 54.7 x 73 cms

143
Claude Monet
Le déjeuner sur l'herbe at Chailly, left-hand fragment, 1865–6
Oil on canvas, 418 x 150 cms

144
Claude Monet
Le déjeuner sur l'herbe at Chailly, central fragment,
1865–7
Oil on canvas, 248 x 217 cms

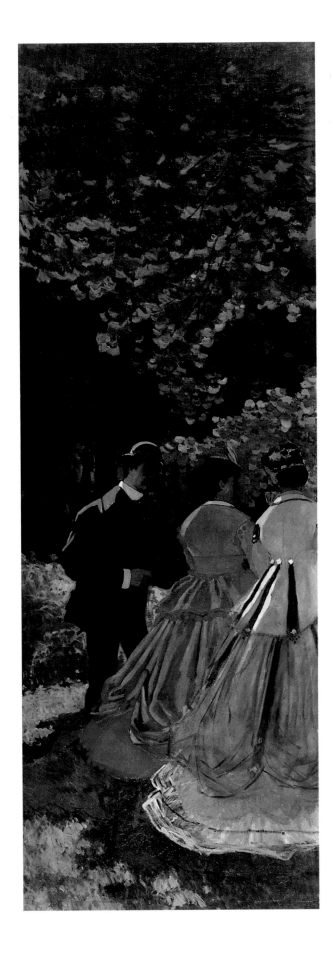

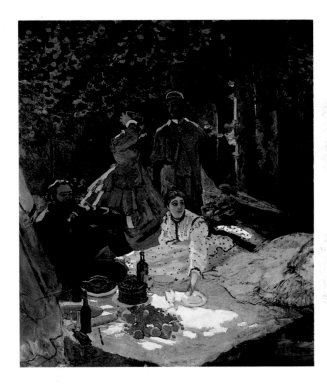

145
Claude Monet
*Woodgatherers at the edge of the
forest*, 1864
Oil on panel, 59.7 x 90.2 cms

146
Claude Monet
*The road to Chailly, route de
Bas-Bréau*, 1865
Oil on canvas, 43.5 x 59 cms

147
Claude Monet
*The Bodmer oak, Fontainebleau
forest*, 1865
Oil on canvas, 96.2 x 129.2 cms

figures into broken patches of dappled sunlight.

The more naturalistic style of Monet's painting was complemented by a more naturalistic interpretation of the subject. Manet presented his audience with the unlikely combination of two middle class men and a naked woman picnicking in a forest, a scene taken from a section of an engraving after a painting by Raphael by Marcantonio Raimondi. Consistent with the demands of naturalism, Monet's painting is altogether more plausible. It takes its subject matter from a variety of sources. The painting depends in part upon the conventions of the *fête-champêtre*, a genre pioneered by Watteau, Lancret and Van Loo in the eighteenth century in which the leisured aristocracy of the *ancien régime* were shown against the backdrop of a fictional, lyrical landscape. The painting, however, heavily relies upon the middle class vision of the natural world articulated by contemporary guides to the forest in which the signs of the city – the urban dress of the men and women, the fashionable dog, the provisions set out on the white cloth and so on – are set against the bourgeois ideal of nature, the forest of Fontainebleau. Alfred Bousquet's advice – forget about staining your trousers and your silk robe (quoted in the introduction) – could, it seems, have been written for this very painting.

Frédéric Bazille painted several works during his visit to Chailly, among them landscapes and figure paintings One painting, *The improvised hospital* (plate 149) shows the wounded Monet recovering in bed at Chailly following an accident while working in the forests, an event which interrupted his work on *Le déjeuner sur l'herbe*.[26] Both Manet and Monet's versions of the painting prompted several pictures on related themes by Bazille. *Landscape at Chailly* (plate 150), painted in 1865, shows three figures clustered beneath a clump of trees beside a river and owes an obvious debt to Monet's painting. Bazille also used the theme of figures in the open air for a sequence of paintings of members of his family. *The family reunion* (plate 155), painted in 1867 while on vacation at Meric, shows his family posing on the terrace with eight of the 11 figures staring out directly at the audience. Bazille, like Monet, was attempting to unite the group of figures with the aid of natural daylight. In this instance, however, the figures are set, not in dappled shade, but saturated in sunlight, harsh in outline and with little modulation in tone.

Renoir's major painting made in Fontainebleau in 1866 is of Mère Anthony's *auberge* at Marlotte (plate 153), described by Théodore Duret as an annex to Barbizon, and one of the most popular inns among landscape painters.[27] Renoir probably took his lead not from Manet but rather from Gustave Courbet's *After dinner at Ornans*.

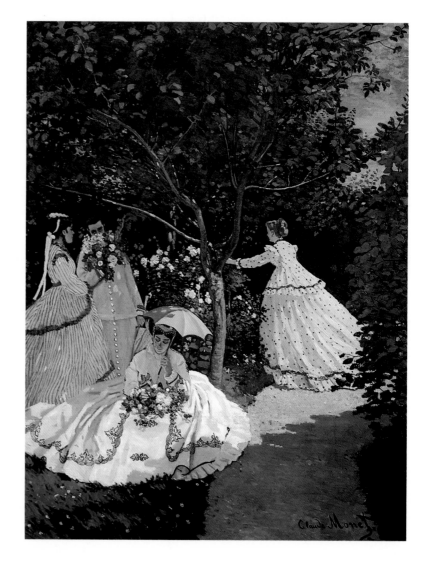

148
Claude Monet
Women in the garden, 1866–7
Oil on canvas, 255 x 205 cms

149
Frédéric Bazille
The improvised hospital (Monet after his accident at the inn at Chailly), 1865–6
Oil on canvas, 47 x 65 cms

150
Frédéric Bazille
Landscape at Chailly, 1865
Oil on canvas, 81.5 x 101.6 cms

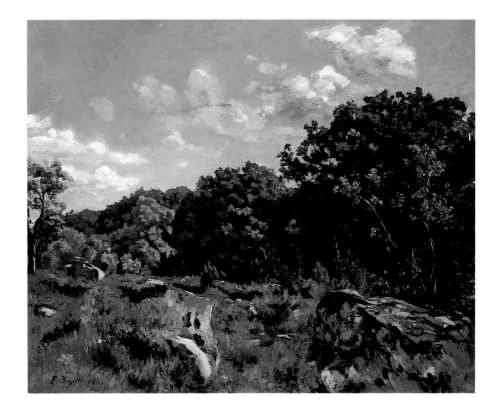

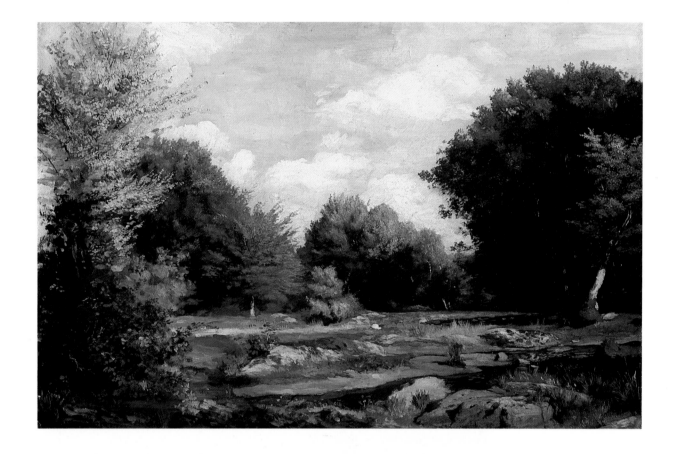

151
Pierre-Auguste Renoir
Clearing in the woods, 1865
Oil on canvas, 57 x 83 cms

152
Pierre-Auguste Renoir
Portrait of Jules Le Coeur walking his dogs at Fontainebleau,
1866
Oil on canvas, 106 x 80 cms

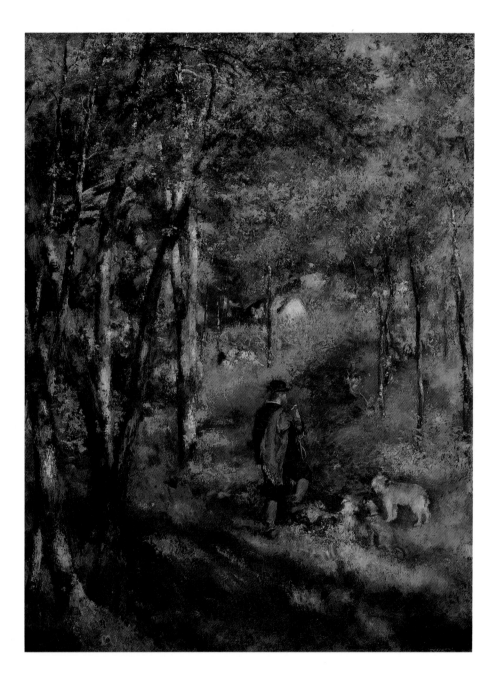

153
Pierre-Auguste Renoir
The auberge of Mère Anthony,
Marlotte, 1866
Oil on canvas, 76 x 51 cms

154
Gustave Courbet
After dinner at Ornans, c.1849
Oil on canvas, 195 x 297 cms

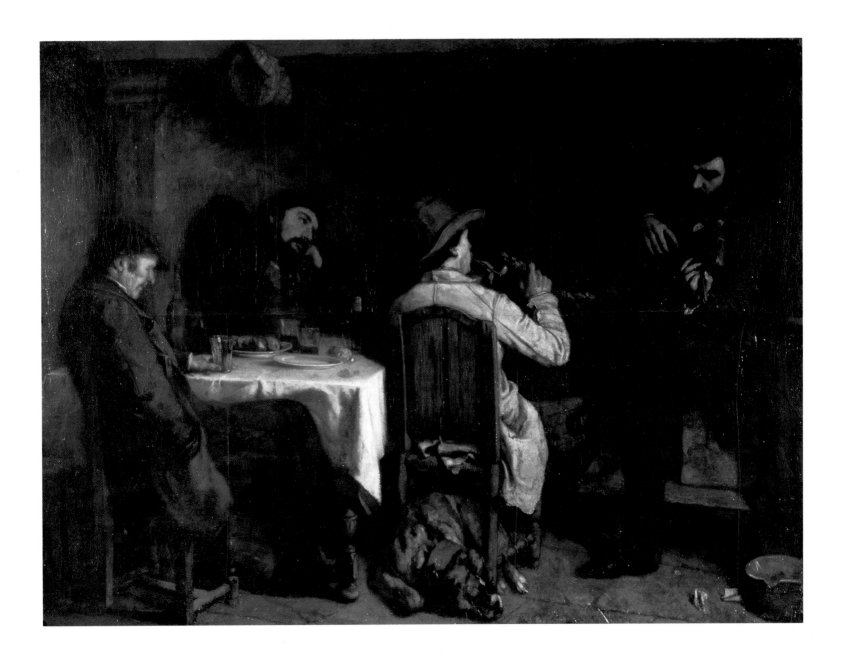

155
Frédéric Bazille
The family reunion, 1867
Oil on canvas, 152 x 230 cms

156
Claude Monet
Haystacks, midday, 1890
Oil on canvas, 65.6 x 100.6 cms

157
Claude Monet
Haystacks, snow effect, 1891
Oil on canvas, 65 x 91 cms

(plate 154) Like Courbet, Renoir arranged his life-size figures around a table, one of whom has his back to the spectator. Manet's presence in the picture can, however, be felt indirectly. Poised conspicuously on the edge of the table is a copy of journal *L'Evénement*, the newspaper in which Emile Zola had defended Manet against attacks by conservative art critics in 1867 and called attention to the importance of contemporary subject matter in painting. It has been suggested that the three figures, Renoir (in the background), Alfred Sisley and Jules Le Coeur, may be discussing the subject of Zola's apologia. Later in his life Renoir spoke warmly of his memories of the *auberge*. He referred to it as a 'real village inn' and had fond memories of the *patronne*, shown with a head scarf in the background, of the pretty maid-servant Nana, seen on the right of the painting, and of scrawling on the walls – (an image of Henri Murger, the founder of the Bohemian ideal, appears in the background). Even the dog was remembered: its name was Toto and it had a wooden leg.

Home and away

During the final years of the Second Empire, naturalist painting became increasingly ambitious both in terms of the subjects it depicted and the way in which it presented them. Although the countryside continued to feature in the work of some members of the Impressionist circle – Sisley, for instance, continued to paint rural themes for much of his career – many landscape painters increasingly turned their attention to urban subjects. It is important to remember that the urban scene changed dramatically in the 1850s and 1860s. The size of the population of Paris doubled during the July Monarchy and an extensive building programme was undertaken to accommodate the increase in the 1850s. Moreover, there was a boom in the economy and much of the surplus wealth awash in the capital was used to finance a spectacular leisure industry: cafés, *cafés-concerts*, restaurants, circuses, theatres, prostitution, and holidays on the Seine, the Normandy coast and in the countryside, in fact most of the subjects recorded in Impressionist paintings.[28]

Some Impressionists, like Degas and Caillebotte, painted with meticulous clarity. Others, however, painted various aspects of life in the city with rapidly applied broken brush marks similar to those found in naturalist painting. Renoir and Monet's paintings of La Grenouillère, for example, show a leisure resort downstream on the Seine, just outside Paris. Here, figures parade on the jetty leading to a little floating restaurant, or prepare for a dip in the river. The application of paint, like that used by Boudin, serves to

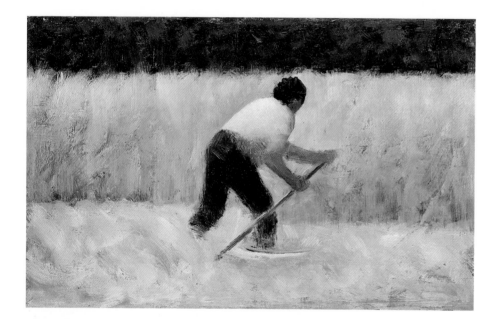

erode the subjects' identity so that the spectator takes on the role of disinterested observer before whom the spectacle of contemporary life unfolds in abstract, temporal fragments caught in a succession of dabs of paint.

As Monet's paintings developed in the late 1860s and early 1870s their execution became even more daring. *Impression sunrise, a view of the port at Le Havre,* shown at the first Impressionist exhibition of 1874, was painted so impulsively and with such fluid pigment that the subject matter all but dissolved. Although urban and industrial motifs, recorded with broken, rapidly applied patches of paint, were seen as the very essence of originality and modernity in art, some critics disliked this form of painting intensely. The art critic Louis Le Roy's spoof review of the first Impressionist exhibition claimed that the fictitious Monsieur Vincent, a landscape painter and pupil of Bertin, had been driven to distraction.[29] He was so affected by the paintings that he went mad and left the exhibition doing an Indian war dance along the Boulevard des Capucines. Other critics, like Castagnary, however, regarded such painting as a positive departure in French culture. Its emphasis upon the contemporary urban world, expressed with daring and originality on the part of the painter, was deemed to be an example of the creative strength of the national character, an essential quality if France was to recover from the humiliating defeat by the Prussians and the horror of the Commune of 1871.[30]

In the hands of Manet, Monet, Cézanne, Renoir, Pissarro and their colleagues, landscape painting was no longer seen as a marginal pursuit but was deemed to be a new and optimistic style invested with the artistic and political hopes for the future. Stéphane Mallarmé, one of the movement's most articulate apologists, writing in 1876, explained some of the aims of the Impressionist painters. In an article written to explain Impressionism to an English audience, he stated:

At that critical moment for the human race when nature desires to work for herself, she requires certain lovers of hers – new and impersonal men placed directly in communion with the sentiment of their time – to lose the restraint of education, to let hand and eye do what they will, and thus through them reveal herself.

For the mere pleasure of doing so? Certainly not, but to express herself, calm, naked, habitual, to those new-comers of tomorrow, of which each one will consent to be an unknown unit in the mighty numbers of a universal suffrage, and to place in their power a newer and more succinct means of observing her.[31]

158
Georges-Pierre Seurat
The reaper, 1881-2
Oil on panel, 16.5 x 25 cms

159
Camille Pissarro
View from Louveciennes, 1869
Oil on canvas, 52.7 x 81.9 cms

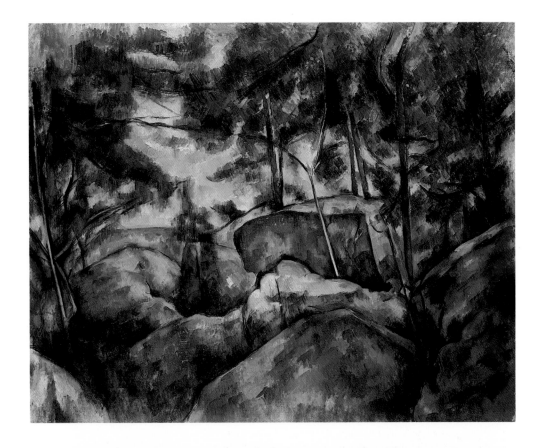

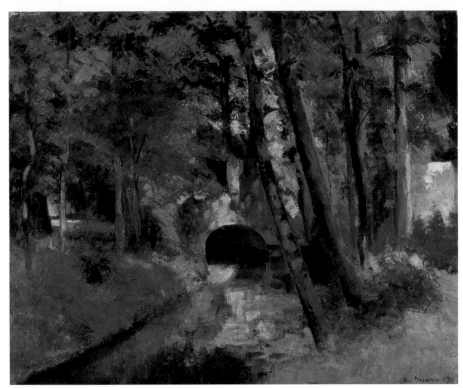

160
Paul Cézanne
Rocks in the forest, 1894
Oil on canvas, 73.3 x 92.4 cms

161
Camille Pissarro
The little bridge, 1875
Oil on canvas, 65.5 x 81.5 cms

Clearly, for Mallarmé, Impressionist painting was no longer a genre which had to take its place among other categories of painting but was the quintessential expression of the age and occupied the centre stage in contemporary art.

Many of the principles that have come to be associated with Impressionist practice – flecks of paint applied to the canvas to record momentary experience, the artist working 'face to face with vibrant reality' often under conditions of extreme hardship – can be found in French painting throughout the 1880s. These concerns are particularly evident, for example, in Monet's series paintings of the Haystacks of the 1890s (plates 156 and 157). By the mid-1880s, however, avant-garde painting in France had begun to change. The ideas underpinning Impressionist painting, like Barbizon painting before it, were generally accepted by critics and the establishment. Modernity in painting was no longer contingent upon an engagement with the urban environment; quite the reverse was true as the younger generation of avant-garde painters increasingly began to search for ways of escaping from the industrialized city and seeking spiritual refinement among remote communities. The urban environment, and later, western culture in general, was seen by a number of avant-garde painters as fundamentally corrupt and they began to look for a 'primitive' antidote to the decadence of the modern world. From the mid- 1880s the city was increasingly cast in a disparaging light and greater emphasis was attached to the spiritual refinement of rural communities both at home and abroad. In fact, Robert Herbert has pointed to the general similarities between the motives underpinning the work of Barbizon painters, the desire to escape from the city to find spiritual solace in nature, and those underpinning the work of Pissarro, Gauguin and Van Gogh in the last two decades of the nineteenth century.[52]

Pissarro's attitude towards urban themes was often conditioned by his anarchist political opinions. Unlike other Impressionist painters who played the role of the disinterested *flâneur*, casting a largely uncritical gaze at the urban scene, his work was increasingly informed by a commitment to the well-being of rural communities, a concern which had a marked effect on his attitudes to industry. Richard Brettel has observed that Pissarro generally avoided painting images of bourgeois leisure.[53] His painting of Louveciennes of 1869 (plate 159), for example, shows a rural environment just outside Paris, a district which was on the point of being swallowed up by the expanding city to the east. Here, few signs of its impending fate are apparent. Pissarro draws attention to the blossom on the trees, to the white-capped peasant and to the rough

162
Camille Pissarro
Turkey girl, 1884
Gouache on board, 81 x
65.5 cms

163
Jean-François Millet
Shepherdess leaning against a tree, 1849
Black crayon on paper, 29.8 x
19.2 cms

164
Paul Gauguin
Vision after the sermon, 1888
Oil on canvas, 74.4 x 93.1 cms

dirt road. When images of technology are introduced into his pictures, they are largely unobtrusive and take the form of small factories set comfortably within a landscape, similar in composition to those used by Daubigny. In turn, paintings of Pontoise made in the late 1860s have a similarly rural quality and show a tranquil country town sufficiently far from the influence of Paris to retain something of its provincial independence. In the early 1870s Pissarro's attitudes to the urban technological environment were somewhat ambivalent; on the one hand mechanized industry could be seen as a capitalist tool, alienating the mind and spirit of the labourer, but on the other, it could also bring social progress and improve the lot of the rural poor. As early as 1874, however, Pissarro, distressed by the effects of urban expansion on rural culture, went off in search of 'real country'.[34] He made several excursions to Montfoucault, a district some 100 miles to the west of Paris. Here, traditional peasant customs remained largely intact. Inhabitants of Montfoucault still wore their traditional local costumes and were well-known for their pious Catholic beliefs. Pissarro's *The pond at Montfoucault* of 1875 (plate 166) shows a woman with several cows drinking from the pond. Dressed in clogs and a white cap, she is set in a tranquil, rural environment lit by diffused Impressionist sunlight. The painting's centrally placed motif, the benign way in which the figure is shown as an integral part of the landscape, and the manner in which peasant labour is cast as a fundamentally pleasant and wholesome activity, recycles many of the conventions used by some Barbizon painters a generation or two earlier. In *The Little Bridge, Pontoise* (plate 161), flak is directed, albeit covertly, at the rural middle classes. The painting shows a stone bridge stradling a stream, flanked on each side by trees, part of one of a number of private estates in the hands of the local *haute bourgeoisie* near Pissarro's native Pontoise. In this, and several other paintings of the district, however, Pissarro's has studiously avoided any reference to the grand country houses that had passed out of the hands of the nobility and into those of the middle classes and presents a humbler image of natural world, part of a peasant rather than a bourgeois patrimony.

Pissarro's paintings of rural life became more idealized as the pace of industrialization increased in France in the 1880s. Largely dependent upon conventions established by Millet, Pissarro conjured up a strong graphic image of the peasant, a visual symbol of resistance to the modern world. His debt to Millet can be seen in *The sower* of 1896 (plate 167) and *Turkey girl* of 1884 (plate 162). In both instances the figures are represented in simplified graphic form and borrow directly from compositions used

by Millet. The images also have a strong lyrical flavour; the *Turkey girl*, for example, appears in a state of mental and physical relaxation, surrounded by a tranquil flock of birds and lit by a radiant light which serves to unite the figure with its environment. Despite the sense of lyricism common to the work of both painters, Pissarro was keen to resist being labelled as a romantic peasant painter, a tag which had been firmly attached to Millet after the publication of Sensier's biography and the large retrospective exhibition of his works held at the Ecole des Beaux-Arts in 1887. Political ideals, the desire to draw attention to the material interests of the dispossessed, constantly informed Pissarro's work and prompted him to cast aspersions on the biblical inflections Millet gave to his paintings of the rural poor. For Pissarro, the relationship between men and women and their environment was determined by economic and social factors rather than by an immutable curse handed down to Man after the Fall. It was Pissarro's political commitments, the notion that art should address social issues, that also led him to cast doubts on the ambitions and paintings of another refugee from the city – Paul Gauguin.

Gauguin first went in search of a primitive culture in 1886 when he left Paris for the Breton village of Pont Aven. The area and its inhabitants were thought to have retained a mixture of primitive savagery and simple Christian piety long extinct in the decadent city. In fact, Emile Bernard, Gauguin's companion at Pont Aven, was so taken with the piety of the local community that he abandoned his atheism. Gauguin himself maintained that his introduction to the 'barbarism' of the district was a source of personal rejuvenation. Gauguin's interest in primitive culture led to a radical change of style in his paintings in the late 1880s. He abandoned an Impressionist technique in favour of much flatter areas of colour. This approach is evident in one of the first paintings made by Gauguin at Pont Aven, *Vision after the sermon* (plate 164). Here, a group of peasant women experience a vision following a mass. The lower section of the painting is represented naturalistically with subtle modelling on the habits of the peasants. In the upper section of the painting, however, the vision of Jacob wrestling with an angel is painted using an unrealistic style, a style prompted by the fact that the subject depicts something mysterious and intangible. Gauguin explained that '...for me in this painting, the landscape and the struggle exist only within the imagination of the praying people, the product of the sermon. This is why there is a contrast between the real people and the struggle in the landscape devoid of naturalism and out of proportion.'[35] A similarly unnaturalistic style is used in Gauguin's *Hay-*

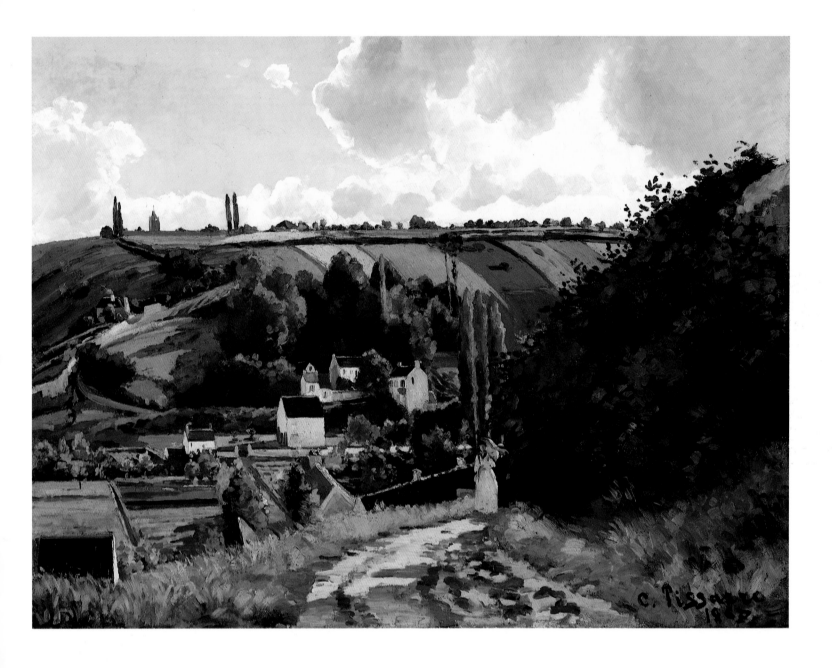

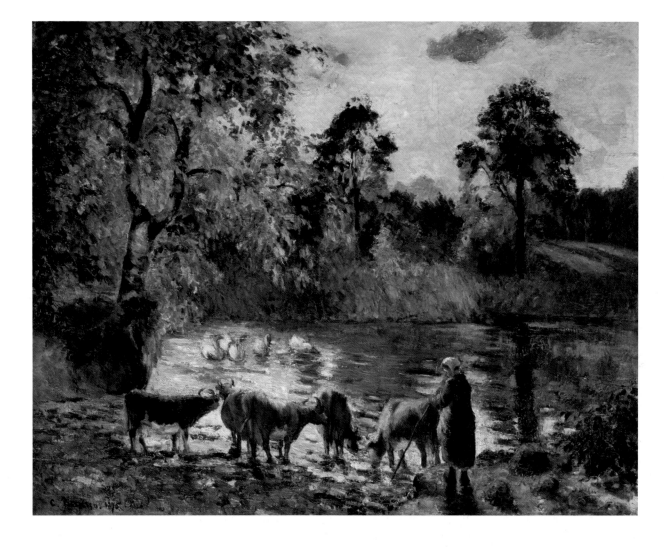

165
Camille Pissarro
Jallais hill, Pontoise, 1867
Oil on canvas, 87 x 114.9 cms

166
Camille Pissarro
The pond at Montfoucault, 1875
Oil on canvas, 73 x 92.1 cms

167
Camille Pissarro
The sower, 1896
Pencil on paper

168
Paul Gauguin
Haymaking, 1889
Oil on canvas, 92 x 73.3 cms

169
Paul Gauguin
*Haymaking in Derout-
Lollichon, Pont Aven*, 1888
Oil on canvas, 73 x 92 cms

170
Paul Gauguin
Tahitian Pastorals, 1893
Oil on canvas, 86 x 113 cms

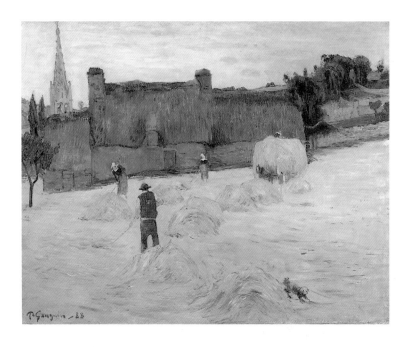

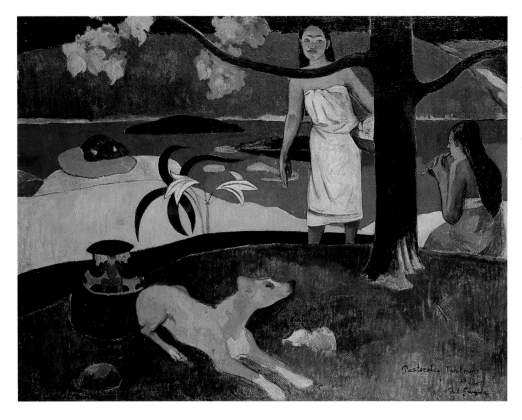

making, painted in 1889 (plate 168). The women working in the fields are set against a steeply raked field and become graphic symbols for a primitive community and a timeless agricultural ritual.

The compulsion to look for some form of spiritual purity beyond the confines of bourgeois life affected the career of Gauguin's colleague Vincent Van Gogh even before he decided to become a painter. He had taken up a Christian mission to work among the industrial poor of the Borage and embraced his task with such fervour that he swapped his clothes for theirs, voluntarily deprived himself of food and lived in a hovel. Similar sympathies for the poor influenced Van Gogh's art. His first major oil painting, *The potato eaters* of 1885, shows a peasant family gathered around a table for a meagre evening meal of potatoes and coffee. Here, Van Gogh has attempted to portray the poverty of the scene not just by depicting a peasant family but also by using coarsely applied pigment and monochrome colours, similes for the qualities of the very earth that barely sustains them. Van Gogh wrote about the painting in a letter to his brother Théo in 1885:

I have tried to emphasize that those people, eating their potatoes in the lamplight, have dug the earth with those very hands they put in the dish, and so it speaks of manual labour, and how they have honestly earned their food.

I have wanted to give the impression of a way of life quite different from that of civilized people. Therefore I am not at all anxious for everyone to like it or to admire it at once.[36]

A disaffection for life in the city and with those who painted it led Van Gogh to leave the avant-garde circle of artists in Paris for Arles in the south of France, a district that remained relatively untouched by industrialization. Writing to his brother shortly after arriving at Arles, Van Gogh explained:

It is only that which I learned in Paris is leaving me, and I am returning to the ideas I had in the country before I knew the Impressionists. And I should not be surprised if the Impressionists soon find fault with my way of working for it has been fertilized by Delacroix's ideas rather than by theirs.[37]

Van Gogh admired Delacroix and many other Barbizon painters but had a near fanatical love for the work of Millet. Van Gogh's debt to Millet is evident in his very earliest works and continued to figure in his painting until his death. It is visible in the way in which single figures are explained in dramatically simplified shapes, the way in which the material life of the peasant and his or her place

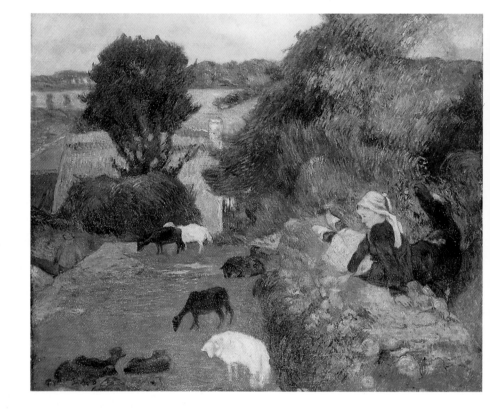

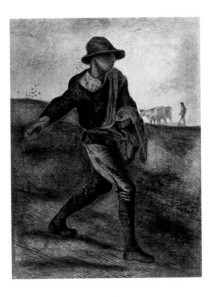

171
Paul Gauguin
The Breton shepherdess, 1886
Oil on canvas, 60.4 x 73.3 cms

172
Vincent Van Gogh
The sower, after Millet, 1881
Pen and ink and wash on paper,
heightened with green and
white, 48 x 36.5 cms

173
Vincent Van Gogh
The diggers, after Millet, 1889
Oil on canvas, 73 x 92 cms

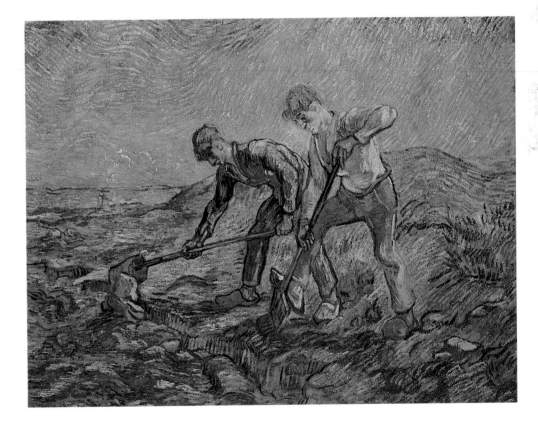

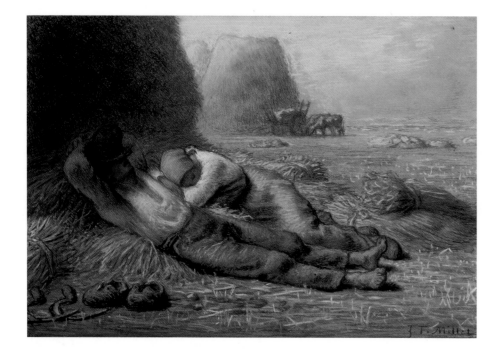

in the landscape are explained through the physical matter of paint, and the way in which the figures are bound to their environment through the formal qualities of light and brush strokes. In numerous instances Van Gogh's subjects were taken directly from those by Millet. Images of the striding sower painted by Van Gogh in 1888 (plate 172) and the sleeping peasants (plate 175) are transposed directly from Millet's paintings of similar subjects. Perhaps the most significant bond between the two painters, however, is the attention they both devoted to manual labour in the countryside and the intrinsic dignity and moral integrity of those that perform it. Labour for the Impressionists was only one of a broad repertoire of subjects to be found in the city and surrounding suburbs. It gave artists an opportunity to depict some of the odd poses struck by those employed to sing and dance on stage, and those employed to wash and iron laundry or to scrape and polish the floors of new apartments. There is, however, seldom any demonstration of heartfelt sympathy for the plight of people who perform such tasks. An emphasis upon the spiritual at the expense of the material dimension of human existence, the notion that the modern world is fundamentally decadent but that there is some form of moral and spiritual sanctuary to be found in the less sophisticated cultures of the countryside, are among the main articles of faith that link not only Van Gogh and Millet but also Post Impressionism with the work of the Barbizon School. Like Barbizon painters, many Post Impressionists expressed a fundamental distaste for the contemporary urban environment and sought a form of spiritual and artistic integrity by retiring from the sophisticated, venal milieu of the city to the unsophisticated primeval purity of the countryside. Like a number of Barbizon painters, the Post Impressionists set city and country in stark opposition: for Fontainebleau, read Montfoucault, Pont-Aven, the Borage or Tahiti.[58]

Postscript

Landscape painting gradually rose in status in the nineteenth century. During the early decades it had to ingratiate itself with history painting to be taken seriously, but 100 years later the world's greatest living artist was a landscape painter whose name had become synonymous with Impressionism. Monet had worked hard to achieve the accolade. He exhibited alongside Rodin (France's greatest living sculptor) in a deliberate bid to achieve world-wide recognition on the eve of the centennial celebrations of 1889. He had also raised funds to buy Manet's *Olympia* for the state, thereby preparing the ground for his own eventual succession as an apostle of the modern tradition.[59]

174
Jean-François Millet
Noonday rest, 1866
Pastel and black crayon on
paper, 28.8 x 42 cms

175
Vincent Van Gogh
The siesta, after Millet, 1889
Oil on canvas, 73 x 91 cms

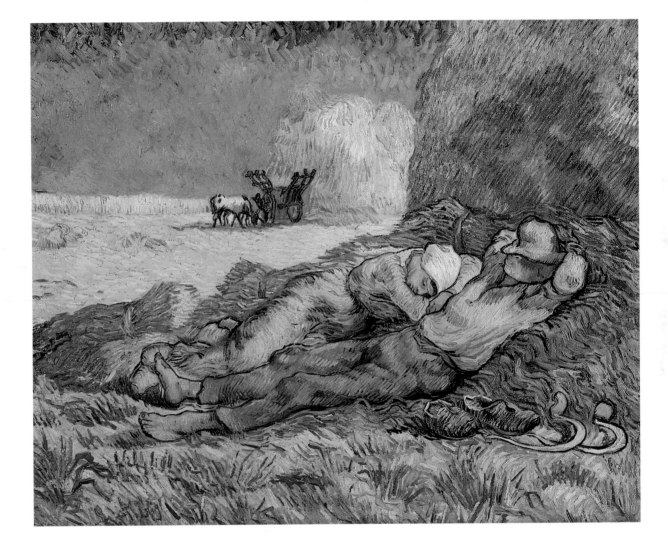

Landscape painting's final apotheosis, however, took shape in a suite of 'decorations', panoramic paintings of the lily pond made at Monet's garden at Giverny. Here, the spectator's vision is dominated by the monumental 360 degree panoramic vista made up of a suite of panels, each one a metre and a half in height. The decorations make wildly contradictory demands on the viewer. On the one hand the spectator is swamped by the experience, in that the sheer breadth of the paintings far exceeds the field of human vision, on the other he or she is required to examine the subject in some detail. The paintings have no horizon, implying that the viewer is looking down towards the pond, and the upper sections of the pictures represent only the near middle distance. This format is evident on one fragment of the installation at the Orangerie. Here, the trunk of a willow is presented next to the picture plane, its top cupped by the lower and upper edges of the picture. The paintings are enormously ambitious and have a counterpart only in Baroque painting of the seventeenth century and installations in art of the second half of the twentieth century. The decorations, eventually assembled as a large installation at the Orangerie in Paris, are not just ambitious in aesthetic terms, however. They were donated by the artist to the French state partly in recognition of the nation's acquisition of *Women in the garden* for 220,000 francs, but also to mark France's victory in the World War One.

In the past grand *tableaux*, especially those that marked important national events, were invariably either history paintings or in the case, say, of Courbet, re-workings of the conventions used by history painting. Now a landscape painting concerned purely with the experience of Nature, albeit stage-managed in the form of a garden and conceived on an heroic scale, could celebrate a victory over Germany, France's bitterest enemy. Monet announced his intention to offer the nation two decorative panels to his friend the Prime Minister, Georges Clemenceau, and proposed that he should sign them on Armistice day.[40] The critic Georges Geffroy described how the artist had offered the paintings to France, 'like a bouquet of flowers in homage to the victory in war and to the conquering country'. Throughout the twentieth century the place of landscape painting in the canon of modern art has been secure, and the hierarchy of genres in the fine arts that had so dogged Barbizon painters and their successors is nothing more than a curiosity of art history, and one that has to be recovered from the cultural clutter of Impressionism.

176
Claude Monet
Waterlilies, morning, 1916–26
Oil on canvas, mounted on the wall, 200 x 426 cms

1. Henriet, F., *Le paysagiste au champs*, Paris, 1876, p. 13.

2. Ibid., pp. 106-7.

3. Gastineau, B., 'Ce qu'on trouve dans un forêt' in *Hommage à C.-F. Denecourt – Fontainebleau, paysages, legendes, souvenirs, fantasies*, ed. Desnoyers, F., Paris, 1855, pp. 183-4.

4. For an extensive account of the relationship between landscape painting and the bourgeois appreciation of the countryside in nineteenth-century France see Green, N., *The Spectacle of Nature: Landscape and Bourgeois Culture in Nineteenth-Century France*, Manchester and New York, 1990.

5. Preface to *Hommage à C.-F. Denecourt*, p. 1.

6. For an account of the history of the term 'Barbizon School' see Sillevis, J., and Kraan, H., *The Barbizon School*, The Hague, 1985, pp. 47-52.

7. Hayes Tucker, P., *Monet in the 90s: the Series Paintings*, New Haven and London, 1989, pp. 110ff.

1. Mirbeau, O., Introductory essay to *Tableaux de Claude Monet*, exhibition catalogue, Paris, 1889, pp. 5ff. For an account of the Mirbeau's role in the exhibition see Hayes Tucker, P., *Monet in the 90s*, pp. 55-9.

2. Denvir, B., ed., *The Impressionists at First Hand*, London, 1987, pp. 195ff.

3. Hayes Tucker, P., *Monet in the 90s*, pp. 69ff.

4. For a history of the French Academy in the nineteenth century see Boime, A., *The Academy and French Painting in the Nineteenth Century*, New Haven and London, 1986, pp. 1-7.

5. Quoted in Blunt, A., *Nicolas Poussin*, London and Oxford, 1967, p. 220.

6. Benoit, F., *L'art sous la révolution et l'empire*, Paris, 1897, p. 45.

7. Valenciennes, P.-H., *Elémens de perspective pratique, à l'usage des artistes suivis de reflexions et conseils à un élève sur la peinture, et particulièrement sur le genre de paysage*, Paris, 1800, pp. 382ff. For a summary of changes in French landscape painting in the nineteenth century see Peter Galassi's essay 'The Nineteenth Century: Valenciennes to Corot' in Galassi, P., et al, *Claude to Corot: the Development of Landscape Painting in France*, London and New York, 1990, pp. 233-9.

8. Galassi, P., *Corot in Italy: Open-air Painting and the Classical Landscape Tradition*, New Haven and London, 1991, p. 15.

9. For a detailed account of the training of academic landscape painters see Strich, J., 'Connaissance, classification et sympathie: Les cours de paysage et la peinture de paysage au XIXème siècle, in, *Littérature*, 61, 1986, pp.17ff., and Boime, A., *The Academy and French Painting*, pp. 133-46.

10. Valenciennes, *Elémens*, p. 382.

11. Galassi, P., *Corot in Italy*, p. 66.

12. Valenciennes, *Elémens*, p. 376.

13. Millin de Grandmaison, A.-L., *Dictionnaire des Beaux-Arts*, Paris, 1806, Vol. 3, pp. 107ff. The various categories of landscape painting current in France in the early nineteenth century are discussed in Galassi's essay 'The Nineteenth Century: Valenciennes to Corot', pp. 236-7, and in Boime, A., *The Academy and French Painting*, pp. 136ff.

14. Galassi, P., 'The Nineteenth Century: Valenciennes to Corot', pp. 236ff.

15. Valenciennes, *Elémens*, pp. 479-83.

16. For a detailed account of the influence of Dutch art on French landscape painting see Ten Doeschate Chu, P., *French Realism and the Dutch Masters: The Influence of Dutch Seventeenth-Century Painting on the Development of French Painting between 1830 and 1870*, Utrecht, 1974, pp. 18-31.

17. For an account of the status of Dutch art in early nineteenth-century France see Van Holthe Tot Echten, G., 'L'envoie des jeunes artistes nederlandais à Paris pendant la règne de Louis Napoléon Bonaparte, 1806-1810', *Gazette des Beaux-Arts*, 126ème année, 1984, pp. 37-70.

18. Saint-Victor, P. de, in *Hommage à C.-F. Denecourt*, p. 188.

19. Deperthes, J.-B., *Théorie du paysage*, Paris, 1818, pp. 2-5 and pp. 159ff. See also Boime, A., *The Academy and French Painting*, pp. 159ff.

20. Sensier, A., *Etude de Georges Michel*, Paris, 1873, p. 21.

21. Clarke, M., *Corot and the Art of Landscape*, London, 1991, p. 42.

22. Sensier, A., *Etude de Georges Michel*, pp. 20-1.

23. McWilliam, N., and Parsons, C., 'Le paysan de Paris: Alfred Sensier and the Myth of Rural France', *Oxford Art Journal*, 6, no. 2, 1983, p. 39.

24. Durand-Ruel, P., 'Memoires de Paul Durand-Ruel' in Venturi, L., *Les archives de l'impressionisme*, Paris and New York, 1939, Vol. 2, p. 162.

25. Scott, B., 'The Duchesse de Berry as a Patron of the Arts', *Apollo*, October, 1986, pp. 345-53.

26. Venturi, L., 'Memoires de Paul Durand-Ruel', p. 148.

27. Pointon, M., *The Bonington Circle: English Watercolour and the Anglo-French Landscape 1790-1855*, Brighton, 1985.

28. Leslie, C. R., ed., *Memoirs of the Life of John Constable*, Oxford, 1980, p. 121.

29. Délécleuze, E., *Journal des débats*, Paris, 1 September 1825, pp. 1-3, and *Journal des débats*, Paris, 3 September 1829, p. 3.

30. Sillevis, J., and Kraan, H., *The Barbizon School*, p. 17.

31. Deperthes, J.-B., *Théorie du paysage*, Paris, 1818, pp. 2-3.

1. Green, N., *The Spectacle of Nature*, pp. 67-89. This chapter is much indebted to the research undertaken by Nicholas Green.

2. Janin, J., *Voyage de Paris à la Mer, description historique des Villes, Bourgs, Villages et des bords de la Seine. Orne d'un grand nombre des vignettes dessinées sur les lieux par Morel-Fatio et Daubigny*, Paris, 1843.

3. Curmer, L., *Les jardins des plantes*, Paris, 1849.

4. For a summary of the careers of Barbizon painters see Miquel, P., *L'Ecole de la nature: Le paysage français au XIXème siècle*, Maurs-la-Jolie, 1975, 6 volumes.

5. Millin de Grandmaison, A.-U., *Dictionnaire des Beaux-Arts*, Paris, 1806, Vol. 3, pp. 38-41.

6. For an account of the history of the development of the diorama in Paris see Gernsheim, H. and A., *L.-J.-M. Daguerre: The History of the Diaorama and Daguerreotype*, London, 1956, pp. 13-45.

7. Ibid, pp. 28-9.

8. Hibbert, C., *The Grand Tour*, London, 1987, pp. 155ff. For an account of tourism in France in the late-eighteenth century see ibid., pp. 41ff.

9. Obituary notice for Baron Isidore Taylor in Chennevières, P. de, *Souvenirs d'un directeur des Beaux-Arts*, Paris, 1883-9, Vol. III, p. 34. Edition reprinted 1979.

10. Miquel, P., *Ecole de la nature*, Vol. 3, p. 199.

11. Hyde, R., *Panoramania*, Barbican Art Gallery, London, 1988, pp. 109-14 and p. 119.

12. House, J., *Monet, Nature into Art*, New Haven and London, 1989, p. 137.

13. Hibbert, C., *The Grand Tour*, pp. 75ff.

14. Taylor, I., de Cailleux, A., and Nodier, C., *Voyage pittoresques et romantiques dans l'ancienne France*, Paris, 1820. For an account of the genesis of the *Voyages pittoresques* see de Chennevières, P., *Souvenirs*, Vol. III, pp. 35ff.

15. Chennevieres, P., ibid., pp. 37-8.

16. Janin, J., *Quatre promenades dans la forêt de Fontainebleau ou description physique et topographique de cette forêt*, Fontainebleau, 1837. One of the earliest guides to the forest is Abbé Guibert's *Description Historique des Châteaux, Bourg et Forêt de Fontainebleau*. For a summary of the first guides to the Forest of Fontainebleau see Green, N., *The Spectacle of Nature*, pp. 167-81.

17. Desnoyers, F., 'Ebauche de Fontainebleau' in Desnoyers, F., ed., *Hommage à C.-F. Denecourt*, Paris, 1855, p. 26.

18. Denecourt, C.-F., *Guide du voyageur dans la palais et la forêt de Fontainebleau, ou choix des promenades les plus pittoresques, orne d'une carte*, Paris, 1840.

19. Bernard, F., *Fontainebleau et ses environs*, Paris, 1853, p. 3.

20. Ibid., p. 20.

21. Janin, J., *Voyages de Paris à la mer*, Paris, 1847, p. 4.

22. Bernard, F., *Fontainebleau et ses environs*, pp. 118-19.

23. Ibid., p. 3.

24. Ibid., pp. 95-6.

25. Ibid., p. 94.

26. For a survey of the development of the printing industry in the 1830s see Bezecha, R., 'The Renaissance of Book Illustration' in *The Art of the July Monarchy, France 1830 - 1848*, exhibition catalogue, University of Missouri, Columbia and London, 1990, pp. 192-213.

27. Melot, M., *The Graphic art of the Pre-Impressionists*, New York, 1978, pp. 284-5.

28. Baudelaire, C., 'Painters and Etchers' in *Art in Paris 1845-1862*, ed. Baudelaire, C., Oxford, 1981, p. 219.

29. For a detailed account of methods of reproduction and distribution of prints in France in the mid-nineteenth century see Melot, M., *Graphic Art of the Pre-Impressionists*, pp. 7-19.

30. Ibid., pp. 270-1.

31. Ibid., p. 269.

32. The development of the printed *vignette* and its relationship to British art in the nineteenth century is explored in Rosen, C., and Zerner, R., *Romanticism and Realism: The Mythology of Nineteenth-Century Art*, London, 1984, pp. 73-96.

33. For a summary account of the production and distribution of small decorative bronzes see *Un Age d'Or des Arts Décoratifs, 1814-1848*, exhibition catalogue, Galeries Nationales du Grand Palais, Paris, 1991, pp. 318ff. Miquel, P., refers to the career of Antoine Barye in *Ecole de la nature*, Vol. 2, pp. 58ff.

34. Venturi, L., 'Memoires de Paul Durand-Ruel', p. 153.

35. Clarke, M., *Corot and the Art of Landscape*, London, 1991, p. 80.

36. Fay Hallé, A., and Mundt, B., *Nineteenth-Century European Porcelain*, London, 1983, pp. 114-15.

37. Miquel, P., refers to the early careers of Barbizon painters in 'Paris porcelain factories of the 1820s' in Vols. 2, 3, and 4 of *Ecole de la nature*. See also Plinville de Guillebon, R., *Paris Porcelain 1770-1850*, London, 1972, p. 138 and pp. 211ff.

38. Greene, N., *The Spectacle of Nature*, pp. 25ff.

1. Bory, J. L., *La révolution de Juillet*, Paris, 1972, p. 363.

2. For a summary account of the foundation of the July Monarchy see Marinan, M., *Painting Politics for Louis-Philippe*, New Haven and London, 1988, pp. 27-33.

3. The formation of collections of pictures assembled during the July Monarchy is under-researched. Some indication of bourgeois tastes in art during the 1830s and 1840s, however, is given by Boime, A., 'Entrepreneurial Patronage in Nineteenth-Century France' in Carter, E. C., ed., *Enterprise and Entrepreneurs in Nineteenth- and Twentieth-Century France*, Baltimore, 1976, pp. 140-50. See also Green, N., *The Spectacle of Nature*, pp. 25-8, and Whiteley, L., 'Art et commerce d'art en France avant l'époque impressioniste' in *Romantisme*, Paris, 1983.

4. Jal, A., *Causeries du Louvre*, Paris, 1833, p. 103.

5. Rosenthal, L., *Du Romantisme au réalisme: Essai sur l'évolution de la peinture en France de 1830 à 1848*, Paris, 1914, p. 20.

6. Boime, A., *The Academy and French Painting in the Nineteenth Century*, p. 178. See also Hadjinicolaou, N., 'Art in a Period of Social Upheaval' in *Oxford Art Journal*, 6, no. 2, 1983, p. 29.

7. Quoted in Hadjinicolaou, N., 'Art in a Period of Social Upheaval', p. 33.

8. For a detailed account of radical organizations in the arts during the early days of the July Monarchy see Rosenthal, L., *Du Romantisme au réalisme*, pp. 31ff.

9. Hadjinicolaou, N., 'Art in a Period of Social Upheaval', pp. 29-32.

10. Rosenthal, L., *Du Romantisme au réalisme*, p. 263.

11. Ibid., pp. 266ff.

12. Miquel, P., *Ecole de la nature*, Vol. 3., p. 368.

13. Blanc, C., *Artistes de mon temps*, Paris, 1876, p. 438.

14. Thoré, T., *Salon de T. Thoré 1844-1848*, Paris, 1868, p. 1.

15. Rousseau's adaptation of academic techniques in the execution of his sketches and finished tableaux is discussed by Green, N., in the introductory essay for *Théodore Rousseau*, exhibition catalogue, Sainsbury Centre for the Visual Arts, University of East Anglia, Norwich, 1982, pp. 14-15.

16. Sensier, A., *Souvenirs sur Théodore Rousseau*, Paris, 1872, p. 53f.

17. Planche, G., *Etudes sur les écoles*, Paris, 1855, Vol. 1, pp. 281ff. and Vol. 2, p. 38.

18. Thoré, T., *Salon de T. Thoré*, p. 119.

19. Baudelaire, C., *Art in Paris*, p. 24.

20. Clarke, M., *Corot and the Art of Landscape*, p. 60.

21. Miquel, P., *Ecole de la nature*, Vol. 2, p. 33.

22. Mainardi, P., *Art and Politics of the Second Empire: the Universal Exhibitions of 1855 and 1857*, New Haven and London, 1989, p. 83.

23. Miquel, P., *Ecole de la nature*, Vol. 3, p. 23.

24. Galassi, P., *Corot in Italy*, pp. 212-14.

25. Baudelaire, C., *Art in Paris*, p. 1.

26. Thoré, T., *Salon de T. Thoré*, preface to the 'Salon de 1847', p. 382.

27. Ibid., preface to the 'Salon de 1844', p. 6.

28. Ibid., p. 470f.

29. Baudelaire, C., *Art in Paris*, pp. 24-5.

30. Sensier, A., *Etude de Georges Michel*, Paris, 1873, p. 3 and pp. 80-6.

31. Venturi, L., 'Memoires de Paul Durand-Ruel', pp. 143-220.

32. Miquel, P., *Ecole de la nature*, Vol. 4, pp. 384ff.

33. For an account of the activities of art dealers during the nineteenth century see Miquel, P., *Ecole de la nature*, Vol. 5, pp. 300-410. For more specific references to art dealers during the July Monarchy see Green, N., *The Spectacle of Nature*, pp. 25ff., and Boime, A., 'Entrepreneurial Patronage' in Carter, E. C., ed., *Enterprise and Entrepreneurs*, pp. 140-50.

34. Bonaffée, E., *Causeries sur l'art et la curiosité*, Paris, 1878, p. 122.

35. Thoré-Burger, T., *Galérie de M. M. Perire*, Paris, 1867. See also the catalogue of the Perire Sale, Paris, March 1872.

36. Blanc, C., *Trésor de la curiosité*, Paris, 1857, pp. 433-4. See also the catalogue of the Perire Sale Paris, 9 December 1846. On the Schnieder Collection see 'Galleries de M. Schnieder', *Gazette des Beaux-Arts*, Paris 1876, 2ème période, 13, pp. 494-6. The contents of the Hartmann Collection is discussed in *Gazette des Beaux-Arts*, Paris 1881, 2ème période, 23, pp. 456-64.

37. For an account of the collection of the Duc d'Orléans see *Un Age d'Or des Arts Décoratifs*, p. 33.

1. For a summary of the collapse of the July Monarchy and the causes of the February Revolution see Collingham, H.A.C., *The July Monarchy: A Political History of France, 1830-1848*, London, 1988, pp. 385-414.

2. Victor Hugo, quoted in Cobban, A., *A History of Modern France*, Harmondsworth, 1986, p. 130.

3. For an account of the events between the February Revolution and the June Days of 1848 see Clark, T. J., *The Absolute Bourgeois: Artists and Politics in France, 1848-1851*, London, 1988, pp. 9-16.

4. Nochlin, L., *The Politics of Vision, Essays on Nineteenth-Century Art and Society*, London, 1991, pp. 1-2.

5. Thoré, T., *Salons de T. Thoré*, p. 559.

6. Patterns of State patronage in France immediately after the 1848 revolution are examined in Clark, T. J., *The Absolute Bourgeois*, pp. 49-50.

7. Anon., *Revue de Deux Mondes*, Paris, 1849, p. 385.

8. Clark, T. J., *Absolute Bourgeois*, pp. 49-50.

9. For an account of the art market during the period following the February Revolution see Venturi, L., 'Memoires de Paul Durand-Ruel', pp. 156-7.

10. Rosenthal, L., 'La genesse du réalisme avant 1848', *Gazette des Beaux-Arts*, Paris, 1913, IVème période, p. 180, and Weisberg, G., *The Realist Tradition: French Painting and Drawing, 1830-1900*, Cleveland, 1980, pp. 5-9.

11. Faunce, S., 'Reconsidering Courbet' in *Courbet Reconsidered*, exhibition catalogue, Brooklyn Museum, New Haven and London, 1988, p. 3. See also Gaillard, F., 'Gustave Courbet et le réalisme; Anatomie de la réception critique d'un oeuvre: "un enterrement"', in *Revue d'histoire littéraire de la France*, Paris, 1980, 6, pp. 978-98.

12. Ashton, D., and Brown Hare, D., *Rosa Bonheur: A Life and a Legend*, London, 1981, pp. 88-9.

13. Champfleury, J., *Le Réalisme*, Paris, 1857, p. 270.

14. Mainardi, P., *Art and Politics of the Second Empire*, New Haven and London, 1989, p. 60.

15. Quoted from Gautier in the original French in *Jean-François Millet*, exhibition catalogue, Arts Council of Great Britain, Hayward Gallery, London, 1976, p. 62. See also Sensier, A., *La vie et l'oeuvre de Jean-François Millet*, Paris, 1881, p. 105.

16. Jacque, F., *Le Livre d'Or de Jean-François Millet* quoted in Miquel, P., *Ecole de la nature*, Vol. 3, p. 581.

17. Pollock, G., *Millet*, London, 1977, p. 16.

18. Paul de Saint Victor, quoted in Miquel, P., *Ecole de la nature*, Vol. 3, p. 588.

19. Quoted in McWilliam, N., and Parsons, C., 'Le Paysan de Paris: Alfred Sensier and the Myth of Rural France', note 20, p. 42.

20. Quoted in Miquel, P., *Ecole de la nature*, Vol. 3, p. 595.

21. Ibid., p. 596.

22. Sensier, A., *La Vie et l'oeuvre de Jean-François Millet*, pp. 241-2.

23. For an account of the history of the Forest of Fontainebleau and its management of timber, stone and sand as a resource see Domet, F., *Histoire de la forêt de Fontainebleau*, Paris, 1867.

24. Green, N., *The Spectacle of Nature*, p. 211.

25. Domet, F., *Histoire de la forêt de Fontainebleau*, p. 42. For a summary of the development of agriculture in the nineteenth century see Plancke, J., *L'agriculture dans le Seine et Marne 1853-1953*, Paris, 1982.

26. Sand, G., *La mare au diable*, Paris, 1973 edition, p.35.

27. Ibid., p. 36.

28. Wey, F., *Dictionnaire du droit et de devoirs*, Paris, 1848, pp. 53-7.

29. Balzac, H. de, *Les paysans*, Paris, 1864, p. 272.

30. Bonnemere, E., *Histoire des paysans*, Paris, 1857, pp. 433ff.

31. Ashton, D., and Browne Hare, D., *Rosa Bonheur*, p. 94.

32. Champfleury, J., 'Salon de 1846' quoted in Miquel, P., *Ecole de la nature*, Vol. 2, p. 330.

33. *L'Artiste*, 1853, quoted in Miquel, P., *Ecole de la nature*, Vol. 2, p. 336-7.

34. Ibid.

35. Ibid., p. 178.

36. Clark, T. J., *Absolute Bourgeois*, pp. 79-80.

37. Quoted in *The Peasant in French Nineteenth-Century Art*, Douglas Hyde Gallery, Trinity College, Dublin, 1990, p. 109.

1. Denvir, B., ed., *Impressionists at First Hand*, London, 1987, p. 163.

2. Mantz, P., 'Revue de l'Exposition Centennelle', *Gazette des Beaux-Arts*, Paris, 1889, p. 345.

3. Ibid., p. 354.

4. Ibid., p. 355.

5. Gimpel, R., *Diary of an Art Dealer*, London, 1986, p. 9.

6. Zola, E., 'Les actualistes', in *Ecrits sur l'art*, ed. Zola, E., Paris, 1991, p. 207.

7. I am indebted to Patricia Mainardi's book *Art and Politics of the Second Empire: the Universal Expositions of 1855 and 1867*, New Haven and London, 1989, pp. 33-8, and Green, N., 'All the Flowers of the Field: the State, Liberalism and Art in France under the early Third Republic', *Oxford Art Journal*, 1987, 10, no. 1, pp. 73-5, for this account of government policy in the arts during the early Second Empire.

8. Ibid., p. 194.

9. Rewald, J., *The History of Impressionism*, London, 1986, p. 86. See also Emile Zola's account of the reception of Manet's painting 'Edouard Manet étude biographique et critique' in *Ecrits sur l'art*, pp. 158-9.

10. Mainardi, P., *Art and Politics of the Second Empire*, p. 169.

11. Ibid., p. 176.

12. Mantz, P., 'Salon de 1867', *Gazette des Beaux-Arts*, Paris, 1867, p. 328.

13. McWilliam, N., and Parsons, C., *Le Paysan de Paris*, pp. 38-9.

14. Weitzenhoffer, F., *The Havermeyers: Impressionism Comes to America*, New York, 1986, p. 41.

15. Zola, E., *Ecrits sur l'Art*, p. 186.

16. Tayor, J. C., *Nineteenth-Century Theories of Art*, Los Angeles and London, 1982, p. 428.

17. Champfleury, J., 'Nouvelles recherches sur la vie et l'oeuvre des frères Le Nains', *Gazette des Beaux-Arts*, Paris, 1860, p. 179.

18. Zola, E., 'Mon Salon' in *Ecrits sur l'art*, p. 215.

19. House, J., *Monet, Nature into Art*, p. 47.

20. Moreau-Nelaton, E., *Daubigny raconté par lui même*, Paris, 1925, p. 54.

21. Miquel, P., *Ecole de la nature*, Vol. 3, p. 686.

22. Baudelaire, C., 'Salon of 1859' in *Art in Paris*, pp. 199-200.

23. Quoted in Rewald, J., *The History of Impressionism*, p. 44.

24. Mantz, P., 'Salon de 1865', *Gazette des Beaux-Arts*, Paris, 1865, p. 26.

25. For a detailed account of the evolution of this painting see Isaacson, J., *Monet: Le déjeuner sur l'herbe*, London, 1972. See also Champa, K. S., *Studies in Early Impressionism*, New Haven and London, 1973, pp. 1-12 and House, J., *Monet: Nature into Art*, p. 135.

26. For an account of Bazille's work around the Forest of Fontainebleau see *Frédéric Bazille and Early Impressionism*, exhibition catalogue, Art Institute of Chicago, Chicago, 1978, and Isaacson, J., *Monet: Le déjeuner sur l'herbe*, pp. 25-6.

27. *Renoir*, exhibition catalogue, Hayward Gallery, London, 1985, pp. 184-5. See also Champa, K. S., *Studies in early Impressionism*, pp. 41-4.

28. For a detailed account urban culture and its influence on Impressionist painting see Herbert, R. L., *Impressionism, Art, Leisure and Parisian Society*, New Haven and London, 1988.

29. Leroy, L., *L'exposition des Impressionistes*, Charivari, 25 April 1874.

30. Hayes Tucker, P., 'The First Impressionist Exhibition and Monet's Impression Sunrise: A Tale of Timing, Commerce and Patriotism', *Art History*, 7, no. 4, 1984, pp. 465-76.

31. Mallarmé, S., 'The Impressionists and Edouard Manet' in *The New Painting: Impressionism 1874-1876*, exhibition catalogue, Museum of Fine Arts Museums of San Fransico, San Francisco, 1986, pp. 33-4.

32. Herbert, R. L., 'City versus Country: the Rural Image in French Painting from Millet to Gauguin', *Art Forum*, 8, February 1970, pp. 44-5.

33. Brettel, R., *Pissarro and Pontoise*, London, 1993, p. 39.

34. Thomson, R., *Camille Pissarro*, London, 1990, p. 51.

35. See Perry, G., et al, *Modern Art Practices and Debates: Primitivism, Cubism and Abstraction*, New Haven and London, 1993, pp. 32-4.

36. Quoted in Chipp, H. B., *Theories of Modern Art: A Source Book by Artists and Critics*, Los Angeles and London, 1969, p. 29.

37. Quoted in Pollock, G., and Orton, F., *Van Gogh*, Oxford, 1977, p. 40.

38. For a summary account of Primitivism and its influence on the art of the early twentieth century see Perry, G., *Modern Art Practices and Debates; Primitivism, Cubism and Abstraction*, pp. 3-85.

39. See Hayes Tucker, P., *Monet in the 90s: The Series Paintings*, pp. 60-1.

40. Wildenstien, D., *Monet, biographie et catalogue raisonné*, Lausanne and Paris, 1974-85, Vol. 4, pp. 84-125.

List of Plates

A nymph playing with Cupid, 1857
(*Nymphe désarmant l'amour*)
Oil on canvas, 78.5 x 57 cms
Paris, Musée du Louvre
plate 125 page 181

Sèvres-Brimborion, view towards Paris, 1855-65
(*Sèvres-Brimborion, vue des hauteurs de Paris*)
Oil on canvas, 34 x 49 cms
Paris, Musée du Louvre
plate 130 page 186

Souvenir of Mortefontaine, 1864
(*Souvenir de Mortefontaine*)
Oil on canvas, 65 x 89 cms
Paris, Musée du Louvre
plate 131 page 187

Gustave COURBET 1819-77

Stream in the forest, 1862
(*Rivière dans la forêt*)
Oil on canvas, 157 x 114 cms
Boston, Museum of Fine Arts, (gift of Mrs Samuel Parkman Oliver)
plate 1 page 6

Siesta during the haymaking season, 1867-8
(*La sieste pendant la saison des foins - montagnes du Doubs*)
Oil on canvas, 212 x 275 cms
Paris, Musée du Petit Palais
plate 90 page 128

The stonebreakers, 1849
(*Le casseur de pierres*)
Oil on canvas, 190 x 300 cms
Dresden, destroyed WWII
plate 94 page 138

Burial at Ornans, c.1849-50
(*L'Enterrement à Ornans*)
Oil on canvas, 311.5 x 668 cms
Paris, Musée d'Orsay
plate 96 page 140

The Bathers, 1853
(*Les Baigneuses*)
Oil on canvas, 227 x 193 cms
Montpellier, Musée Fabre
plate 97 page 143

The winnowers, 1854
(*Les cribleuses de blè*)
Oil on canvas, 131 x 167 cms
Nantes, Musée des Beaux-Arts
plate 98 page 145

After dinner at Ornans, c.1849
(*L'Après-dinée à Ornans*)
Oil on canvas, 195 x 297 cms
Lille, Musée des Beaux-Arts
plate 154 page 207

Louis Jacques Mandé DAGUERRE 1787-1851

Ruins of Holyrood chapel, c.1824
(*Ruines de la chappelle de Holyrood*)
Oil on canvas, 211 x 256.6 cms
Liverpool, Walker Art Gallery (Board of Trustees of the National Museums and Galleries on Merseyside)
plate 44 page 62-3

The effect of fog and snow seen through a ruined Gothic colonnade, 1826
(*Colonne gothique avec effet de neige et de brouillard*)
Oil on canvas, 102 x 154 cms
Paris, Collection Gérard Lévy and François Lepage
plate 48 page 68

Charles-François DAUBIGNY 1817-78

The storm, 1842
(*L'orage*, extrait de *Chants et Chansons Populaires de la France*)
Etching
Paris, Bibliothèque Nationale
plate 54 page 78

The cedar tree, 1842
(*Le cèdre du Liban*)
Etching
Published in *Le Jardin des Plantes*, Vol. I, p. 238
Paris, Bibliothèque Nationale
plate 55 page 79

The poet's song, 1842
(*Le chant du barde*, extrait de *Chants et Chansons Populaires de la France*)
Etching
Paris, Bibliothèque Nationale
plate 56 page 80

The swallows, 1842
(*Les hirondelles* extrait de *Chants et Chansons Populaires de la France*)
Etching
Paris, Bibliothèque Nationale
plate 57 page 80

The eagle's nest in the forest of Fontainebleau, 1844
(*Carrefour du nid de l'aigle, forêt de Fontainebleau*)
Etching
Published in *l'Artiste*, series 4, Vol. II
Paris, Bibliothèque Nationale
plate 58 page 80

Jacques-Louis DAVID 1748-1825

The death of Socrates, 1780-7
(*La mort de Socrate*)
Oil on canvas, 129.5 x 196.2 cms
New York, The Metropolitan Museum of Art
(Wolfe Fund 1931, Catharine Lorillard Wolfe Collection)
plate 12 page 22

Saint Jerome, 1840
(*Saint Jérôme*)
Etching,
Published in *l'Artiste*
Paris, Bibliothèque Nationale
plate 60 page 82

Pool with stags, 1845
(*Mare avec cerfs*)
Etching
Paris, Bibliothèque Nationale
plate 62 page 85

The harvest, 1851
(*La Moisson*)
Oil on canvas, 135 x 196 cms
Paris, Musée du Louvre
plate 109 page 159

The banks of the Seine, 1851
(*Vue de la Seine, près de Mantes*)
Oil on canvas, 70 x 105 cms
Nantes, Musée des Beaux-Arts
plate 127 page 182

View on the Oise, 1873
(*Les bords de la rivière, vue de l'Oise*)
Oil on panel, 38.7 x 66 cms
London, National Gallery
plate 132 page 188

Sunset over the Oise, 1865
(*Soleil couchant sur l'Oise*)
Oil on canvas, 39 x 67 cms
Paris, Musée du Louvre
plate 133 page 189

Alders, 1872
(*Les Aulnes*)
Oil on mahogany, 33 x 57.1 cms
London, National Gallery
plate 134 page 191

The 'Botin' and steamboats, 1862 from *Voyage en Bateau*
(*Le 'Botin' et les bateaux à vapeur* extrait de *Voyage en Bateau*)
Etching
Paris, Bibliothèque Nationale
plate 135 page 192

The floating studio, 1862 from *Voyage en Bateau*
(*Le bateau-atelier*, extrait de *Voyage en Bateau*)
Etching
Paris, Bibliothèque Nationale
title page and plate 136 page 192

Alexandre-Gabriel DECAMPS 1803-60

The experts (formally *The Critics*), 1837
(*Les experts*)
Oil on canvas, 46.4 x 64.1 cms
New York, The Metropolitan Museum of Art, (the H. O. Havemeyer Collection, bequest of Mrs H. O. Havemeyer, 1929)
plate 89 page 126

Eugène Ferdinand Victor DELACROIX 1798-1863

28th July – Liberty leading the people, 1830
(*Le 28th juillet – La Liberté guidant le peuple*)
Oil on canvas, 260 x 325 cms
Paris, Musée du Louvre
plate 91 page 130

Jean-Louis DEMARNE 1754-1829

The road, 1803
(*Route*)
Oil on canvas, 44 x 55 cms
Paris, Musée Marmottan
plate 28 page 40

The gust of wind, undated
(*Le coup de vent*), dimensions unknown
Oil on canvas
Private Collection
plate 29 page 41

Eugène François Marie-Joseph DEVÉRIA 1805-65

King Louis Philippe taking the oath on 9th August 1830, 1830
(*Serment de roi de maintenir la Charte de 1830*)
Oil on canvas, 77 x 110 cms
Versailles, Musée National du Château de Versailles
plate 69 page 94

Narcisse DIAZ DE LA PEÑA 1807-76

The ferry crossing at sunset, 1837
(*Passage du bac, effet de soleil couchant*)
Oil on canvas, 76 x 117 cms
Amiens, Musée de Picardie
plate 46 page 66

The hills of Jean de Paris, (forest of Fontainebleau), 1867
(*Les hauteurs du Jean de Paris, forêt de Fontainebleau*)
Oil on canvas, 84 x 106 cms
Paris, Musée du Louvre
plate 52 page 73

Stormy landscape, undated
(*L'orage menaçant*)
Oil on canvas, 97.8 x 130.5 cms
Cambridge, Fitzwilliam Museum, University of Cambridge
plate 81 page 116-17

Bohemians going to a fête, 1844
(*Bohémiens se rendant à une fête*)
Oil on canvas, 101 x 81.3 cms
Boston, Museum of Fine Arts, (bequest of Susan Cornelia Warren)
plate 82 page 118

Cattle in the forest of Fontainebleau, 1846
(*Le Bas-Bréau, forêt de Fontainebleau*; également nommé, *Vaches dans la forêt de Fontainebleau*)
Oil on canvas, 70.5 x 130 cms
Paris, Musée du Louvre
plate 83 page 119

Common at sunset (*The Fisherman*), 1850
(*Soleil couchant*)
Oil on panel, 37.1 x 54.6 cms
London, National Gallery
plate 84 page 119

Jules DUPRÉ 1811-89

Willows with a man fishing, undated
(*La Saulaie*)
Oil on canvas, 21.6 x 27 cms
London, National Gallery
plate 66 page 88

Crossing the bridge, 1838
(*Pont sur la rivière du Faye*)
Oil on canvas, 49.5 x 64.8 cms
London, The Wallace Collection
plate 68 page 91

Paul GAUGUIN 1848-1903

Vision after the sermon, 1888
(*La vision après le sermon*)
Oil on canvas, 74.4 x 93.1 cms
Edinburgh, National Gallery of Scotland
plate 164 page 215

Haymaking, 1889
(*Fenaison*)
Oil on canvas, 92 x 73.3 cms
London, Courtauld Institute Galleries (Courtauld Collection)
plate 168 page 218

Haymaking in Derout-Lollichon, Pont Aven, 1888
(*Fenaison en Bretagne, Pont Aven*)
Oil on canvas, 73 x 92 cms
Paris, Musée d'Orsay
plate 169 page 219

232

Bibliography

Ashton, D., and Brown Hare, D., *Rosa Bonheur: A Life and a Legend*, London, 1981.

Balzac, H. de, *Les paysans*, Paris, 1864.

Baudelaire, C., 'Painters and Etchers' in *Art in Paris 1845-1862*, Oxford, 1981.

Bazin, G., *Corot*, Paris, 1973 (3rd edition).

Benoit, F., *L'art sous la révolution et l'empire*, Paris, 1897.

Bernard, F., *Fontainebleau et ses environs*, Paris, 1853.

Billy, A., *Les beaux jours de Barbizon*, Entrepilly, 1985.

Blunt, A., *Nicolas Poussin*, London and Oxford, 1967.

Boime, A., *The Academy and French Painting in the Nineteenth Century*, New Haven and London, 1986.

Boime, A., 'Patronage in Nineteenth-Century France' in Carter, E. C., ed., *Enterprise and Entrepreneurs in Nineteenth- and Twentieth-Century France*, Baltimore, 1976.

Bonaffée, E., *Causeries sur l'art et la curiosité*, Paris, 1878.

Bonnemere, E., *Histoire des paysans*, Paris, 1857.

Bory, J. L., *La révolution de Juillet*, Paris, 1972.

Bouret, J., *The Barbizon School and Nineteenth-Century French Landscape*, London, 1973.

Brettel, R., *Pissarro and Pontoise*, London, 1993.

Broude, N., *Impressionism: A Feminist Reading*, New York, 1991.

Champa, K. S., *Studies in Early Impressionism*, New Haven and London, 1973.

Chennevières, P. de, *Souvenirs d'un directeur des Beaux-Arts*, Paris, 1883-9.

Chicago, *Frédéric Bazille and Early Impressionism*, exhibition catalogue, Art Institute of Chicago, 1978.

Clark, T. J., *The Absolute Bourgeois: Artists and Politics in France, 1848-1851*, London, 1988.

Clarke, M., *Corot and the Art of Landscape*, London, 1991.

Collingham, H.A.C., *The July Monarchy: A Political History of France 1830-1848*, London, 1988.

Curmer, L., *Les jardins des plantes*, Paris, 1849.

Denecourt, C.-F., *Guide du voyageur dans la palais et la forêt de Fontainebleau, ou choix des promenades les plus pittoresques, orne d'une carte*, Paris, 1840.

Deperthes, J.-B., *Théorie du paysage*, Paris, 1818.

Desnoyers, F., ed., *Hommage à C.-F. Denecourt - Fontainebleau, paysages, legendes, souvenirs, fantasies*, Paris, 1855.

Domet, F., *Histoire de la forêt de Fontainebleau*, Paris, 1867.

Dublin, *The Peasant in 19th-Century French Art*, exhibition catalogue, Douglas Hyde Gallery, Trinity College, Dublin, 1980.

Durand-Ruel, P., 'Memoires de Paul Durand-Ruel' in Venturi, L., *Les archives de l'impressionisme*, Paris and New York, 1939.

Fay Hallé, A., and Mundt, B., *Nineteenth-Century European Porcelain*, London, 1983.

Forges, de, M.-T., *Barbizon*, Paris, 1972.

Galassi, P., *Corot in Italy: Open-air Painting and the Classical Landscape Tradition*, New Haven and London, 1991.

Gernsheim, H. and A., *L.-J.-M. Daguerre: The History of the Diaorama and Daguerreotype*, London, 1956.

Green, N., *The Spectacle of Nature: Landscape and Bourgeois Culture in Nineteenth-Century France*, Manchester and New York, 1990.

Grunchec, P., *Les concours des Prix de Rome*, Paris, 1986.

Hadjinicolaou, N., 'Art in a Period of Social Upheaval' in *Oxford Art Journal*, 6, no. 2, 1983.

Hayes Tucker, P., *Monet in the 90s: the Series Paintings*, New Haven and London, 1989.

Henriet, F., *Le paysagiste au champs*, Paris, 1876.

Herbert, R. L., 'City versus Country: The Rural Image in French Painting from Millet to Gauguin', *Art Forum*, 8, February 1970.

Herbert, R. L., *Impressionism, Art, Leisure and Parisian Society*, New Haven and London, 1988.

Herbert, R. L., *Barbizon Revisited*, Boston 1962.

Hibbert, C., *The Grand Tour*, London, 1987.

House, J., Monet, *Nature into Art*, New Haven and London, 1989.

Hyde, R., *Panoramania*, Barbican Art Gallery, London, 1988.

Isaacson, J., *Monet: Le déjeuner sur l'herbe*, London, 1972.

Jal, A., *Causeries du Louvre*, Paris, 1833.

Janin, J., *Quatre promenades dans la forêt de Fontainebleau*, Fontainebleau, 1837.

Janin J., *Voyage de Paris à la Mer, description historique des Villes, Bourgs, Villages et des bords de la Seine. Orne d'un grand nombre des vignettes dessinées sur les lieux par Morel-Fatio et Daubigny*, Paris, 1843.

London, *Jean-François Millet*, exhibition catalogue, Arts Council of Great Britain and the Hayward Gallery, London, 1976.

Mainardi, P., *Art and Politics of the Second Empire: the Universal Exhibitions of 1855 and 1857*, New Haven and London, 1989.

Marinan, M., *Painting Politics for Louis-Philippe*, New Haven and London, 1988.

McWilliam, N., and Parsons, C., 'Le Paysan de Paris: Alfred Sensier and the Myth of Rural France', *Oxford Art Journal*, 6, no. 2, 1983.

Melot, M., *The Graphic Art of the Pre-Impressionists*, New York, 1978.

Millin de Grandmaison, A. L., *Dictionnaire des Beaux-Arts*, Paris, 1806.

Miquel, P., *L'Ecole de la nature: Le paysage français au XIXème siècle*, Maurs-la-Jolie, 1975, 6 volumes.

Missouri, University of, *The Art of the July Monarchy: France 1830 - 1848*, exhibition catalogue, Columbia and London, 1990.

New York, Brooklyn Museum, *Courbet Reconsidered*, exhibition catalogue, New Haven and London, 1988.

Nochlin, L., *The Politics of Vision: Essays on Nineteenth-Century Art and Society*, London, 1991.

Norwich, *Théodore Rousseau*, exhibition catalogue, Sainsbury Centre for the Visual Arts, University of East Anglia, Norwich, 1982.

Paris, *Un Age d'Or des Arts Décoratifs, 1814-1848*, exhibition catalogue, Galeries Nationales du Grand Palais, Paris, 1991.

Planche, G., *Etudes sur les écoles*, Paris, 1855, 2 volumes.

Planche, G., *Salon de 1831*, Paris, 1831.

Plinville de Guillebon, R., *Paris Porcelain 1770-1850*, London, 1972.

Pointon, M., *The Bonington Circle: English Watercolour and the Anglo-French Landscape 1790-1855*, Brighton, 1985.

Pugh, S., ed., *Reading Landscape: Country-City-Capital*, Manchester and New York, 1990.

Rewald, J., *The History of Impressionism*, London, 1986.

Rosen, C. and Zerner, R,. *Romanticism and Realism: The Mythology of Nineteenth-Century Art*, London, 1984.

Rosenthal, L., *Du Romantisme au réalsime: Essai sur l'évolution de la peinture en France de 1830 à 1848*, Paris, 1914.

Sand, G., *La mare au diable*, Paris, 1973 edition.

Sensier, A., *Etude de Georges Michel*, Paris, 1873.

Sensier, A., *Souvenirs sur Théodore Rousseau*, Paris, 1872.

Sensier, A., *La Vie et l'oeuvre de Jean-François Millet*, Paris, 1881.

Sillevis, J., and Kraan, H., *The Barbizon School*, The Hague, 1985.

Taylor, I., de Cailleux, A., and Nodier, C., *Voyages pittoresques et romantiques dans l'ancienne France*, Paris, 1820.

Ten Doeschate Chu, P., *French Realism and the Dutch Masters: The Influence of Dutch Seventeenth-Century Painting on the Development of French Painting between 1830 and 1870*, Utrecht, 1973.

Thomson, R., *Camille Pissarro*, London, 1990.

Valenciennes, P.-H., *Elémens de perspective pratique, à l'usage des artistes suivis des réflexions et conseils à un élève sur la peinture, et particulièrement sur le genre de paysage*, Paris, 1800.

Venturi, L., *Les archives de l'impressionisme*, Paris and New York, 1939.

Weisberg, G., *Bonvin: la vie et l'oeuvre*, Paris, 1979.

Weisberg, G., *The Realist Tradition: French Painting and Drawing, 1830-1900*, Cleveland, 1980.

Weitzenhoffer, F., *The Havermeyers: Impressionism Comes to America*, New York, 1986.

Wey, F., *Dictionnaire du droit et de devoirs*, Paris, 1848.

Whiteley, L., 'Art et commerce d'art en France avant l'époque impressioniste' in *Romantisme*, Paris, 1983.

Zola, E., *Ecrits sur l'art*, Paris, 1991.

Acknowledgements

Photographs Bridgeman Art
Library, London: pages 25, 41,
110-11, 128, 143, 168, 207 and
224-5; Photograph © 1993 The
Art Institute of Chicago. All
rights reserved: page 203
(bottom); Photograph Christies,
London: page 180; Photograph
C. Derleeschauwer: page 105;
Photograph Charles Desavary ©
Artephot, Paris: page 124;
Photographs
Giraudon/Bridgeman Art
Library, London: pages 11, 12,
156 (bottom) and 187;
Photograph Giraudon, Paris:
pages 81, 108, 153 and 202;
Photograph Luiz Hossaka: page
205; Photographs Lauros-
Giraudon, Paris: pages 16, 73,
87, 104, 121, 148, 167, 179 and
200; Photograph Charles
Marville: page 13; Roy Miles
Gallery, London: page 41;
Photograph © Ville de Nantes,
Musée des Beaux-Arts, P. J.,:
pages 145 and 182; Photograph
A. Repska: page 113; Photograph
Rheinisches Bildarchiv, Köln:
page 171; Photograph H. W.
Mesdag Museum, Den
Haag/The Hague: page 103;
Photographs © RMN, Paris:
pages 12, 15, 31, 36, 42,
44 (bottom), 58, 84, 88 (top), 94,
106, 119 (top), 120, 130, 133,
140-1, 146, 150, 155, 159, 160,
164-5, 169, 173, 181 (top),
185 (bottom), 186, 189, 196,
198 (bottom), 199 (top and
bottom), 203 (top), 208,
219 (top), 223; Photograph
Roumagnac Photographer: page
114; Photograph Scala, Florence:
page 9; Photograph J. P.
Verniette: page 30; Photograph
© Roger Viollet, Paris: page 102;
Photograph Witt Library,
Courtauld Institute of Art,
University of London: page 138.